Salvador Dalí

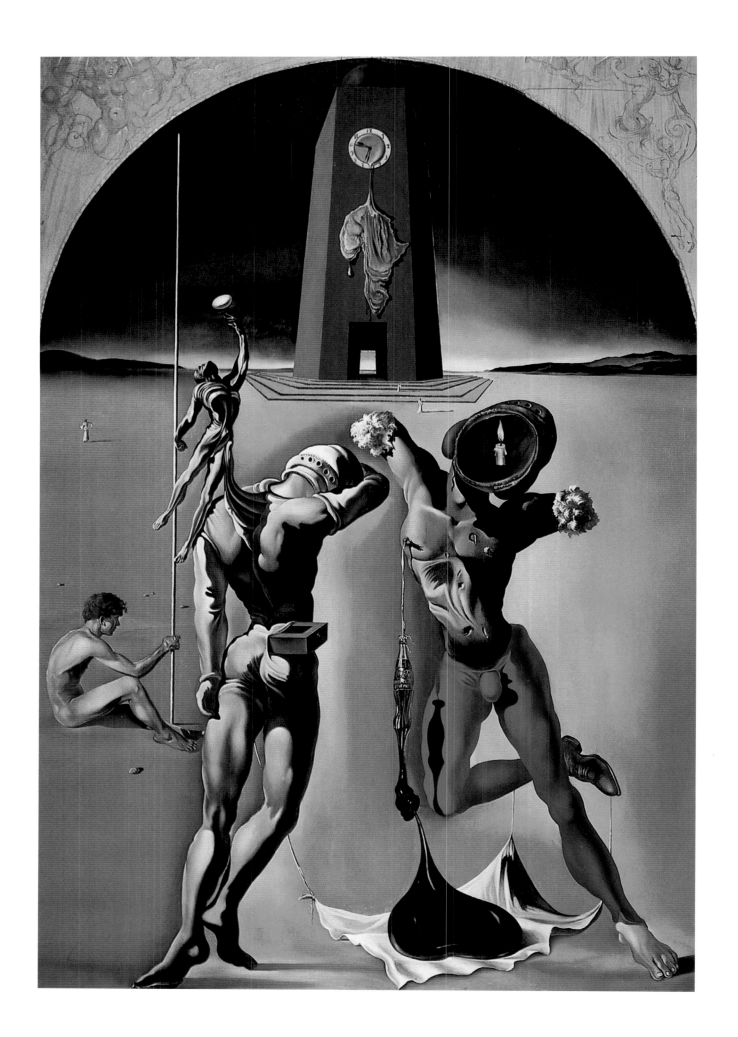

Robert Descharnes · Gilles Néret

SALVADOR DALÍ

1904–1989

TASCHEN

KÖLN LONDON LOS ANGELES MADRID PARIS TOKYO

ILLUSTRATION PAGE 2:
Poetry of America (The Cosmic Athletes), 1943
Poésie d'Amérique (Les Athlètes cosmiques)
Oil on canvas, 116.8 x 78.7 cm
Fundación Gala-Salvador-Dalí, Figueras

To stay informed about upcoming TASCHEN titles, please request our magazine
at www.taschen.com/magazine or write to TASCHEN America, 6671 Sunset
Boulevard, Suite 1508, USA-Los Angeles, CA 90028, contact-us@taschen.com,
Fax: +1-323-463.4442. We will be happy to send you a free copy of our magazine
which is filled with information about all of our books.

Printed in China
ISBN 3–8228–5008–X

Contents

The Dandy and his Mirror

"A dandy," wrote Charles Baudelaire, "must be looking in his mirror at all times, waking and sleeping." Dalí could easily have become the living proof of Baudelaire's dictum. But the literal mirror was not enough for him. Dalí needed mirrors of many kinds: his pictures, his admirers, newspapers and magazines and television. And even that still left him unsatisfied.

So one Christmas he took a walk in the streets of New York carrying a bell. He would ring it whenever he felt people were not paying enough attention to him. "The thought of not being recognised was unbearable." True to himself to the bitter end, he delighted in following Catalonian television's bulletins on his state of health during his last days alive (in Quiron hospital in Barcelona); he wanted to hear people talking about him, and he also wanted to know whether his health would revive or whether he would be dying soon. At the age of six he wanted to be a female cook – he specified the gender. At seven he wanted to be Napoleon. "Ever since, my ambition has been continually on the increase, as has my megalomania: now all I want to be is Salvador Dalí. But the closer I get to my goal, the further Salvador Dalí drifts away from me."

He painted his first picture in 1910 at the age of six. At ten he discovered Impressionist art, and at fourteen the Pompiers (a 19th century group of academic genre painters, among them Meissonier, Detaille and Moreau). By 1927 he was Dalí, and the poet and playwright Federico García Lorca, a friend of his youth, wrote an 'Ode to Salvador Dalí.' Years later Dalí claimed that Lorca had been very attracted to him and had tride to sodomize him, but had not quite managed it. Dalí's thirst for scandal was unquenchable. His parents had named him Salvador "because he was the chosen one who was come to save painting from the deadly menace of abstract art, academic Surrealism, Dadaism, and any kind of anarchic "ism" whatsoever."[1]

If he had lived during the Renaissance, his genius would have been recognized at an earlier stage and indeed considered normal. But in the twentieth century, which Dalí damned as stupid, he was thought provocative, a thorn in the flesh. To this day there are many who misunderstand the provocativeness and label him insane. But Dalí repeatedly declared: "...the sole difference between me and a madman is the fact that I am not mad!"[2] Dalí also said: "The difference between the Surrealists and me is that I am a Surrealist"[3] – which is perfectly true. And he also

"Every morning when I wake up I experience an exquisite joy – the joy of being Salvador Dalí – and I ask myself in rapture what wonderful things this Salvador Dalí is going to accomplish today."

The Sick Child (Self-Portrait at Cadaqués),
c.1923
L'enfant malade (Autoportrait à Cadaqués)
Oil and gouache on cardboard, 57 x 51 cm
Collection of Mr. and Mrs. Reynolds Morse,
Loan to the Salvador Dalí Museum, St. Petersburg (Fla.)

claimed: "I have the universal curiosity of Renaissance men, and my mental jaws are constantly at work."[4]

Dalí's fame spread worldwide. The Japanese established a Dalí museum. Interest in his work grew constantly during his lifetime. And all the while Dalí was Dalí, provoking the world with surreal inventiveness and his own bizarre personality. At his death he left a vast body of work – which had occasionally been obscured from view by the artist himself while he was alive. During the terminal stages of modern art, nihilistically pursuing its reductive, self-destructive course, Dalí was one of the few to propose a way out. A great deal of work remains to be done before his proposal is fully grasped.

The alternative he proposed begins with the great Old Masters and takes us via the conquest of the irrational to the decoding of the subconscious, deliberately including recent scientific discoveries. Writing in 1964, Michel Déon acutely observed: "It is tempting to suppose we know Dalí because he has had the courage to enter the public realm. Journalists devour every syllable he utters. But the most surprising thing about him is his earthy common sense, as in the scene where a young man who wants to make it to the top is advised to eat caviar and drink champagne if he does not wish to fret and toil to the end of his days. What makes Dalí so attractive is his roots and his antennae. Roots that reach deep into the earth, absorbing all the earthiness (to use one of Dalí's favourite notions) that has been produced in four thousand years of painting, architecture and sculpture. Antennae that are picking up things to come, tuned to the future, anticipating it and assimilating it at lightning speed. It cannot be sufficiently emphasized that Dalí is a man of tireless scientific curiosity. Every discovery and invention enters into his work, reappearing there in barely changed form."[5]

Dalí was a Catalonian and proud of it. He was born on 11 May 1904 in Figueras, a small town in the province of Gerona. Later he was to celebrate his birth in his own inimitable fashion: "Let all the bells ring! Let the toiling peasant straighten for a moment the ankylosed curve of his anonymous back, bowed to the soil like the trunk of an olive tree, twisted by the tramontana...

Look! Salvador Dalí has just been born!

It is on mornings such as this that the Greeks and the Phoenicians must have disembarked in the bays of Rosas and of Ampurias, in order to come and prepare the bed of civilization and the clean, white and theatrical sheets of my birth, settling the whole in the very centre of this plain of Ampurdán, which is the most concrete and the most objective piece of landscape that exists in the world."[6]

Salvador Dalí's Catalonian roots were the key to a major aspect of his work. The Catalonians are reputed to believe only in the existence of things they can eat, hear, feel, smell or see. Dalí made no secret of this materialistic and culinary atavism: "I know what I'm eating. I don't know what I'm doing." A fellow-Catalonian Dalí liked to quote, the philosopher Francesc Pujols, compared the spread of the Catholic church to a pig fattened for the slaughter; Dalí, on the other hand, adapted St. Augustine in his own typical fashion: "Christ is like cheese, a whole

Portrait of Hortensia, Peasant Woman from Cadaqués, c.1918–19
Portrait d'Hortensia, paysanne de Cadaqués
Oil on canvas, 35 x 26 cm
Private collection

mountain range of cheese!"[7] An orgiastic sense of food is present throughout Dalí's work: in *Soft Watches*, which derived from a dream of runny camembert (a metaphysical image of time, devouring itself and all else, too); in various versions of *Anthropomorphic Bread* (p. 65), in *Ordinary French Loaf with Two Fried Eggs Riding without a Plate, Trying to Sodomize a Heel of a Portuguese Loaf* (p. 64), in *Fried Eggs on a Plate without the Plate* (p. 71), in *Gala with Two Lamb Chops Balanced on Her Shoulder* (p. 75), in *Cannibalism of the Object* (p. 118), *Ghost of Vermeer van Delft, Usable as a Table, Dynamic Omelettes with Fine Herbs* or even in a picture on the subject of the Spanish Civil War which Dalí titled *Soft Construction with Boiled Beans (Premonition of Civil War)* (p. 109).

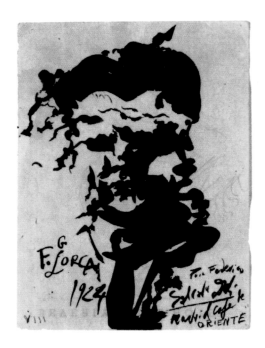

Triple Portrait of García Lorca, 1924
done by Salvador Dalí
in the "Oriente" Café in Madrid

Of course, Dalí's Catalonian atavism was not expressed in terms of edibles only. We see it in the presence in his pictures of the Plain of Ampurdán, which he was very fond of and declared to be the loveliest scenery on earth. The stretch of Catalonian coastline from Cape Creus to Estartit, with Cadaqués midway, provided Dalí with the landscape settings of his most famous paintings, lit with the Mediterranean's unmistakable light. The rugged crags and cliffs were the origin of Dalí's predilection for the worn and primeval: for fossils, bones, anthropomorphic objects, and the other twilit atavisms that dominate his output.

For Dalí, the centre of the world was in Catalonia – to be exact, at Perpignan railway station. "Do you suppose there are landscapes suitable for paintings all over the earth, simply because it is round? A round face isn't all noses, is it? There are very few landscapes."[8] To Dalí's way of thinking, Catalonia was the earth's nose, the point everything was focussed upon. In Dalí there was much of the paradigmatic Catalonian envisaged by Francesc Pujols: "When Catalonia is the queen and mistress of the world . . . when people take a close look at the Catalonians, it will be like looking at the very blood of Truth, and taking their hand will be like touching the hand of Truth . . . Because they are Catalonians, they will be repaid everything, wherever they may go."[9] Dalí liked to apply these phrases to his own life, and was indeed quite relentless in doing so.

It seems fair to say that Dalí's love of money was a Catalonian trait, one that harked back to Phoenician ancestry. It was not for nothing that André Breton anagramatically dubbed him "Avida Dollars." Money held a magical attraction for him. In *Les passions selon Dalí* (1968) Dalí wrote: "To a mystic such as myself, Man is an alchemical substance meant for the making of gold."[10] He quite openly confessed that he delighted in accumulating gold through his art.

The fact of his birth in Figueras made Dalí a Catalonian – that is to say, a Spaniard of a particular kind. He was proud of being Spanish, and was delighted by Sigmund Freud's comment when they met: "I have never seen a more complete example of a Spaniard. What a fanatic!"[11] In his *Journal d'un génie* Dalí declared: "The most important things that can happen to any painter in our time are these: 1. To be Spanish. 2. To be called Gala Salvador Dalí."[12]

In 1904 (when Dalí was born) Catalonia's Golden Age of trade had made it a wealthy province. The Catalonians are a proud people, given to pomp and display, and hoped to make Barcelona the Athens of the 20th century. Picasso was then twenty-three years old and making his way, while Antoni Gaudí, Catalonia's remarkable and idiosyncratic architectural genius, was at work on the last of the great cathedral, the Sagrada Familia.

Dalí's father, Salvador Dalí y Cusí, came from Cadaqués, a fine fishing town positioned (in Lorca's words) "at the still point where the scales of sea and mountains came to rest." Dalí senior was an authoritarian, though his views were liberal. He had a notary's practice in Figueras, some twenty miles from his birthplace. The young Salvador was adored and spoilt by his parents, and always got his own way. Everything was his for the asking – with a very few exceptions, among them access to

Portrait of the Cellist Ricardo Pichot, 1920
Portrait du violoncelliste Ricardo Pichot
Oil on canvas, 61.5 x 49 cm
Private collection, Cadaqués

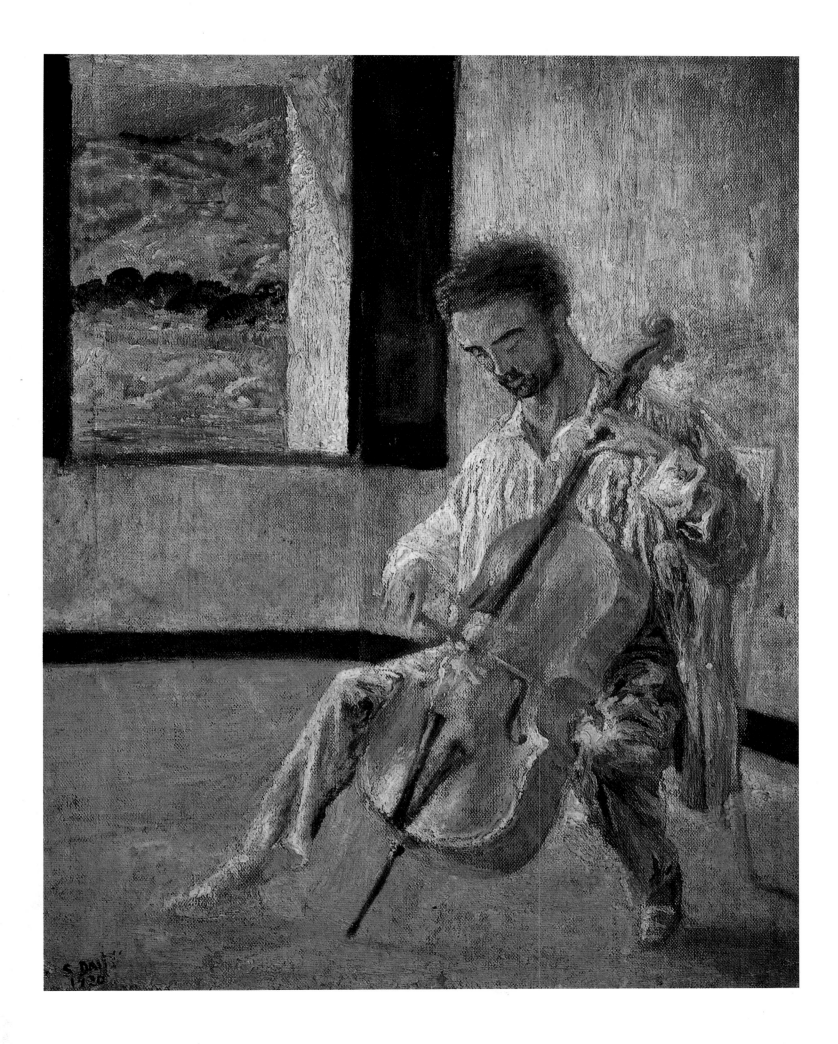

the kitchen. Dalí was to recall: "When I was six, it was a sin for me to eat food of any kind in the kitchen." He would lay in wait for moments when he could steal away to enjoy his forbidden pleasures, "and while the maids stood by and screamed with delight I would snatch a piece of raw meat or a broiled mushroom on which I would nearly choke but which, to me, had the marvelous flavour, the intoxicating quality, that only fear and guilt can impart.

"Aside from being forbidden the kitchen I was allowed to do anything I pleased. I wet my bed until I was eight for the sheer fun of it. I was the absolute monarch of the house. Nothing was good enough for me. Behind the partly open kitchen door I would hear the scurrying of those bestial women with red hands; I would catch glimpses of their heavy rumps and their hair straggling like manes; and out of the heat and confusion that rose from the conglomeration of sweaty women, scattered grapes, boiling oil, fur plucked from rabbits' armpits, scissors spattered with mayonnaise, kidneys, and the warble of canaries – out of that whole conglomeration the imponderable and inaugural fragrance of the forthcoming meal was wafted to me, mingled with a kind of acrid horse smell. As I said, I was a spoiled child."[13]

Evidently Dalí's childhood can account for a number of things in his later life and work. He himself offered an explanation for the astonishing extent to which his parents indulged him: "My brother died at the age of seven from an attack of meningitis, three years before I was born. His death plunged my father and mother into the depths of despair; they found consolation only upon my arrival into the world. My brother and I resembled each other like two drops of water ... Like myself he had the unmistakable facial morphology of a genius. He gave signs of alarming precocity ... My brother was probably a first version of myself, but conceived too much in the absolute."[14] At times we intuit in Dalí's life and work the presence of this brother whom he never knew and who in fact died nine months – the duration of a pregnancy – before Salvador Dalí's birth.

In spite of his liberal attitudes, Dalí's father would not so readily have accepted that his son was to be a painter if friends, particularly the Pichot family, had not encouraged the youth in his wish. Dalí later recalled the decisive role the family played in his life: "My parents had already undergone the influence of the personality of the Pichot family before me," he wrote in *The Secret Life of Salvador Dalí*. "All of them were artists and possessed great gifts and an unerring taste. Ramón Pichot was a painter. Ricardo a cellist, Luis a violinist, Maria a contralto who sang in opera. Pepito was, perhaps, the most artistic of all."[15] The Pichots would give concerts by moonlight, and would not shy from hauling their grand piano up onto the cliffs. "So if I paint grand pianos on cliffs or by cypresses, it is by no means a fantastic dream vision," Dalí noted; "they are things I have seen, things that have made an impression on me." It was when Dalí saw pictures Ramón Pichot had painted that he decided to become a painter. "But the paintings that filled me with the greatest wonder where the most recent ones, in which deliquescent impressionism ended in certain canvases by frankly adopting in an almost uniform

"At the age of six I wanted to be a cook. At seven I wanted to be Napoleon – and my ambition has steadily grown ever since."

Portrait of my Father, 1920–1921
Portrait de mon père
Oil on canvas, 90.5 x 66 cm
Gift from Dalí to the Spanish state

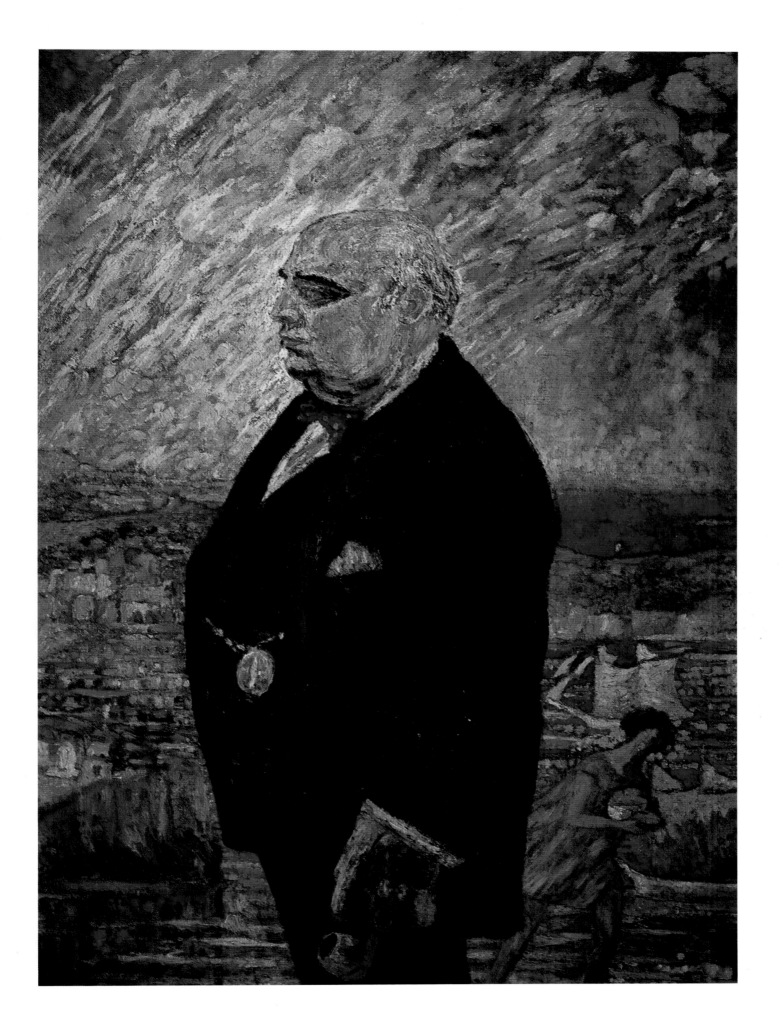

manner the *pointilliste* formula. The systematic juxtaposition of orange and violet produced in me a kind of illusion and sentimental joy like that which I had always experienced in looking at objects through a prism, which edged them with the colours of the rainbow. There happened to be in the dining room a crystal carafe stopper, through which everything became 'impressionistic.' Often I would carry this stopper in my pocket to observe the scene through the crystal and see it 'impressionistically.'"[16]

Salvador's school career was undistinguished, to put it mildly. He had a mediocre primary education, learning the basics of drawing and watercolour painting and discovering the beauty of calligraphy, and then attended a Marist grammar school, the only school in Figueras that offered the chance to sit school-leaving examinations.

It was at this time that he painted his first works, showing houses and the Catalonian landscape. These paintings had so idiosyncratic a power that Pepito Pichot advised his friend the notary to have his son given art tuition. Siegfried Burmann, a German portrait and landscape painter who happened to be on holiday in the area, was also astounded by the young

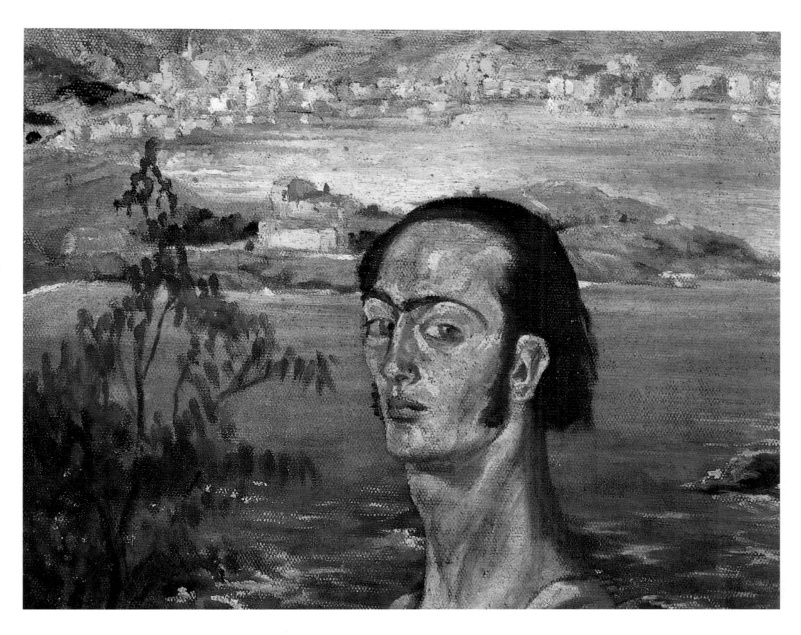

Self Portrait with the Neck of Raphael,
1920–1921
Autoportrait au cou de Raphaël
Oil on canvas, 41.5 x 53 cm
Gift from Dalí to the Spanish state

Salvador's exceptional gift, and in 1914 made him a present of his first palette and tubes of paint.

In 1917 Salvador Dalí attended Professor Juan Nuñez's drawing course at the *Escuela Municipal de Grabado*. Needless to say, he delighted in doing the exact opposite of what he was taught, and particularly in confronting Nuñez and obliging him to concede that he, Dalí, was right. On one occasion, when his task was to sketch a beggar, Dalí's teacher recommended that he use a soft pencil and merely graze the paper lightly with it; so of course Dalí smothered his drawing in black until it was only an incoherent mass of dark blotches, and then proceeded to ink it over. At this point he had no alternative but to adopt a scraping technique. Using his penknife he scratched away, producing dazzling whites: " ... where I wanted my whites to emerge more subdued, I would spit directly on the given spot and my rubbing then produced peelings that were more grayish and dirty. Soon I mastered the operation of bringing out the pulp of the paper in such a way as really to look like a kind of down ... It was, so to speak, the direct imitation of the old man's beard." According to

Dalí, who doubtless exaggerated his teacher's admiration, Nuñez clasped him in a smothering embrace and exclaimed: "Look at our Dalí – isn't he great!"[17]

It was also the time Dalí himself referred to as his "stone period:" "I used stones, in fact, to paint with. When I wanted to obtain a very luminous cloud or an intense brilliance, I would put a small stone on the canvas, which I would thereupon cover with paint. One of the most successful paintings of this kind was a large sunset with scarlet clouds. The sky was filled with stones of every dimension, some of them as large as an apple! This painting was hung for a time in my parents' dining room, and I remember that during the peaceful family gatherings after the evening meal we would sometimes be startled by the sound of something dropping on the mosaic. My mother would stop sewing for a moment and listen, but my father would always reassure her with the words, 'It's nothing – it's just another stone that's dropped from our child's sky!'... With a worried look, my father would add, 'The ideas are good, but who would ever buy a painting which would eventually disappear while their house got cluttered up with stones?"[18] In early May 1918, Dalí exhibited some of his paintings in the theatre at Figueras, and attracted the attention of two famous critics, Carlos Costa and Puig Pujades, who forecast a brilliant career for the artist.

After passing his school-leaving exams, Dalí tried to persuade his father to let him go to the Madrid Academy of Art. His son's obstinate determination, together with the support of Professor Nuñez and the Pichot family, finally vanquished his father's misgivings and he gave his consent. Perhaps the death of his wife, on 6 February 1921 in Barcelona, also helped to weaken his resistance. The loss of the person who had meant more to him than anyone else caused Salvador Dalí great grief. He

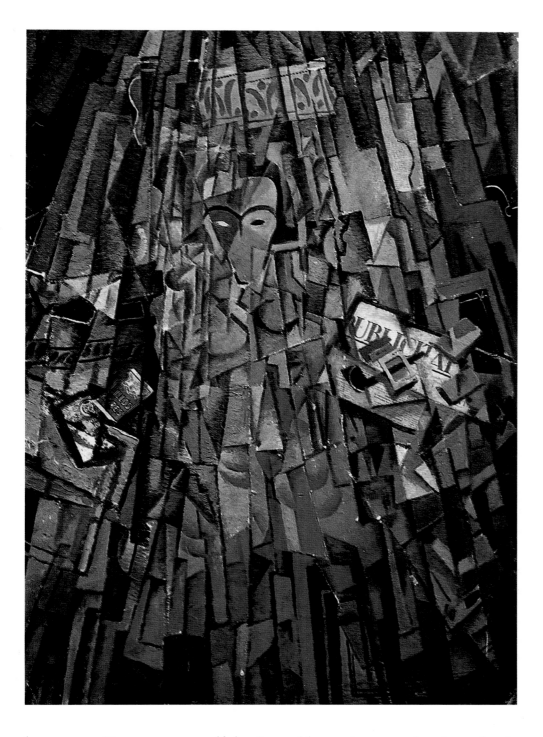

Cubist Self-Portrait, 1923
Autoportrait cubiste
Gouache and collage on card, 104.9 x 74.2 cm
Teatro-Museo Dalí, Figueras

later wrote "I swore to myself that I would snatch my mother from death and destiny."[19]

Together with his father and his sister Ana María, Dalí went to Madrid to sit the entrance exam at the San Fernando Academy of Painting, Sculpture and Graphic Arts. He was accepted – and an insightful comment on his technical ability and rebarbative character accompanied the acceptance: "In spite of the fact that it does not have the dimensions prescribed by the regulations, the drawing is so perfect that it is considered approved by the examining committee."[20]

Dalí moved into a room in the *Residencia de Estudiantes* – a residence for students of well-to-do families. There he painted his first cubist, pointillist and divisionist works, under the influence of another Spanish

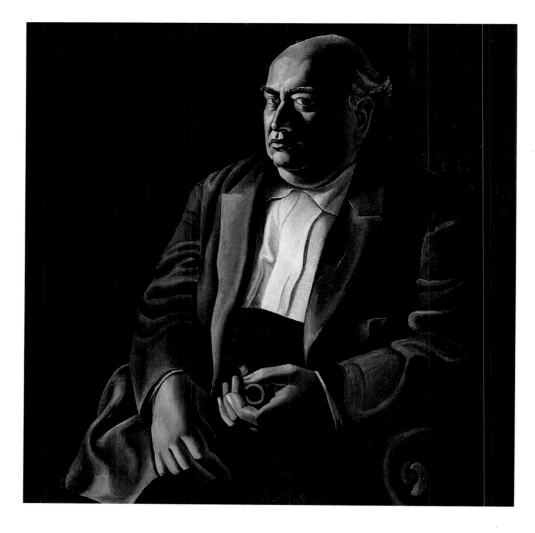

Portrait of my Father, 1925
Portrait de mon père
Oil on canvas, 104.5 x 104.5 cm
Museu d'Arte Modern, Barcelona

artist, Juan Gris, and of the Italien Futurists, for whom he retained a lifelong admiration. With only a few exceptions, his work at this time used a reduced palette of black, white, sienna and olive green – a reaction to his exuberant use of colour in the previous year or so. In his personal appearance, Dalí was already working on a distinctive style. "With my velvet jacket, my hair which I wore like a girl's, my gilded cane and my sideburns reaching more than halfway down my cheeks, my appearance was in truth so outlandish and unusual that I was taken for an actor."[21] "I detested long trousers and decided to wear shorts and socks, and now and then puttees. On rainy days I wore a cape... It was so long that it almost touched the ground... I now realize that the people who knew me in those days were not exaggerating in the slightest in describing my appearance at the time as 'fantastic.' It really was. Whenever I went out or returned to my room, people would gather, curious to see me. And I would stride past them, head held proudly high."[22]

Dalí found the lecturers a disappointment. They were still preoccupied with things that he had already moved on from. Eager for the new, they did not teach him the classicism he was after. Meanwhile, Dalí entered Madrid's avant-garde, making the acquaintance of Pepín Bello, García Lorca, Luis Buñuel, Pedro Garfías, Eugenio Montes and Rafael Barradas. There was only one aged professor whom Dalí approved of, the only one who had a thorough knowledge of his field and taught it to his

Portrait of Luis Buñuel, 1924
Portrait de Luis Buñuel
Oil on canvas, 70 x 60 cm
Centro de Arte Reina Sofia, Madrid

Portrait of the Artist's Father and Sister, 1925
Portrait du père et de la soeur de l'artiste
Charcoal drawing, 49 x 30 cm
Private collection, Barcelona

Girl at the Window, 1925
Personnage à une fenêtre
Oil on canvas, 103 x 75 cm
Museo Español de Arte Contemporáneo,
Madrid

students in a conscientiously professional way without making concessions to aesthetic progressivism. This man also wore a frock coat (which was much to Dalí's taste), a black pearl pinning his tie, and would correct his students' work wearing white gloves, to avoid dirt. "He had a pair of sensationally penetrating, photographic little eyes, like Meissonier's."[23]

After two tempestuous years in the company of his friends, Dalí was sent down from the Academy. He was charged with having egged on his fellow-students to protest against the appointment of a mediocre artist to a professorial chair. He was even kept under arrest for a few weeks in Gerona. The authorities disapproved of the fact that the Figueras notary's son was the only one in the entire district to have subscribed to *L'Humanité*; their disapproval was all the greater, since the notary himself made no secret of his regrettable Catalonian separatist views. Back in Cadaqués, Dalí devoted himself to his books and to new paintings in the cubist manner, paintings of his beloved landscape or of people close to him. One notable picture of this period is the *Self Portrait with the Neck of Raphael* (p. 15), in which the dominant impression is that of the glaring midday light at Cadaqués. Dalí reported: "People called me Señor Patillas, because I had sideburns;" and, commenting on the origin of the painting, "It was painted in the morning. At times I would get up at dawn and work on four or five paintings simultaneously. I had people to carry the canvasses, but the brushes were attached to my clothes with string; that way, I looked like some kind of Bohemian. And I always had the brush I needed close to hand. Later, I wore overalls that were spattered with glue from top to bottom and were like a real suit of armour."

He viewed the period spent under arrest as an episode, "without any other consequence than to add a lively colour to the already highly coloured sequence of the anecdotic episodes of my life."[24] The Madrid group was ailing without Dalí. "They were all disoriented, lost and dead of an imaginative famine which I alone was capable of placating. I was acclaimed, I was looked after, I was coddled. I became their divinity . . ."[25] He envied Lorca alone because he had greater influence over the group; the group increasingly became Lorca's, and "I knew Lorca would shine like a mad and fiery diamond. Suddenly I would set off at a run, and no one would see me for three days."[26]

Dalí's family were upset that he had been expelled from the Academy. His father was devastated. All of his hopes that his son would enter upon a career in the civil service had come to nothing. "With my sister, he posed for a pencil drawing which was one of my most successful of this period. In the expression of my father's face can be seen the mark of the pathetic bitterness which my expulsion from the Academy had produced on him. At the same time that I was doing these more and more rigorous drawings, I executed a series of mythological paintings in which I tried to draw positive conclusions from my cubist experience by linking its lesson of geometric order to the eternal principles of tradition."[27]

In the autumn of 1925 Dalí returned to the Academy – only to be sent down anew on 20 October the following year, this time for good. The Academy no longer had anything to offer him. It was too late. Salvador had already become Dalí.

Figure between the Rocks, 1926
Personnage parmi les rochers
Oil on plywood, 27 x 41 cm
Collection of Mr. and Mrs. A. Reynolds
Morse, Loan to the Salvador Dalí Museum,
St. Petersburg (Fla.)

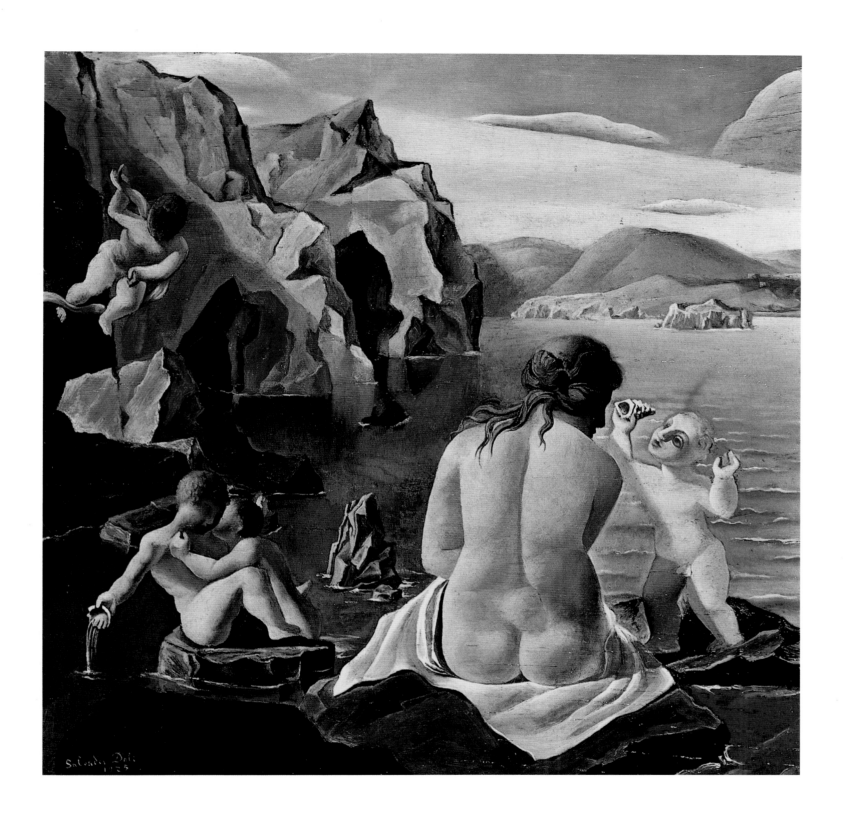

Venus and Amorini, 1925
Vénus et amours
Oil on panel, 23 x 23.5 cm
Private collection

The Proof of Love

Dalí wanted to be talked about in Spain. And that meant he had to become known beyond Catalonia. Exhibitions in Madrid and Barcelona were beginning to attract attention, and Dalí subsequently wrote: "Picasso had seen my *Girl's Back* in Barcelona, and praised it. I received on this subject a letter from Paul Rosenberg asking for photographs, which I failed to send, out of sheer negligence. I knew that the day I arrived in Paris I would put them all in my bag with one sweep."[28]

Persuading his father that he had to continue his studies in Paris was probably not too difficult. And Dalí predicted that once he was in Paris, he would conquer it. Dalí seems to have spent a week in Paris at the beginning of 1927, in the company of his aunt and sister – one of his father's precautions. During this stay, according to Dalí himself, he did three important things: He saw Versailles and the Musée Grévin, and he called on Picasso. "I was introduced to the latter by Manuel Angelo Ortiz, a cubist painter of Granada, who followed Picasso's work to within a centimetre. Ortiz was a friend of Lorca's and this is how I happened to know him. When I arrived at Picasso's on Rue de La Boétie I was as deeply moved and as full of respect as though I were having an audience with the Pope. 'I have come to see you,' I said, 'before visiting the Louvre.' 'You're quite right,' he answered. I brought a small painting, carefully packed, which was called *The Girl of Figueras*. He looked at it for at least fifteen minutes, and made no comment whatever. After which we went up to the next story, where for two hours Picasso showed me quantities of his paintings. He kept going back and forth, dragging out great canvases which he placed against the easel. Then he went to fetch others among an infinity of canvases stacked in rows against the wall. I could see that he was going to enormous trouble. At each new canvas he cast me a glance filled with a vivacity and an intelligence so violent that it made me tremble. I left without in turn having made the slightest comment. At the end, on the landing of the stairs, just as I was about to leave we exchanged a glance which meant exactly, 'You get the idea?' 'I get it!' "[29]

Dalí's period of impressionist, pointillist, futurist, cubist and neo-cubist borrowings was almost at an end. That is to say, these influences – indispensable for a beginner – had been nothing more than a means of expressing images that were peculiar to his own world. He needed the influences; but generally they held him for only a few weeks. His urge to

"I love Gala more than my mother, more than my father, more than Picasso and even more than money."

Portrait of Paul Eluard, 1929
Portrait de Paul Eluard
Oil on card, 33 x 25 cm
Cecile Eluard Boaretto Collection

25

express human feelings retained the upper hand, as in *Honey is Sweeter than Blood* (cf. p. 27) and *Initiation Goose Pimples*. The same was true of his way of treating matter as an all-encompassing hierarchical structure that required collage form: floating corks, objects that were worked into pictures, sand and pebbles, string, sponges. And it also applied to his obsession with creating sexual symbolism in a contemporary idiom; works of this kind, above all *Female Nude* and *Unsatisfied Desire* prompted scandal in Barcelona.

Dalí was then twenty-three and already his work had a certain maturity about it. Indeed, his new work contained the genetic code, so to speak, of all that was to follow.

In spite of the outcry that greeted some of Dalí's work, the Catalonian critics were enthusiastic, and hoped that their new star artist would presently be conquering France. One of them wrote: "Few young painters have made so self-assured an impression as Salvador Dalí, son of the town of Figueras . . . If Salvador now has his eye on France, it is because it lies within his scope, and because his God-given talent demands the opportunity to prove itself. What does it matter if Dalí tends his flame by using Ingres's fine pencil or the coarse cubist approach of Picasso?"

Dalí had become a very close friend of Lorca, and the friendship confirmed in him his wishes and ambitions. Both men indubitably drew a passionate aesthetic vitality from the friendship, a vitality that coincided with their own aims. Dalí, now at a turning point in his life and work, saw his friend's poetic quest as corresponding to his own quest. Gradually, though, the friendship faded, thanks to the Andalusian poet's amorous approaches. The painter, plainly bewildered, was later to write in *Les Passions selon Dalí*: "When García Lorca wanted to have me, I refused in horror."[30] Given Dalí's tendency to invent stories, we shall never know what actually passed between the two young men. One thing seems sure, though: at that time Dalí's experience of women was limited, and lagged far behind the fantasy images that were so fruitful in his art. Later he was to insist that he had still been a virgin when he met Gala.

Another Catalonian, Joan Miró, some years older and already famous, was now enlisted to help persuade Dalí senior to let his gifted son go to Paris. Accompanied by Pierre Loeb, his dealer, Miró visited Figueras. "This event made quite an impression on my father and began to put him on the path of consenting to my going to Paris some day to make a start. Miró liked my things very much, and generously took me under his protection. Pierre Loeb, on the other hand, remained frankly sceptical before my works. On one occasion, while my sister was talking with Pierre Loeb, Miró took me aside and said in a whisper, squeezing my arm, 'Between you and me, these people of Paris are greater donkeys than we imagine. You'll see when you get there. It's not so easy as it seems!'"[31]

It was at this time that Dalí's friend Luis Buñuel approached him with an idea for a film he planned to make with money from his mother. Dalí found the screenplay mediocre. He thought it was sentimental and conventional, and immediately informed Buñuel that he himself "had just written a very short scenario which had the touch of genius, and which went completely counter to the contemporary cinema. This was true. The

Study for 'Honey is Sweeter than Blood,' 1926
Etude pour 'Le miel est plus doux que le sang'
Oil on panel, 36.5 x 45 cm
Private collection, Paris

scenario was written. I received a telegram from Buñuel announcing that he was coming to Figueras. He was immediately enthusiastic over my scenario . . . Together we worked out several secondary ideas, and also the title – it was going to be called *Le Chien Andalou* (cf. p. 36). Buñuel left, taking with him all the necessary material. He undertook, moreover, to take charge of the directing, the casting, the staging, etc. . . . But some time later I went to Paris myself and was able to keep in close touch with the progress of the film and take part in the directing through conversations we held every evening. Buñuel automatically and without question accepted the slightest of my suggestions."[32]

The Surrealists placed great emphasis on automatic writing. Adopting the same principle, the two men juxtaposed their fantasy images. Buñuel, for instance, had seen a tattered cloud pass across the moon, followed by an eye cut open by a razor, while Dalí had dreamt of a hand crawling with ants. They agreed on one simple rule in their deliberations: They would not accept any idea or image that was susceptible of rational,

Apparatus and Hand, 1927
Appareil et main
Oil on panel, 62.2 x 47.6 cm
Collection of Mr. and Mrs. A.Reynolds Morse,
Loan to the Salvador Dalí Museum,
St. Petersburg (Fla.)

OPPOSITE:
Senicitas
(also: Summer Forces and: Birth of Venus), 1927–1928
Senicitas
(ou Forces estivales et: Naissance de Vénus)
Oil on panel, 64 x 48 cm
Museo Español de Arte Contemporáneo, Madrid

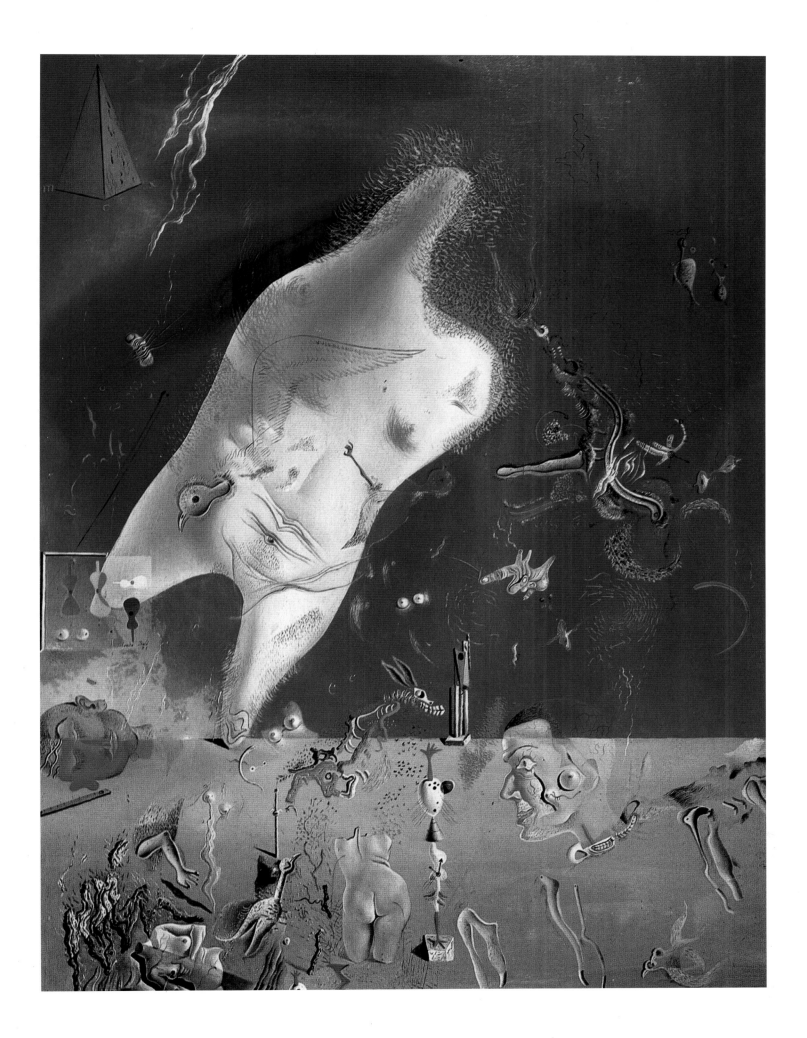

Still Life by Moonlight, 1927
Nature morte au clair de lune
Oil on canvas, 190 x 140 cm
Gift from Dalí to the Spanish state

psychological or cultural explication. They were out to open a door onto the irrational, and in accepting striking images for the film they were not concerned about the possible rationale of the images.

Miró wrote to Dalí's father from Paris and told him that a visit to the French capital would be invaluable, closing his letter with the words: "I am absolutely convinced that your son's future will be brilliant!"[33] Salvador relished the statement and made his decision. Sensing that Paris would bring a confrontation, he spent his last days in preparation, polishing up his approach with the help of intellectual acquaintances associated with the Barcelona magazine *L'Amic de les Arts*. "This group I manipulated as I wished, and used as a convenient platform for revolutionizing the artistic ambiance of Barcelona. I did this all by myself, without stirring from Figueras, and its sole interest for me, naturally, was that of a preliminary experiment before Paris, an experiment that would be useful

in giving me an exact sense of the degree of effectiveness of what I already at that time called my 'tricks.' These tricks were various, and even contradictory."[34]

Despite Dalí's preparations, his conquest of Paris was not a triumph from the word go when he arrived there for the second time in the winter of 1927. Work on *Un Chien andalou* had not yet been completed; he found the film mediocre. Paris seemed full of snares and traps – and "I had not succeeded in finding an elegant woman to take an interest in my erotic fantasies – even any kind of woman, elegant or not elegant!" (as he wrote in *The Secret Life of Salvador Dalí*[35]). It wasn't for lack of trying: "I arrived in Paris saying to myself, quoting the title of a novel I had read in Spain, 'Caesar or Nothing!' I took a taxi and asked the chauffeur, 'Do you know any good whorehouses?' ... I did not visit all of them, but I saw many, and certain ones pleased me immeasurably ... Here I must shut my eyes for a moment in order to select for you the three spots which ... have produced upon me the deepest impression of mystery. The stairway of the 'Chabanais' is for me the most mysterious and the ugliest 'erotic' spot, the Theatre of Palladio in Vicenza is the most mysterious and divine 'aesthetic' spot, and the entrance to the tombs of the Kings of the Escorial is the most mysterious and beautiful mortuary spot that exists in the world. So true it is that for me eroticism must always be ugly, the aesthetic always divine, and death beautiful."[36]

He liked the interior décor of the Parisian brothels very much, but the girls struck him as wretched. Their matter-of-fact, vulgar manner contrasted with the demands of his "libidinous fantasies," and he never laid a finger on them. "After the houses of prostitution, I paid a visit to Juan Miró. We had lunch together, but he did not talk, or at least talked very little. 'And tonight,' he confided to me, 'I'm going to introduce you to Marguerite.' I was sure he was referring to the Belgian painter René Magritte, whom I considered one of the most 'mysteriously equivocal' painters of the moment. The idea that this painter should be a woman and

Detail from:
Still Life by Moonlight, 1927
(opposite)

A head lying on its side frequently appears in Dalí's pictures in the late 1920s. In a study for the *Still Life by Moonlight* the head – symbolic of Dalí's friend Lorca – is marginal, but in the finished painting it has been given a central position on the table. It is an allusion to Lorca's performances in the student residence in Madrid; he would pretend to be dead and try to act out gradual decay.

Detail from:
Study for 'Honey is Sweeter than Blood,' 1926
(p. 27)

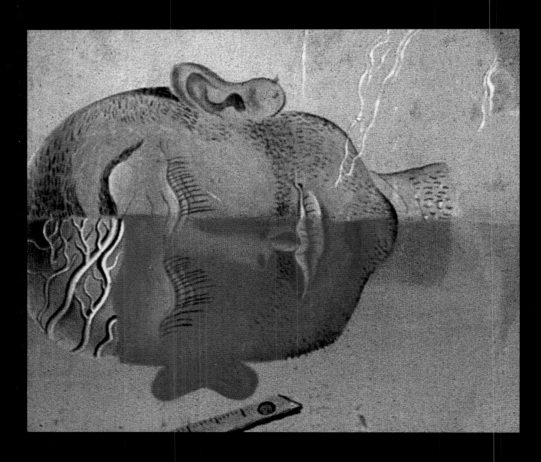

Detail from:
Senicitas, 1927–28
(p. 29)

Detail from:
Portrait of Paul Eluard, 1929
(p. 24)

Detail from:
The Enigma of Desire, 1929
(p. 40/41)

not a man, as I had always supposed, bowled me over completely, and I decided beforehand that even if she was not very, very beautiful, I would surely fall in love with her." To Dalí's great disappointment, Marguerite turned out to be "a very slender girl, with a mobile little face like a nervous death's head;" she was no better at conversation than Miró. "I promptly abandoned my notion of erotic experiments with her."

Miró was seeing things realistically when he told Dalí: "'It's going to be hard for you,' he said to me, 'but don't get discouraged. Don't talk too much (I then understood that perhaps his silence was a tactic) and try to do some physical culture. I have a boxing instructor, and I train every evening.' ... Tomorrow we'll go and visit Tristan Tzara, who was the leader of the Dadaists. He is influential. He'll perhaps invite us to go to a concert. We must refuse. We must keep away from music as from the plague ... The important thing in life is to be stubborn. When what I'm looking for doesn't come out in my paintings I knock my head furiously against the wall till it's bloody." Dalí imagined the wall smeared with Miró's blood and noted: "It was the same blood as my own."[37]

He was waiting for *Un Chien andalou*, waiting "to plunge right into the heart of witty, elegant and intellectualized Paris." He was waiting for that moment which yet lay ahead, that moment in 1929 when Eugenio Montes would write, "Buñuel and Dalí have just placed themselves resolutely beyond the pale of what is called good taste, beyond the pale of the pretty, the agreeable, the epidermal, the frivolous, the French."[38] Meanwhile, Dalí fled Paris once again, for the soothing familiarity of Catalonia. Pleased as he was to be back in the light of Cadaqués, though, he still sensed that a change was happening within him. He had not had much contact with the Surrealists, but now he set out to paint "*trompe l'œil* photographs," making skilful use of all the tricks he had picked up. Dalí was a quarter century ahead of his time, using techniques that later made him the patron saint of the American photo-realists. Dalí's own photographic precision was used for his own distinctive ends, though – to transcribe dream images. It was a method that was to become a constant in his work; the first products, dating from this period, may be considered forerunners of his Surrealist paintings. In 1973, by which time his definition of his own art had been clarified, he was still declaring: "My art is handmade photography of extra-fine, extravagant, super-aesthetic images of the concrete irrational."[39] This, at all events, was the root of Dalí's art; and Dalí was the only painter who could truly be described as consistently and wholly Surrealist, just as Claude Monet was the only truly consistent Impressionist, from the outset of his career as a painter to the pictures of water lilies done late in life.

Dalí worked in a state of unbroken exaltation which peaked in intermittent outbursts of laughter that left him aching: "My family would hear the uproar from down below and wonder, 'What's going on?' 'That child laughing again!' my father would say, amused and preoccupied as he watered a skeletal rosebush wilting in the heat."[40]

Presently there was good news. First a telegram arrived from Camille Goemans, Dalí's dealer, to the effect that, in addition to buying the three paintings he had already chosen, for 3,000 francs, he would exhibit all his

The Donkey's Carcass, 1928
L'âne pourri
Oil, Sand and pebbles on panel, 61 x 50 cm
Private collection, Paris

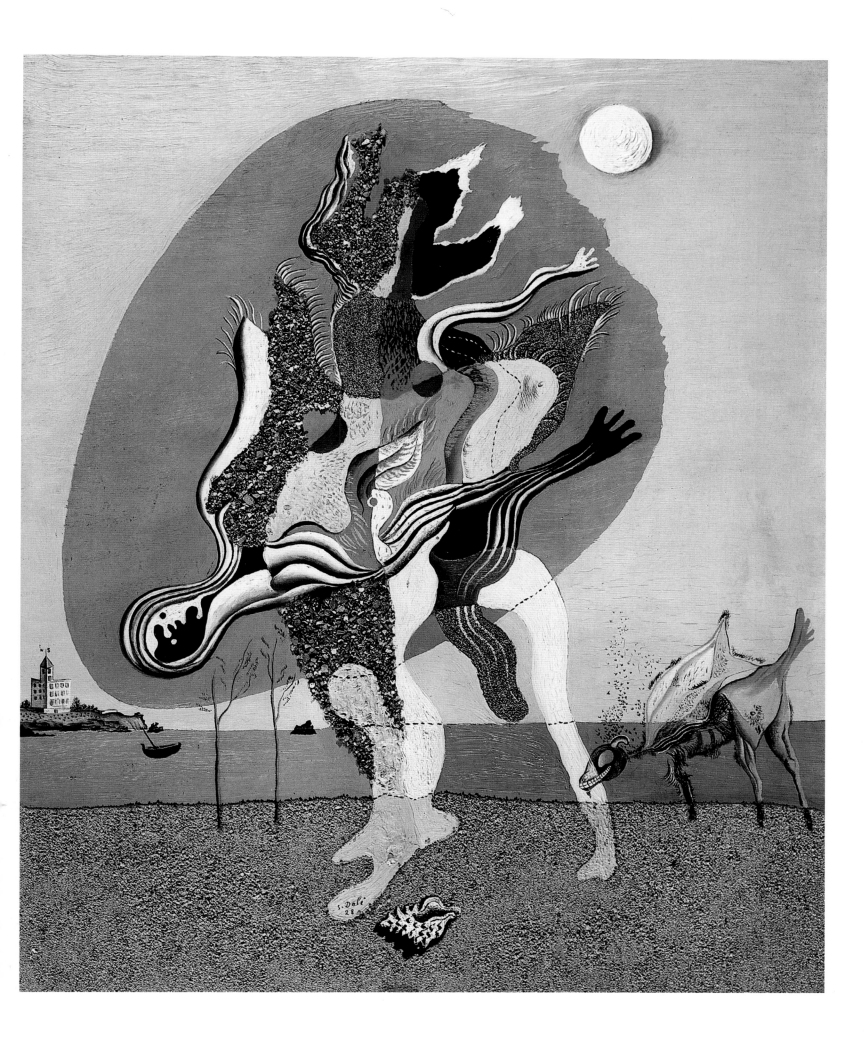

UN CHIEN ANDALOU
de Luis BUÑUEL

Scene from the film 'An Andalusian Dog,' 1929
Un chien andalou
by Luis Buñuel and Salvador Dalí

work at his Paris gallery after the summer break. Then a group of Surrealists descended upon him, no doubt attracted partly by his eccentricity and partly by the sexual and scatological extravagance of his work. The group included René Magritte and his wife, Luis Buñuel, and Paul Eluard with his wife – Gala.

Dalí felt flattered that Paul Eluard should have come to see him. With André Breton and Louis Aragon, Eluard was one of the leading lights of the Surrealist movement; Dalí had met him only briefly, in Paris the previous winter. As for Gala, she was a revelation – the revelation Dalí had been waiting for, indeed expecting. She was the personification of the woman in his childhood dreams to whom he had given the mythical name Galuschka and whom various young and adolescent girls had already stood in for. He recognized her by her naked back; the proof that Gala was the woman was provided by the fact that her physique was precisely that of the women in most of his paintings and drawings. In *The Secret Life of Salvador Dalí* he later described her in these terms: "Her body still had the complexion of a child's. Her shoulder blades and the sub-renal muscles had that somewhat sudden athletic tension of an adolescent's. But the small of her back, on the other hand, was extremely feminine and pronounced, and served as an infinitely svelte hyphen between the willful, energetic and proud leanness of her torso and her very delicate buttocks which the exaggerated slenderness of her waist enhanced and rendered greatly more desirable."[41]

Whenever Dalí tried to talk to her, he had a fit of laughter. Whenever she parted from him, he split his sides laughing the moment her back was turned, laughing until he could no longer stand. His picture *The Lugubrious Game* (p. 38), featuring underpants stained with excrement, was painted in such sumptuous detail that friends wondered whether Dalí had

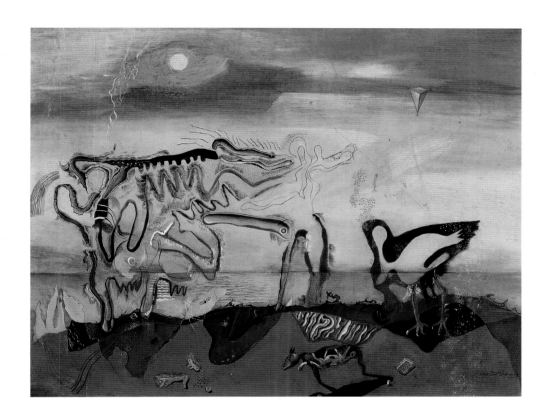

The Spectral Cow, 1928
La vache spectrale
Oil on plywood, 50 x 64.5 cm
Centre Georges Pompidou, Musée National
d'Art Moderne, Paris

coprophagic tendencies. Gala decided to put an end to the speculation and met Dalí for a walk along the cliffs, in the course of which the painter managed to curb his laughter. In response to her question, he hesitated: "If I admitted to her that I was coprophagic, as they had suspected, it would make me even more interesting and phenomenal in everybody's eyes..." But Dalí opted for the truth: "I swear to you that I am not 'coprophagic.' I consciously loathe that type of aberration as much as you can possibly loathe it. But I consider scatology as a terrorizing element, just as I do blood, or my phobia for grasshoppers."[42] The Surrealists were alarmed by the picture because of the excrement, and Georges Bataille[43] saw "an appalling ugliness" in it. Bataille detected fears of castration in it: The body of the figure in the centre of the painting, intent on male dreams, has been torn apart. To its right, a besmirched figure is just escaping castration by "shameful and repellent" behaviour, while the figure on the left is "enjoying his own castration" and seeking a "poetic dimension." Dalí rejected this interpretation, and the disagreement led to a break between Bataille and the Surrealists.

In the course of the long walks Dalí and Gala were now regularly taking along the cliffs at Cape Creus, an intensely melancholy spot, Dalí told her he loved her. He did so in the interval between two fits of laughter, at a cove by Es Cayals. It was not easy for him. The woman everyone called Gala – her name was Helena Devulina Diakanoff, and she was the daughter of a Moscow lawyer – was a fascinating, charming, self-confident person, and she made quite an impression on Dalí. To have her real body so close to his own took his breath away. "Did not the fragile beauty of her face of itself vouch for the body's elegance?" he noted later. In her youth, Gala had been treated for a lung complaint. "I looked at her proud carriage as she strode forward with the intimidating gait of victory,

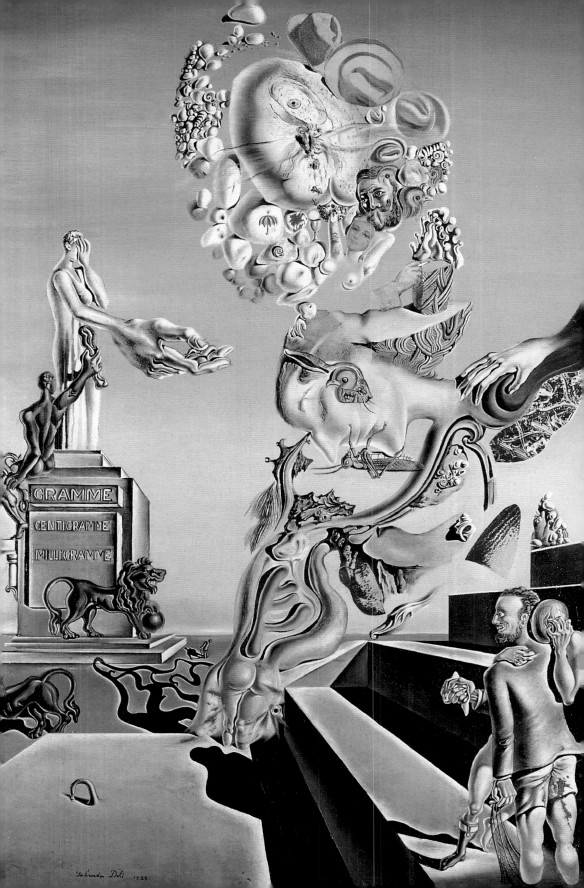

The inscription on the monument reads:

GRAMME
CENTIGRAMME
MILLIGRAMME

Signed lower left: Salvador Dalí 1929

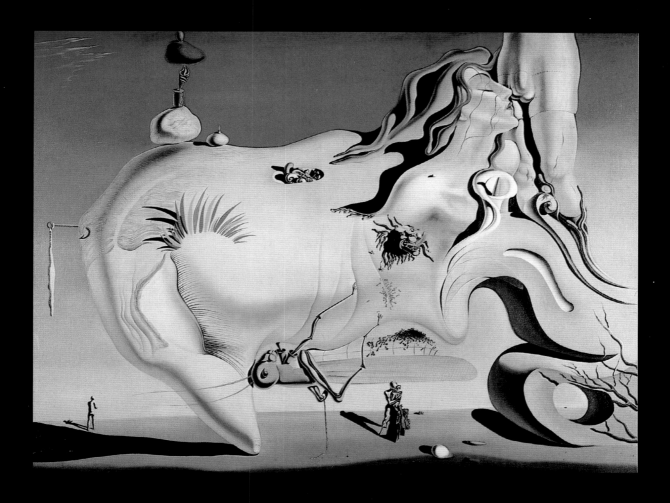

The Great Masturbator, 1929
Le grand masturbateur
Oil on canvas, 110 x 150 cm
Gift from Dalí to the Spanish state

OPPOSITE:
The Lugubrious Game, 1929
Le jeu lugubre
Oil and collage on cardboard, 44.4 x 30.3 cm
Private collection

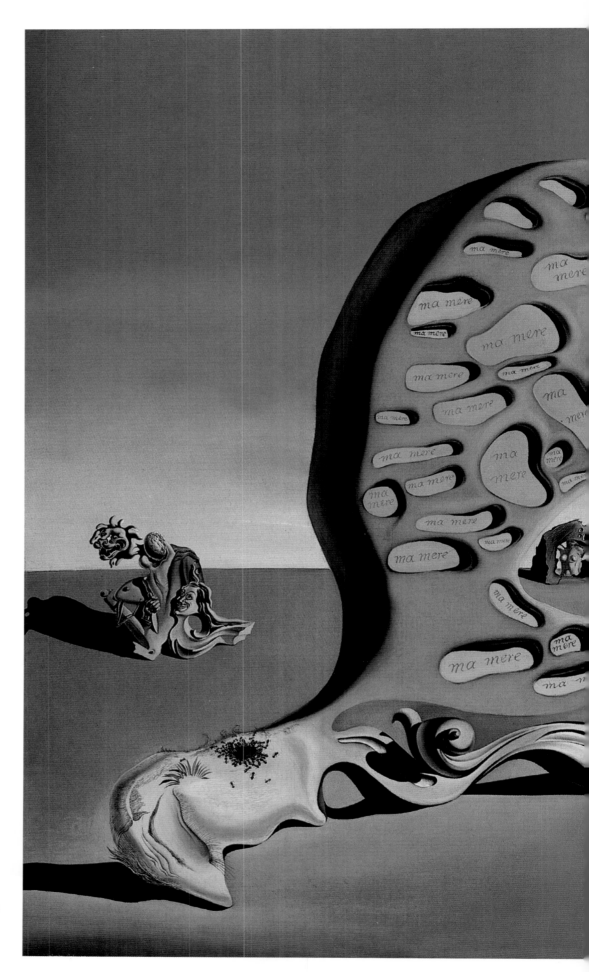

The Enigma of Desire, 1929
L'énigme du desir – Ma mère, ma mère, ma mère
Oil on canvas, 110 x 150 cm
Staatsgalerie Moderner Kunst, Munich

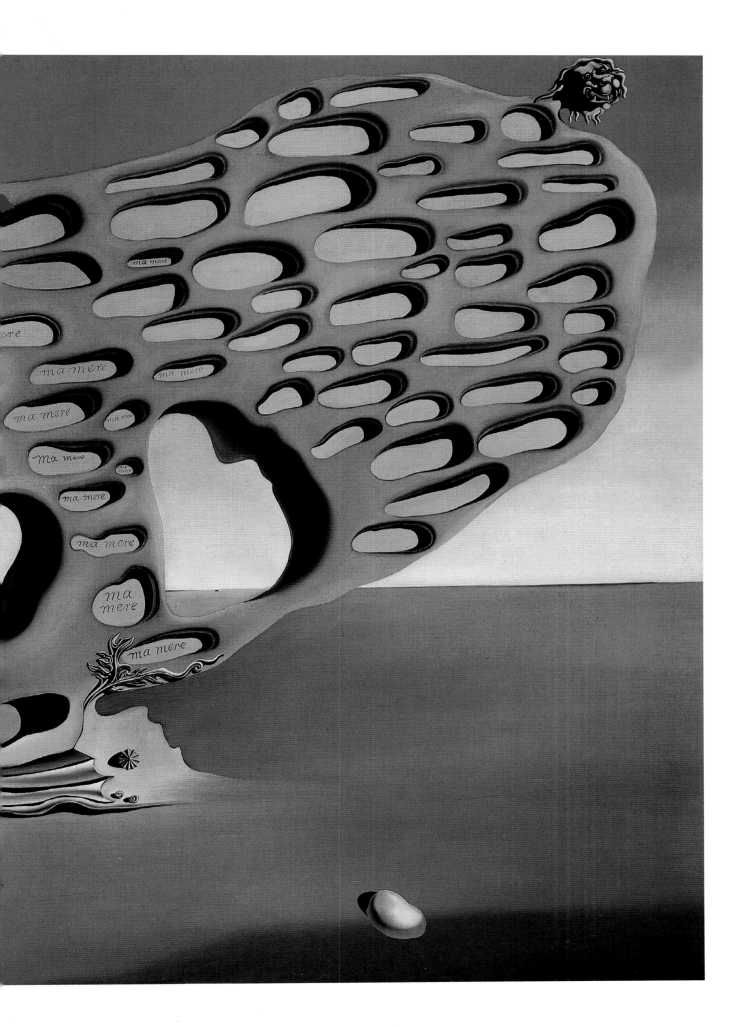

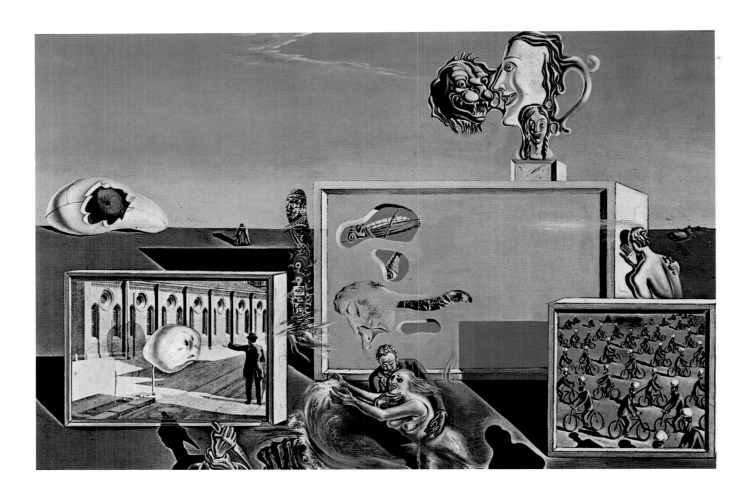

Illumined Pleasures, 1929
Les plaisirs illuminés
Oil and collage on panel, 24 x 34.5 cm
The Sidney und Harriet Janis Collection,
Gift to the Museum of Modern Art,
New York

and I said to myself, with a touch of my budding humour, 'From the aesthetic point of view victories, too, have faces darkened by frowns. So I had better not try to change anything!' I was about to touch her, I was about to put my arm around her waist, when with a feeble little grasp that tried to squeeze with the utmost strength of her soul, Gala's hand took hold of mine... This was the time to laugh, and I laughed with a nervousness heightened by the remorse which I knew beforehand the vexing inopportuneness of my reaction would cause me. But instead of being wounded by my laughter, Gala felt elated by it. For, with an effort which must have been superhuman, she succeeded in again pressing my hand, even harder than before, instead of dropping it with disdain as anyone else would have done. With her medium-like intuition she had understood the exact meaning of my laughter, so inexplicable to everyone else. She knew that my laughter was altogether different from the usual 'gay' laughter. No, my laughter was not scepticism; it was fanaticism. My laughter was not frivolity; it was catacylsm, abyss, and terror. And of all the terrifying outburts of laughter that she had already heard from me this, which I offered her in homage, was the most catastrophic, the one in which I threw myself to the ground at her feet, and from the greatest height! She said to me, 'My little boy! We shall never leave each other.' "[44]

Dalí himself provided the key, both historical and Freudian in character, to their love, which was born that very moment and lasted until death: "She was destined to be my Gravida, 'she who advances,' my victory, my wife. But for this she had to cure me, and she did cure me!"

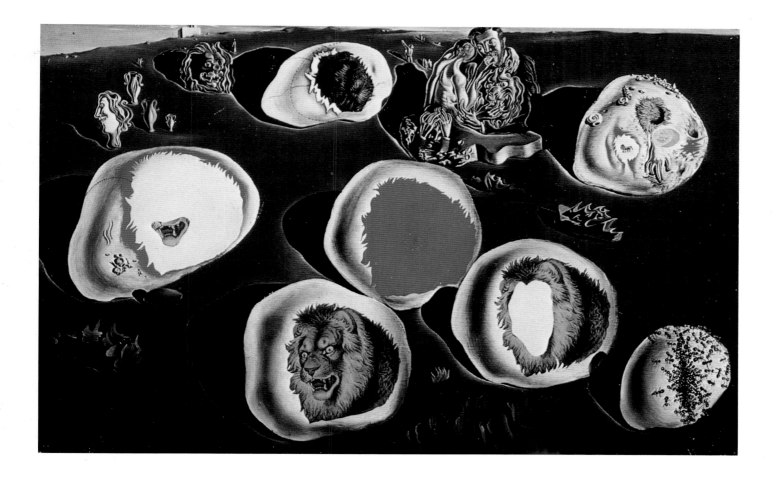

He was healed "solely through the heterogeneous, indomitable and unfathomable power of the love of a woman, canalized with a biological clairvoyance so refined and miraculous, exceeding in depth of thought and in practical results the most ambitious outcome of psychoanalytical methods." Not long before, Dalí had read Wilhelm Jensen's novel *Gravida*, which Sigmund Freud had analyzed. The heroine of the title, Gravida, heals the male protagonist psychologically. Dalí wrote: "I knew that I was approaching the 'great trial' of my life, the trial of love."[45]

At this time, Dalí was at work on *Accommodations of Desire* (p. 43), a painting in which desire is symbolized by lions' heads. Trembling, he asked Gala: " 'What do you want me to do to you?' Then Gala, transforming the last glimmer of her expression of pleasure into the hard light of her own tyranny, answered, 'I want you to kill me!' " Dalí later noted: "One of the lightning-ideas that flashed into my mind was to throw Gala from the top of the bell-tower of the Cathedral of Toledo."[46] But Gala, as predicted, proved the stronger of the two. "Gala thus weaned me from my crime, and cured my madness. Thank you! I want to love you! I was to marry her. My hysterical symptoms disappeared one by one, as by enchantment. I became master again of my laughter, of my smile, and of my gestures. A new health, fresh as a rose, began to grow in the centre of my spirit."[47]

Dalí saw Gala off at the station in Figueras, where she took a train to Paris. Then he retired to his studio and resumed his ascetic life, completing the *Portrait of Paul Eluard* (p. 24) which the writer had been sitting

Accommodations of Desire, 1929
L'accommodation des désirs
Oil on panel, 22 x 35 cm
Private collection

PAGE 44:
Imperial Monument to the Child-Woman, 1929
Monument impérial à la femme-enfant
Oil on canvas, 140 x 80 cm
Gift from Dalí to the Spanish state

PAGE 45:
The Invisible Man, 1929–1932
L'homme invisible
Oil on canvas, 140 x 80 cm
Gift from Dalí to the Spanish state

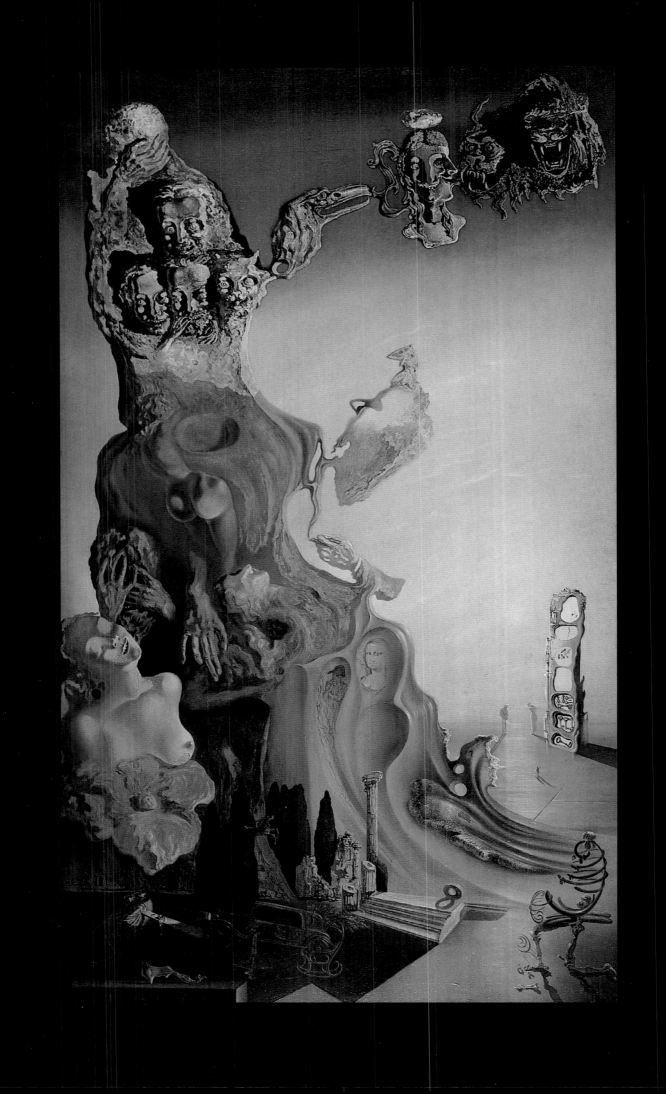

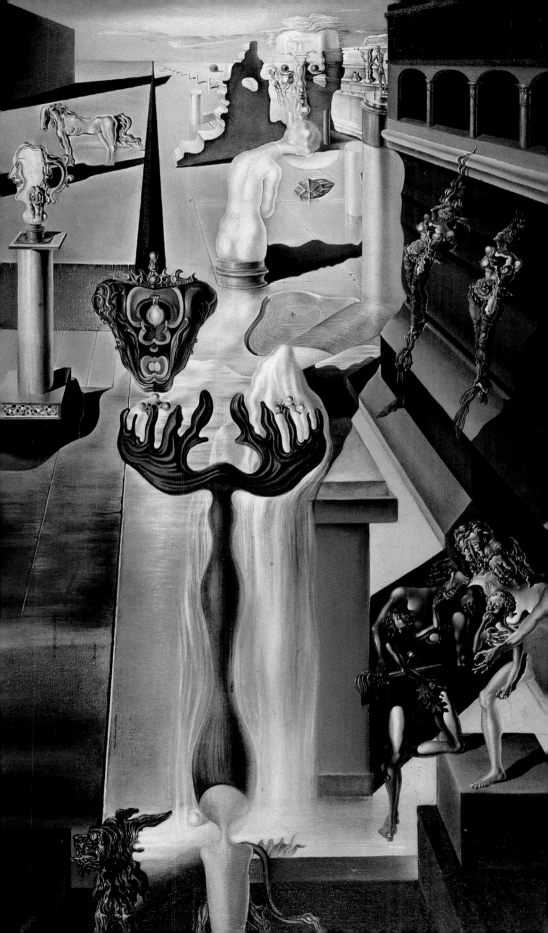

Detail from:
Portrait of Paul Eluard, 1929
(p. 24)

Detail from:
Imperial Monument to the C...
(p. 44)

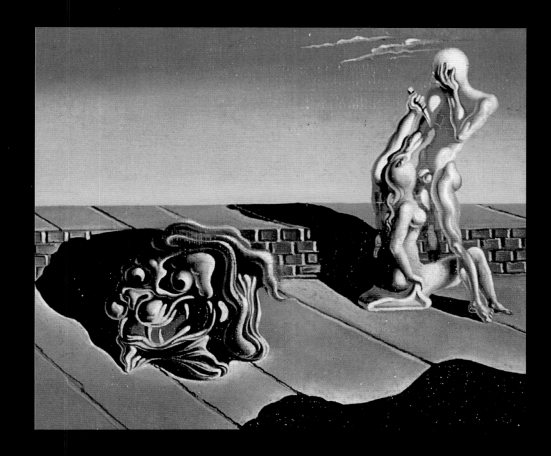

Detail from:
Vertigo, 1930

Detail from:
The Enigma of Desire, 1929
(p. 40/41)

The Fountain, 1930
La fontaine
Oil on panel, 66 x 41 cm
Collection of Mr. and Mrs. A.Reynolds Morse,
Loan to the Salvador Dalí Museum, St. Petersburg (Fla.)

The Dream, 1931
Le rêve
Oil on canvas, 100 x 100 cm
Private collection, New York

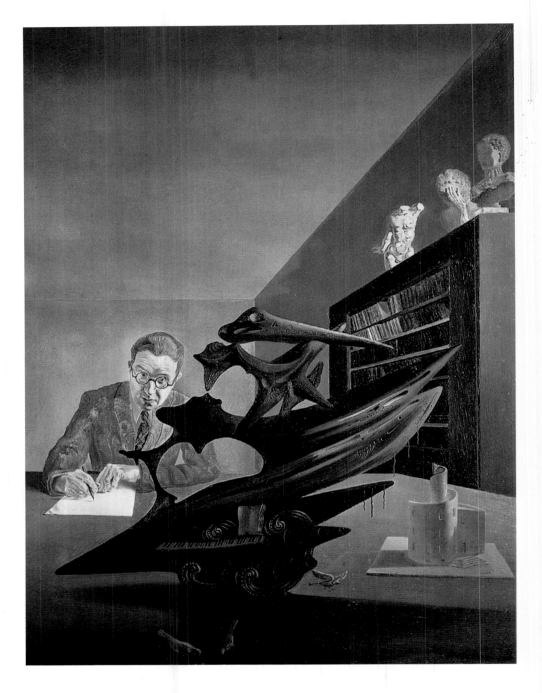

Portrait of Mr. Emilio Terry (unfinished), 1930
Portrait de Monsieur Emilio Terry (inachevé)
Oil on panel, 50 x 54 cm
Private collection

for. He also painted two other pictures, one of which was later to achieve considerable notoriety. "It represented a large head, livid as wax, the cheeks very pink, the eyelashes long, and the impressive nose pressed against the earth. This face had no mouth, and in its place was stuck an enormous grasshopper. The grasshopper's belly was decomposed, and full of ants. Several of these ants scurried across the space that should have been filled by the non-existent mouth of the great anguishing face, whose head terminated in architecture and ornamentations of the style of 1900. The painting was called *The Great Masturbator*"[48] (See p. 39). The picture was a kind of "soft" self-portrait; Dalí had a complete theory of "softness" and "hardness." In the painting he is visibly exhausted, soft as rubber, with ants and a grasshopper on his face. It looks the very image of misery – but there is an explanation in the female face positioned for fellatio: He has felt his ecstasy, just as he was to represent it on the ceiling

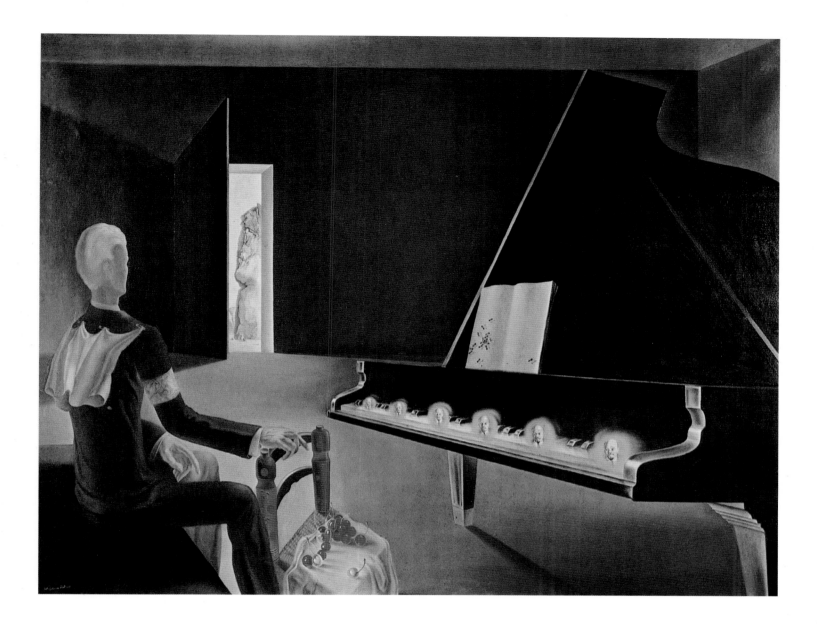

of a room in the Figueras theatre-museum. Dalí frequently claimed to be "totally impotent," but in fact he appears a perfectly good performer in certain pictures. We need only recall his 1934 painting *Atmospheric Skull Sodomizing a Grand Piano*, and remember that for Dalí pianos were female in gender and that, what was more, "musicians are cretins, cretins of the first order."[49] A third painting will suffice to complete our image of Dalí's sexual activity: *The Invisible Harp, fine and medium* (p. 57), painted in 1932 after a photograph he himself took at Port Lligat. Gala can be seen walking away, her derrière still exposed, while in the foreground the "erectile, budding head" of the foremost figure is resting on a crutch and looks like a member after coitus. The sex drive appears in limp and hard forms in Dalí's works and is sublimated or rendered as a cerebral construct. The crutch and the monstrous outgrowth of mental sexuality, of imaginative power inflated by the sheer force of life, also serve as

Evocation of Lenin, 1931
Hallucination partielle. Six apparitions de Lénine sur un piano
Oil on canvas, 114 x 146 cm
Centre Georges Pompidou, Musée National d'Art Moderne, Paris

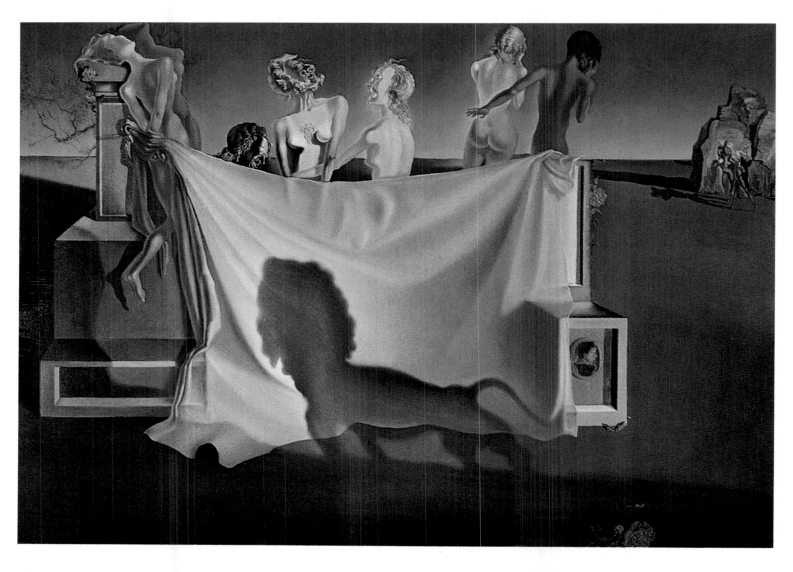

The Old Age of William Tell, 1931
La vieillesse de Guillaume Tell
Oil on canvas, 98 x 140 cm
Private collection

symbols of death and resurrection – like the act of love itself, rising from the ashes into infinity.

Dalí worked hard for a month, and then hired a joiner to crate his pictures for despatch to Paris, monitoring the work himself; the Geomans gallery was due to exhibit his work from 20 November to 5 December. Then, without a thought for the exhibition opening, he went to fetch Gala. Crazed with love, they left Paris two days before the opening and travelled via Barcelona to Sitgès, a small seaside town a few kilometres south of the Catalonian capital. Before leaving, they saw a showing of *Un Chien andalou*, which Buñuel had finally edited into its finished state; the film helped found the reputations of the two artists. Eugenio Montes saw the film as "a date in the history of the cinema, a date marked with blood, as Nietzsche liked, as has always been Spain's way."[50] Dalí, pleased to have escaped the social career Miró had lined up for him, told his fellow-painter: "I prefer to begin with rotten donkeys. This is the most urgent; the other things will come by themselves." He was overjoyed, and later wrote in his *Secret Life:* "The film produced the effect that I wanted, and it plunged like a dagger into the heart of Paris as I had foretold. Our film ruined in a single evening ten years of pseudo-intellectual post-war advance-guardism. That foul thing which is figuratively called abstract art

fell at our feet, wounded to the death, never to rise again, after having seen 'a girl's eye cut by a razor blade' – this was how the film began. There was no longer room in Europe for the little maniacal lozenges of Monsieur Mondrian."[51]

But clouds were gathering in the sky above the idyll. The honeymoon (which Dalí and Gala spent in as physical a style as one could desire) was over, and "the watchful helmsman guiding the rudder of our life's vessel" had to leave her for the time being – first, to collect money from Goemans (most of his pictures had been sold, for prices between 6,000 and 12,000 francs), and then to face the family storm that was brewing back in Figueras.

For a long time, Dalí was secretive about the origins of the breach with his family, the reasons why he was expelled from their midst; and doubtless the motive for his secrecy was consideration for his father. His picture *The Enigma of William Tell* (p. 53) suggests an explanation: "William Tell is my father and the little child in his arms is myself; instead of an apple I have a raw cutlet on my head. He is planning to eat me. A tiny nut by his foot contains a tiny child, the image of my wife Gala. She is under constant threat from this foot. Because if the foot moves only very slightly, it can crush the nut."[52] The painting shows Dalí settling accounts with his father, who had disowned him because he was living with a divorcée (Paul Eluard's ex-wife). But nothing is ever simple in Dalí. He deliberately gave William Tell the features of Lenin, purely to anger the Surrealists. In this aim he succeeded. When he submitted the picture to the 1934 Salon des Indépendants, André Breton flew into a rage, seeing it as a "counter-revolutionary act" and treason against the Bolshevik leader.

The Enigma of William Tell, 1933
L'énigme de Guillaume Tell
Oil on canvas, 201.5 x 346 cm
Moderna Museet, Stockholm

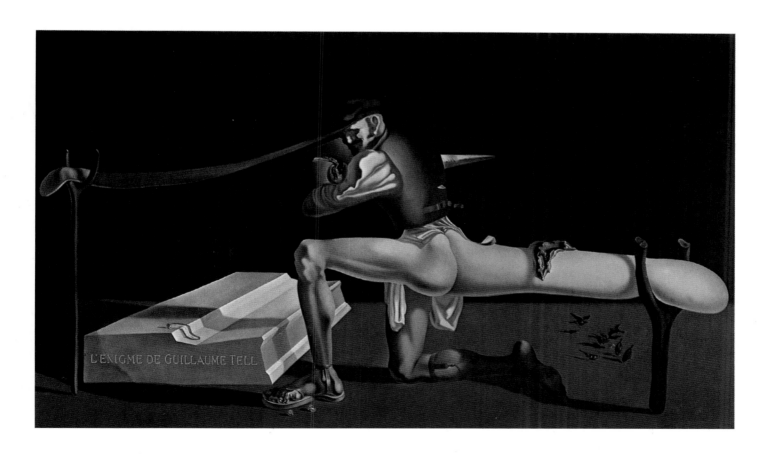

The pope of the Surrealists and his circle even tried to vandalize the painting; but fortunately it had been hung so high that they failed in the attempt.

The second reason for Dalí's breach with his father was doubtless a Surrealist gesture intended to amaze his fellow-travellers. During his short stay in Paris in November, Dalí had shown the Surrealists a holy picture he had bought at the Rambla in Figueras, depicting the Sacred Heart. Across it he had written: "Sometimes I spit on the picture of my mother for the fun of it." Eugenio d'Ors, a Spanish art critic, described this sacrilege in an article he published in a Barcelona daily paper. Dalí's father, outraged by the blasphemy and by the insult offered to the memory of a dead, beloved wife and mother, never forgave his son. Dalí's defence was: "In a dream one can commit a blasphemous act against someone whom one adores in real life, one can dream of spitting on one's mother... In some religions, spitting is a sacred act." But even the most open-minded Figueras notary would have difficulty accepting an explanation of this kind.

Dalí's father simply said: "There is no cause for alarm. He is not remotely practical-minded and cannot even buy a cinema ticket. In a week at most he'll be back in Figueras, down and out, begging my forgiveness." But he had forgotten Gala's presence in Dalí's life. She was clear-sighted and persistent; and instead of returning down and out, Salvador was later to make his return as victorious conqueror of his father, as a hero crowned with a laurel wreath.

In his *Journal d'un génie*, one of Dalí's chapter headings is a quotation from Freud: "The hero is the man who resists his father's authority and overcomes it."[53] Though Dalí greatly admired his charismatic and humane father, he had to make the break and turn his back on the years of his youth. However, he loved his chalk-white village in the sun more than anywhere else and refused even to look at other landscapes – which meant he had to return as soon as possible. With the proceeds of the sale of *The Old Age of William Tell* (p. 52) he bought a tumbledown fisherman's hut in a sheltered bay near Cadaqués, at Port Lligat (the name means "harbour secured with a knot"), and moved there with Gala. For him, Port Lligat was always to remain "one of the most parched places on earth. Mornings there is wild, austere happiness, while evenings are often morbid and melancholy." This was the landscape Dalí most frequently painted.

Once he knew that an irreparable breach had been made and that he must be a stranger to his father's house, Dalí reacted by cutting his hair – his way of going in sackcloth and ashes. "But I did more than this – I had my head completely shaved. I went and buried the pile of my black hair in a hole I had dug on the beach for this purpose, and in which I interred at the same time the pile of empty shells of the urchins I had eaten at noon. Having done this I climbed up on a small hill from which one overlooks the whole village of Cadaques, and there, sitting under the olive trees, I spent two long hours contemplating that panorama of my childhood, of my adolescence, and of my present."[54]

"For me, then, the erotic must always be ugly, the aesthetic always divine, and death always beautiful."

Spectre of Sex Appeal, 1932
Le spectre du sex-appeal
Oil on canvas, 18 x 14 cm
Fundación Gala-Salvador-Dalí, Figueras

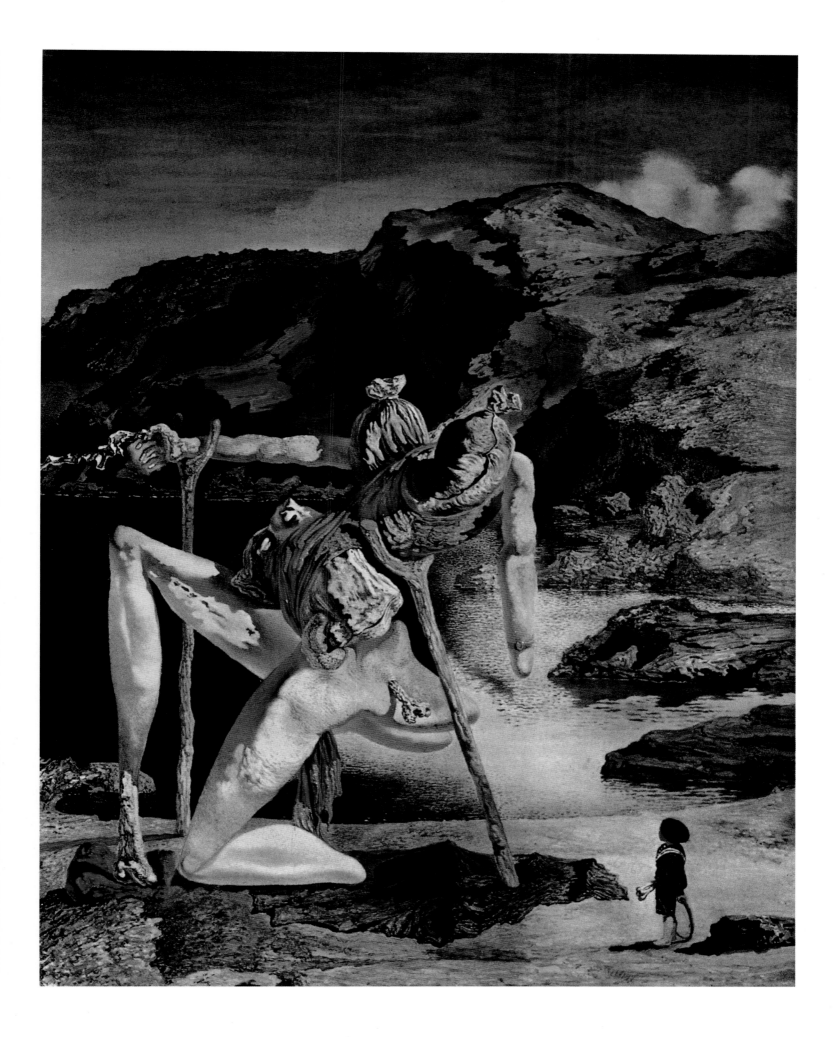

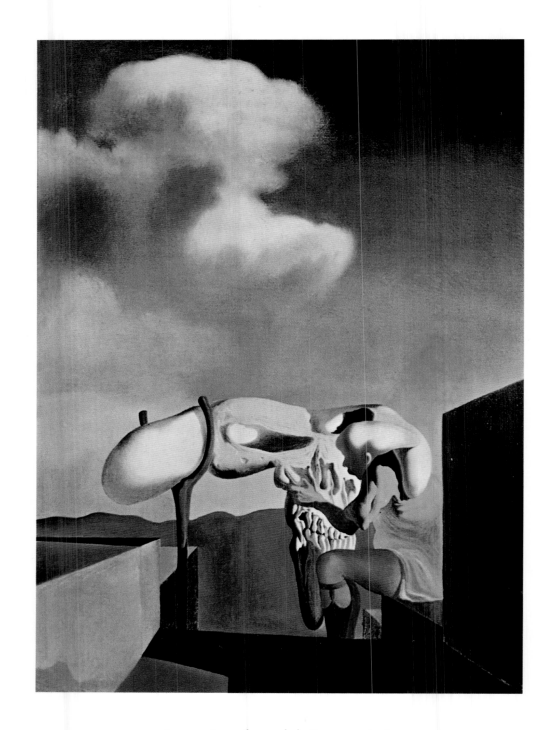

Average Atmospherocephalic Bureaucrat in the
Act of Milking a Cranial Harp, 1933
Bureaucrate moyen atmosphérocéphale dans
l'attitude de traire du lait d'une harpe crânienne
Oil on canvas, 22 x 16.5 cm
Collection of Mr. and Mrs. A. Reynolds
Morse, Loan to the Salvador Dalí Museum,
St. Petersburg (Fla.)

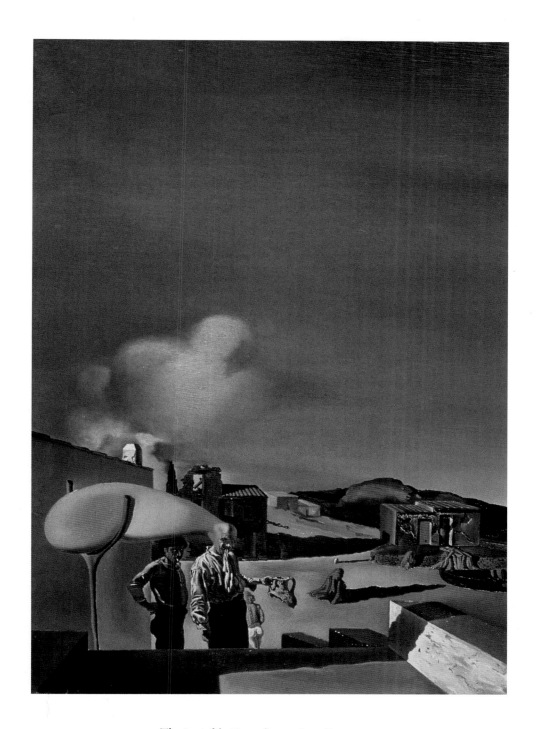

The Invisible Harp, fine and medium, 1932
La harpe invisible, fine et moyenne
Oil on panel, 21 x 16 cm
Private collection

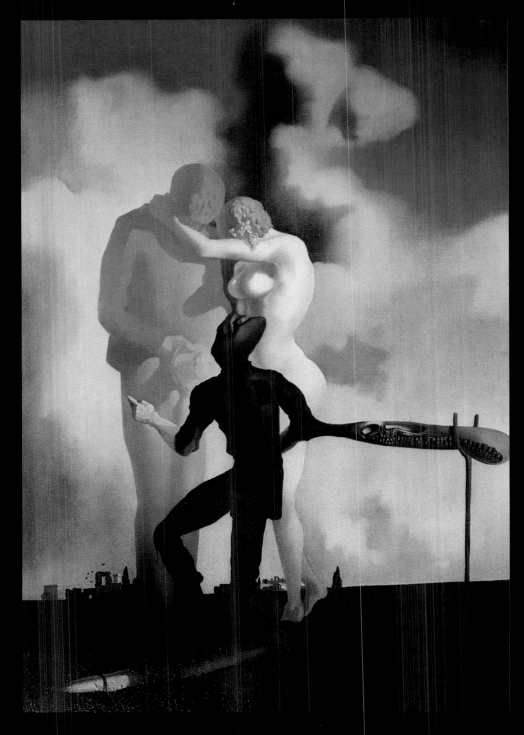

Meditation on the Harp, 1932–1934
Méditation sur la harpe
Oil on canvas, 67 x 47 cm
Collection of Mr. and Mrs. A. Reynolds
Morse, Loan to the Salvador Dalí Museum,
St. Petersburg (Fla.)

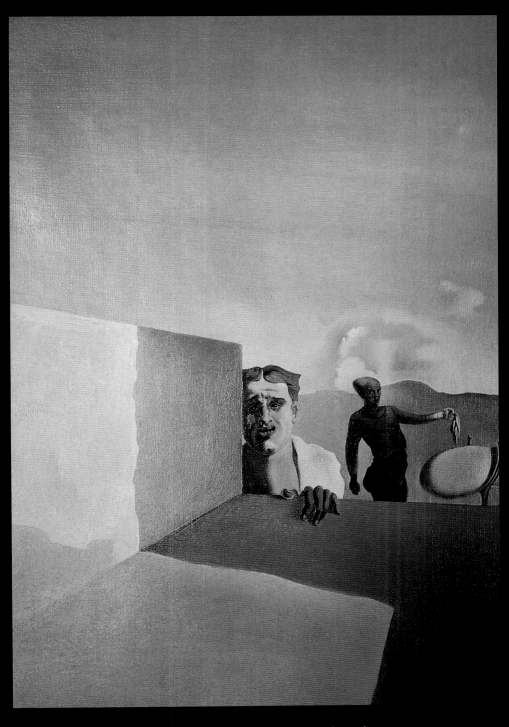

Hairdresser Depressed by the Persistent Good Weather, 1934
Le coiffeur attristé par la persistance du beau temps
Oil on canvas, 24 x 16.5 cm
Klaus G. Perls Collection, New York

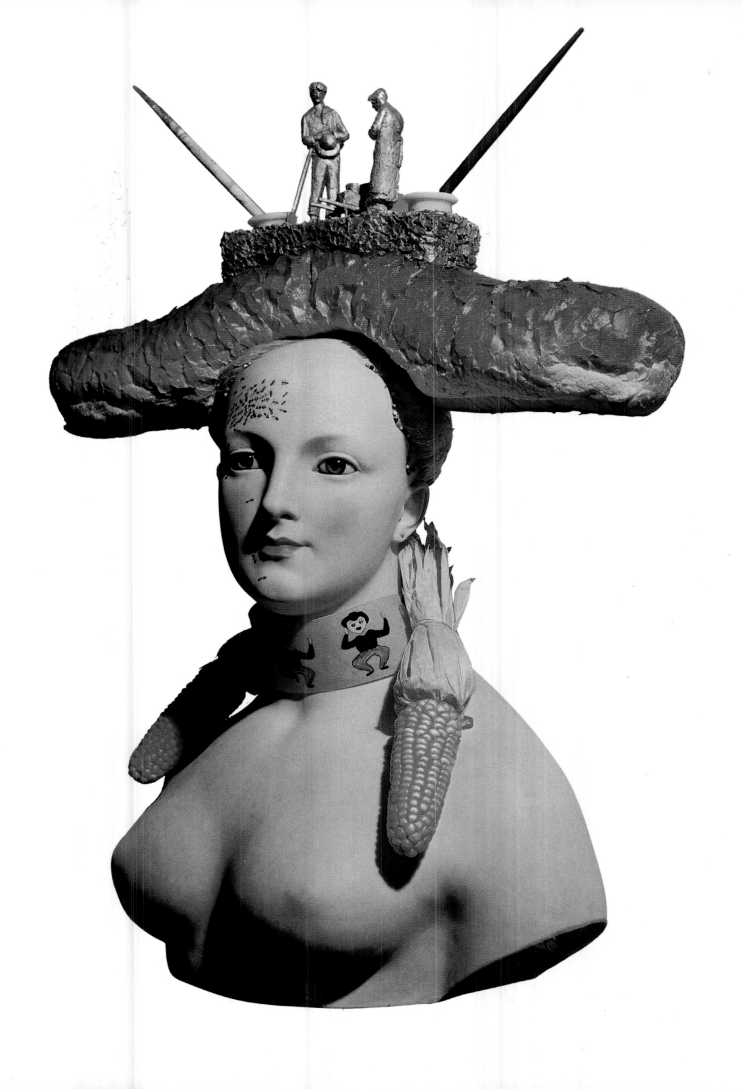

Edible Beauty

Avida Dollars was not always rolling in money. There was a period (brief, admittedly) between his father's allowance and the income from sales of pictures when he was distinctly short of a peseta. The couple's financial circumstances were always to remain complicated. The Dalís would make considerable sums and promptly spend the money. Their "secretaries" would see to it that large amounts disappeared into their own pockets. When Dalí died, his legacy to the Spanish state was, of course, staggering – but he himself was personally poor and his bank account stood at zero, just as his father had always predicted.

When the money ran out – because the Goemans gallery went bankrupt, or rather, because its patron, Viscount Charles de Noailles, took somewhat too lively an interest in abstract art – the Dalís sought refuge in Cadaqués, leaving Paris behind "as one leaves a bucket of offal." Dalí later wrote: "But before our departure we would prepare the dishes that we would leave cooking for two or three months. I would sow among the Surrealist group the necessary ideological slogans against subjectivity and the marvelous."[55] Dalí listed the various "firecrackers" he had tossed in on departure, the demoralizing effect of which he hoped to see upon his return: He had taken the side of Raymond Roussel against Rimbaud; art nouveau objects against African artefacts; *trompe l'œil* still lifes against sculpture; imitation against interpretation. All of this, as he well knew, would do nicely for several years; he deliberately gave very few explanations. At that time he had not yet become 'talkative;' he only said what was absolutely necessary, with the sole aim of unsettling everybody. But at this time he was already rebelling against polite French conversation, which, as he described it, was so nicely spiced with *esprit* and common sense, countering it with his "terribly uncouth" remarks that were "full of Spanish fanaticism." Thus, for instance, to one art critic who talked incessantly of "matter," of Courbet's "matter" and his treatment of that "matter," he replied: "Have you ever tried to eat it? ... When it comes to sh––, I still prefer Chardin's."[56]

At that time, Gala was everything to him. Gala followed him everywhere, defended him, and protected him against others and against himself. He could hardly believe it: "The idea that in my own room where I was going to work there might be a woman, a real woman who moved, with senses, body hair and gums, suddenly struck me as so seductive that it was difficult for me to believe this could be realized."[57]

"Beauty will always be edible, or there will be no such thing as beauty."

Retrospective Bust of a Woman (present state), 1933 (1970)
Buste de femme rétrospectif (état actuel)
China, corn cob, zoetrope strip, bread and inkwell (1970 reconstruction), 54 x 45 x 35 cm
Private collection, Belgium

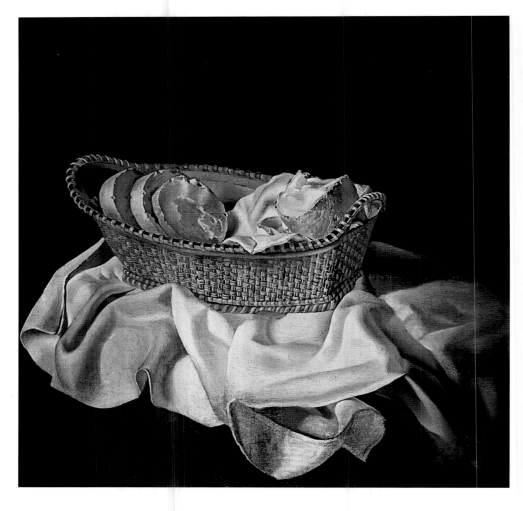

The Bread Basket, 1926
Corbeille de pain
Oil on panel, 31.5 x 31.5 cm
Salvador Dalí Museum, St. Petersburg (Fla.)

He was hardly in Paris but he was itching to leave again. However, he had to go to Paris and let loose "thunder and rain. But this time it's going to be gold! We must go to Paris and get our hands on the money we need to finish the work on our Port Lligat house!"[58] It was a strategy that Dalí was to employ his whole life long; and he gave his own explanation of it in his *Secret Life*.[59] On the one hand, there was the aristocracy, consisting of a particular kind of flamingoes standing on one leg, "an attitude by which they wish to show that, while having to remain standing in order to continue to see everything from above, they like to touch the common base of the world only by what is stricly necessary." To them he offered his crutches: "Crutches, crutches, crutches, crutches. I even invented a tiny facial crutch of gold and rubies. Its bifurcated part was flexible and was intended to hold up and fit the tip of the nose. The other end was softly rounded and was designed to lean on the central hollow above the upper lip. It was therefore a nose crutch, an absolutely useless kind of object to appeal to the snobbism of certain criminally elegant women." Thanks to Dalí and his myriad crutches, the aristocracy stayed upright. "With the pride of your one leg and the crutches of my intelligence, you are stronger than the revolution that is being prepared by the intellectuals, whom I know intimately." On the other hand there were the social climbers – petty sharks frantically chasing success. Dalí had resolved to use both kinds of people, all the people who made up so-called society; to get ahead and become famous he would turn their amateurish, envious

slanders to his own advantage. The first group, the aristocracy, relied on him, while the second, the gossiping and intriguing upstarts, provided an inexhaustible supply of material which he was always able to put to good use.

In response to the primitive Negro artefacts lauded by Picasso and the Surrealists, Dalí urged the claims of decadent European art nouveau. He even rediscovered the Metro entrances that dated from the turn of the century, and saw to it that the Musée de la Ville de Paris bought one of them. (Nowadays the museum considers itself lucky that it made the purchase when it did.) With profound logic he declared: "I have always considered the 1900 period as the psycho-pathological end-product of Greco-Roman decadence. I said to myself: since these people will not hear of aesthetics and are capable of becoming excited only over 'vital agitations,' I shall show them how in the tiniest ornamental detail of an object of 1900 there is more mystery, more poetry, more eroticism, more madness, perversity, torment, pathos, grandeur and biological depth than in their innumerable stock of truculently ugly fetishes possessing bodies and souls of a stupidity that is simply and uniquely savage!"[60]

This revived interest in an artistic trend that had long been out of fashion. People began to search out art nouveau artefacts at flea markets. Maxim's, which was on the point of modernizing the premises, cancelled the work and restored its art nouveau look instead. Even in New York, windows were being dressed in the style of yesteryear. But, as always, Dalí's influence went beyond his person and took on a life of its own; and "I can no longer canalize it, or even profit by it. I found myself in a Paris

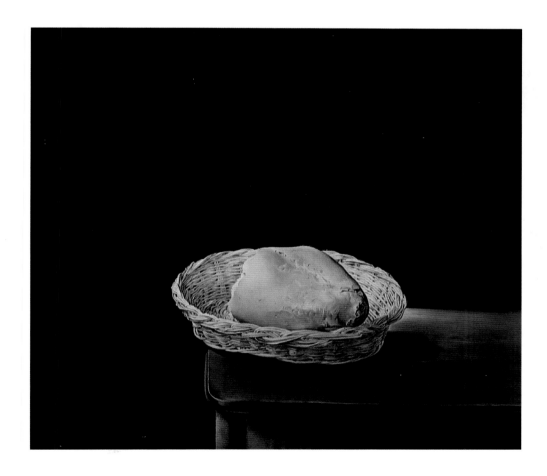

The Bread Basket, 1945
Corbeille de pain
Oil on panel, 33 x 38 cm
Fundación Gala-Salvador-Dalí, Figueras

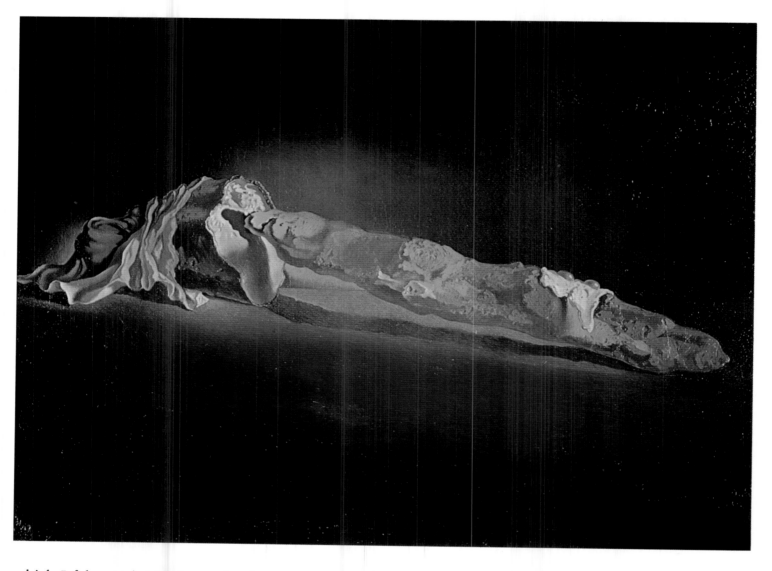

Ordinary French Loaf with Two Fried Eggs
Riding without a Plate, Trying to Sodomize a
Heel of a Portuguese Loaf, 1932
Pain français moyen avec deux oeufs sur le plat
sans le plat, à cheval, essayant de sodomiser une
mie de pain portugais
Oil on canvas, 16.8 x 32 cm
Private collection

which I felt was beginning to be dominated by my invisible influence. When someone... spoke disdainfully of functional architecture, I knew that this came from me. If someone said in any connection, 'I'm afraid it will look modern,' this came from me. People could not make up their minds to follow me, but I had ruined their convictions! And the modern artists had plenty of reason to hate me. I myself, however, was never able to profit by my discoveries, and in this connection no one has been more constantly robbed than I. Here is a typical example of the drama of my influence. The moment I arrived in Paris, I launched the 'Modern Style'... and I was able to perceive my imprint here and there merely in walking about the streets... Everyone managed to carry out my ideas, though in a mediocre way. I was unable to carry them out in any way at all!"[61]

Dalí referred to this time as the period of "discouraging" innovations. Since the "freemasonary of modern art" was blocking sales of his paintings, he collected ideas – which others unfortunately put into practice without him. Or at least they tried to: false fingernails with tiny mirrors to look at oneself in; transparent window dummies that could be filled with water, with fish swimming in the water, in imitation of the circulation of the blood; bakelite furniture made from moulds of the

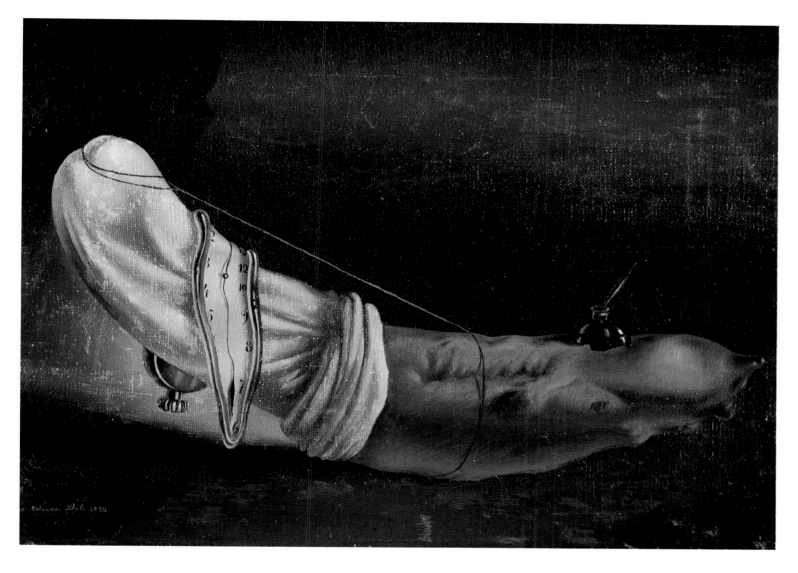

Anthropomorphic Bread, 1932
Pain anthropomorphe
Oil on canvas, 24 x 33 cm
Collection of Mr. and Mrs. A.Reynolds Morse,
Loan to the Salvador Dalí Museum,
St. Petersburg (Fla.)

purchaser's body; rotating ventilator sculptures; kaleidsocopic glasses to be worn whilst driving through boring countryside; make-up designed to render shadows on the face invisible; tactile cinema that used a simple process that enabled the viewer to touch everything he saw – fabrics, furs, oysters, bodies, sand, dogs, and so forth; unpleasant things that people could enjoy throwing at the wall; objects one could not find an appropriate place for, and which provoked discontent and which masochists would fight to get; dresses with padding that created a feminine type to match the erotic fantasies of men – with false breasts at the back, which could have revolutionized fashion for a century; a series of streamlined car chassis that anticipated automobile design of a decade later... Gala would set out every day to sell these ideas, and every evening she would return home downcast, "green in her face, dead tired, and beautiful by the sacrifice of her passion." His notions were dismissed as insane by everyone – or else they could only be realised for an insane sum. Nevertheless, most of his projects ultimately made the market: false fingernails, streamlined cars, and so forth. Shop windows have even been dressed using transparent dummies that served as aquariums for fish – they were found to be reminiscent of Dalí! "This was the best that could happen to me," Dalí said, "for at other times it was claimed that it was I who in my

paintings imitated ideas which had in fact been stolen from me! Everyone preferred my ideas when, after having been progressively shorn of their virtues by several other persons, they began to appear unrecognizable to myself. For once having got hold of an idea of mine, the first comer immediately believed himself capable of improving on it. I was beginning to be known, but this was worse, for then French good sense seized upon my name as a bugaboo. 'Dalí, yes – it's very extraordinary, but it's mad and it can't live.' ... I wanted to tear from this admirative and timorous society a minimum of its gold, which would permit Gala and me to live without that exhausting phantom, the constant worry about money, which we had seen rise for the first time on the African shores of Málaga."[62] The painter tried to cheer himself up: "Row, Dalí, row! Or rather, let the others, those worthy fishermen of Cadaques, row. You know where you want to go; they are taking you there, and one might almost say that it was by rowing, surrounded by fine paranoiac fellows, that Columbus discovered the Americas!"[63]

Maybe from fear of deprivation, maybe because of his frightful Catalonian atavism, Dalí now set about frantically making Surrealist artefacts out of bread. He had already had an especial liking for bread. In his museum at Figueras he papered the walls with round Catalonian loaves. Often he would take a loaf, hug it and lick it and nibble it, and then stand it up as if it were his latest invention. "Nothing could be simpler than to cut out two neat, regular holes on the back of the loaf and insert an inkwell in each one. What could be more degrading and aesthetic than to see this bread-ink-stand become gradually stained in the course of use with the involuntary spatterings of 'Pelican' ink? A little rectangle of the bread-inkstand would be just the thing to stick the pens into when one was through writing. And if one wanted always to have fresh crumbs, fine pen-wiper-crumbs, one had only to have one's bread-inkwell-carrier changed every morning... Upon arriving in Paris, I said to everyone who cared to listen, 'Bread, bread and more bread. Nothing but bread.' This they regarded as the new enigma which I was bringing them from Port Lligat. Has he become a Communist, they would wonder jokingly. For they had guessed that my bread, the bread I had invented, was not precisely intended for the succor and sustenance of large families. My bread was a ferociously anti-humanitarian bread, it was the bread of the revenge of imaginative luxury on the utilitarianism of the rational practical world, it was the aristocratic, aesthetic, paranoiac, sophisticated, jesuitical, phenomenal, paralyzing, hyper-evident bread... One day I said, 'There is a crutch!' Everybody thought it was an arbitrary gesture, a stroke of humour. After five years they began to discover that 'it was important.' Then I said, 'There is a crust of bread!' And immediately it began in turn to assume importance. For I have always had the gift of objectifying my thought concretely, to the point of giving a magic character to the objects which, after a thousand reflections, studies and inspirations, I decided to point to with my finger."[64] In the light of these explanations, we can easily imagine the feelings that the other Surrealists, loyal to Moscow at the time, had towards the iconoclastic and blasphemic Dalí.

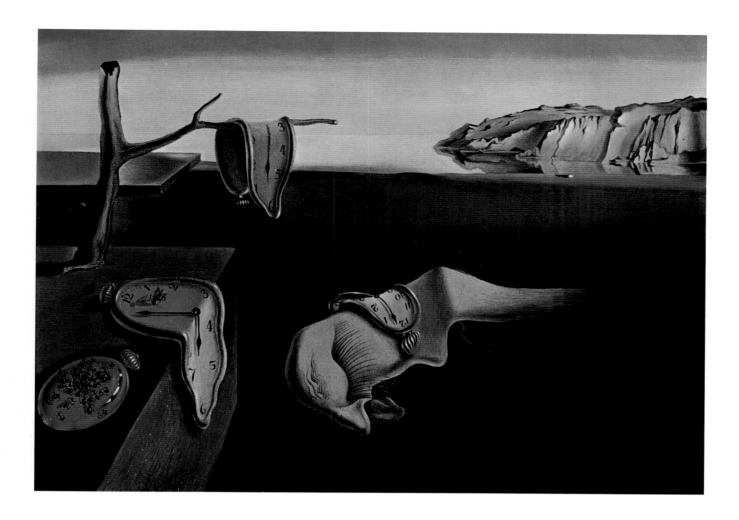

Throughout this time, Dalí was extremely active. He had exhibitions in America, wrote poems, and was involved in the periodicals *Le Surréalisme au Service de la Révolution* and *Minotaure*; in the latter he published his famous article 'On Gruesome and Edible Beauty, on Art Nouveau Architecture,' which concluded with his equally famous pronouncement: "Beauty will be edible or there will be no such thing at all."[65] Above all, though, the film *L'âge d'or* (The Golden Age), for which he wrote the screenplay together with Luis Buñuel, provoked another scandal.

Work on the film got off to a poor start because the two friends were no longer on each other's wavelength. Viscount de Noailles put up the money for the film and gave the creators of *Un Chien andalou* a free hand to do whatever came into their heads. Dalí, obsessed with the splendour and magnificence of Catholicism, suggested: " 'For this film I want a lot of archbishops, bones and monstrances. I want especially archbishops with their embroidered tiaras bathing amid the rocky cataclysms of Cape Creus.' Buñuel, with his naïveté and his Aragonese stubbornness, deflected all this toward an elementary anti-clericalism. I had always to stop him and say, 'No, no! No comedy. I like all this business of the archbishops; in fact, I like it enormously. Let's have a few blasphematory scenes, if you will, but it must be done with the utmost fanaticism to achieve the grandeur of a true and authentic sacrilege!"[66] Dalí was very disappointed when the film opened; he felt it was a travesty of his ideas,

The Persistence of Memory, 1931
La persistance de la mémoire
Oil on canvas, 24 x 33 cm
Museum of Modern Art, New York

"Just as I am astonished that a bank clerk never eats a cheque, so too am I astonished that no painter before me ever thought of painting a soft watch."

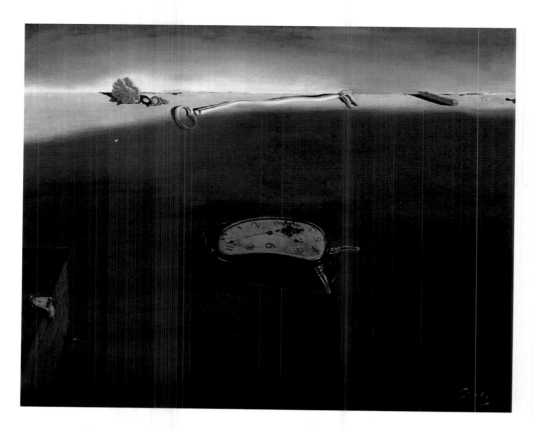

Soft Watches, 1933
Montres molles
Oil on canvas, 81 x 100 cm
Private collection

despite a few fine scenes which he noted with approval – such as the scene where the heroine, overcome by unsatisfied love, sucks the big toe of a marble statue of Apollo, or the scene where a limousine pulls up and the chauffeur opens the door and sets down a monstrance on the pavement, and then a pair of shapely female legs appear from inside the car. "At this moment, at a pre-arranged signal, an organized group of the 'King's Henchmen' proceeded to toss bottles full of black ink that went crashing into the screen," Dalí reported in his *Secret Life.*[67] "Simultaneously, to the cries of 'Down with the Boches!' they fired their revolvers in the air, at the same time throwing stench and tear-gas bombs. The film had shortly to be stopped, while the audience was beaten with blackjacks by the *Action Française* demonstrators. The glass panes of all the doors of the theatre were smashed, the surrealist books and paintings exhibited in the lobby of the theatre (Studio 28) were completely wrecked. One of my canvases was miraculously saved by an usher, who when the fracas began, had seized it and thrown it into the lavatory. But the rest were mercilessly torn to shreds... When the police appeared the wreckage was complete."

The upshot was, of course, that Dalí and his friend were the talk of the town. A controversy raged in the press, and presently the police felt obliged to ban the film. Dalí was afraid of being deported; but the split in opinion on the film saved him from this fate. "Nevertheless," he commented, "everyone preserved a holy fear of undertaking anything with me ... The scandal of *L'âge d'or* thus remained suspended over my head like a sword of Damocles." Dalí decided never again to collaborate with any-one. If there had to be scandals, he preferred to provoke them single-handed, with ideas that were purely his own. "I should have been willing to cause a scandal a hundred times greater, but for 'important reasons' –

Triangular Hour, 1933
L'heure triangulaire
Oil on canvas, 61 x 46 cm
Private collection

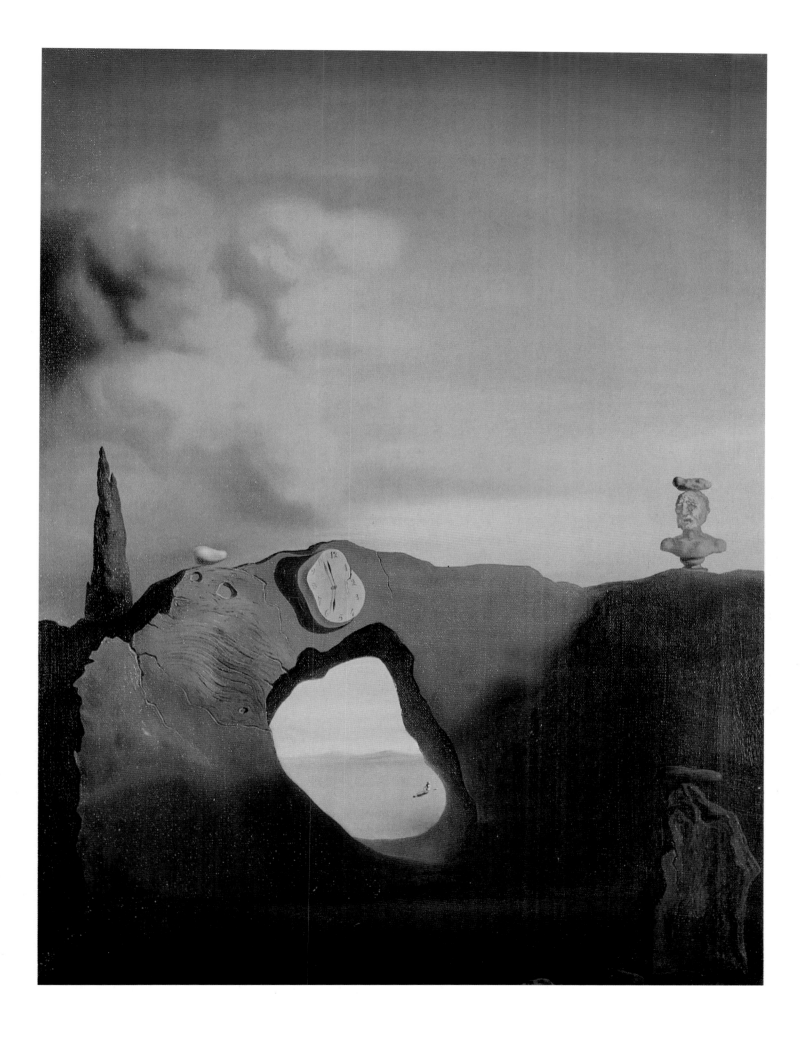

subversive rather through excess of Catholic fanaticism than through naïve anticlericalism." As foreseen, Buñuel had betrayed me, and in order to express himself, had chosen images that made the Himalayas of my ideas into little paper boats."[68] Dalí was well aware "that my disavowal of the film would have been understood by no one ... I had just made *L'âge d'or*. I was going to be allowed to make *The Apology of Meissonier in Painting*."[69] From that time on, people got into the habit of granting him considerable licence and simply saying: "That's just Dalí!"

Also at this time (in 1933), Dalí wrote his *Mythe tragique de l'Angelus de Millet*, which was not published until 1963. It was his interpretation of a picture that obsessed him and which was to pervade his work as thoroughly as the famous limp watches. Dalí saw erotic significance in Jean-François Millet's painting, and gave a detailed account of his view in the essay. "In June 1932, without advance warning of any kind or any conscious association that might have made an explanation possible, Millet's *Angelus* appeared before my mind's eye. The image was very clear and colourful. It made its appearance practically instantaneously, displacing all other images. It made a deep impression on me, indeed devastated me; because, although everything in my vision of the picture precisely 'matched' the reproductions I have seen of it, it nonetheless seemed totally transformed, fraught with so powerful a latent intent that Millet's *Angelus* suddenly struck me as the most bewildering, enigmatic, compact picture, the richest in unconscious ideas, that had ever been painted." Dalí painted numerous versions of the picture's subject, one using a wheelbarrow as an outgrowth of the man's skull (see p. 78), one with a coffin (astonishingly, X-ray examination of the layers of paint on Millet's work later revealed the shape of a coffin). He did it in architectural guise, included the motif alongside Gala, and even located it in the Catalonian cliffs: "In a brief fantasy I indulged in a walk to Cape Creus, the stony landscape of which is a true geological delirium, I imagined the two sculptured figures (in Millet's *Angelus*) hewn out of the highest cliffs ... but furrowed with deep fissures ... Time had worn particularly hard on the man, rendering him unrecognizable, leaving only the vague, shapeless block of the silhouette, which thus became alarming and especially frightening."[70] And all because the young Salvador, when still a schoolboy, could see through the window in the classroom door to where a calendar reproduction of the fateful picture hung in the corridor.

1934 was a particularly busy year. Dalí had six solo exhibitions: two at Julien Levy's in New York (one of them consisting of etchings illustrating Lautréamont's *Les Chants de Maldoror*); two in Paris; one in Barcelona; and above all the first London show, at Zwemmer's. He considered having a fifteen-metre symbolic loaf baked and placing it in the gardens of the Palais Royal – to be followed by a twenty-metre loaf at Versailles, and thirty-metre loaves in all the major cities of Europe – a feast for journalists! Dalí's avowed aim was to erode received notions of logic: "But look here, Dalí, what is all this about 'bread?'" "That is something you should ask of the critical-paranoiac method, my dear."[71] Dalí confessed that at that time he had no clear idea what this might be – though Breton was soon to welcome it enthusiastically enough.

Fried Eggs on a Plate without the Plate, 1932
Oeufs sur le plat sans le plat
Oil on canvas, 60 x 42 cm
Collection of Mr. and Mrs. A. Reynolds Morse, Loan to the Salvador Dalí Museum, St. Petersburg (Fla.)

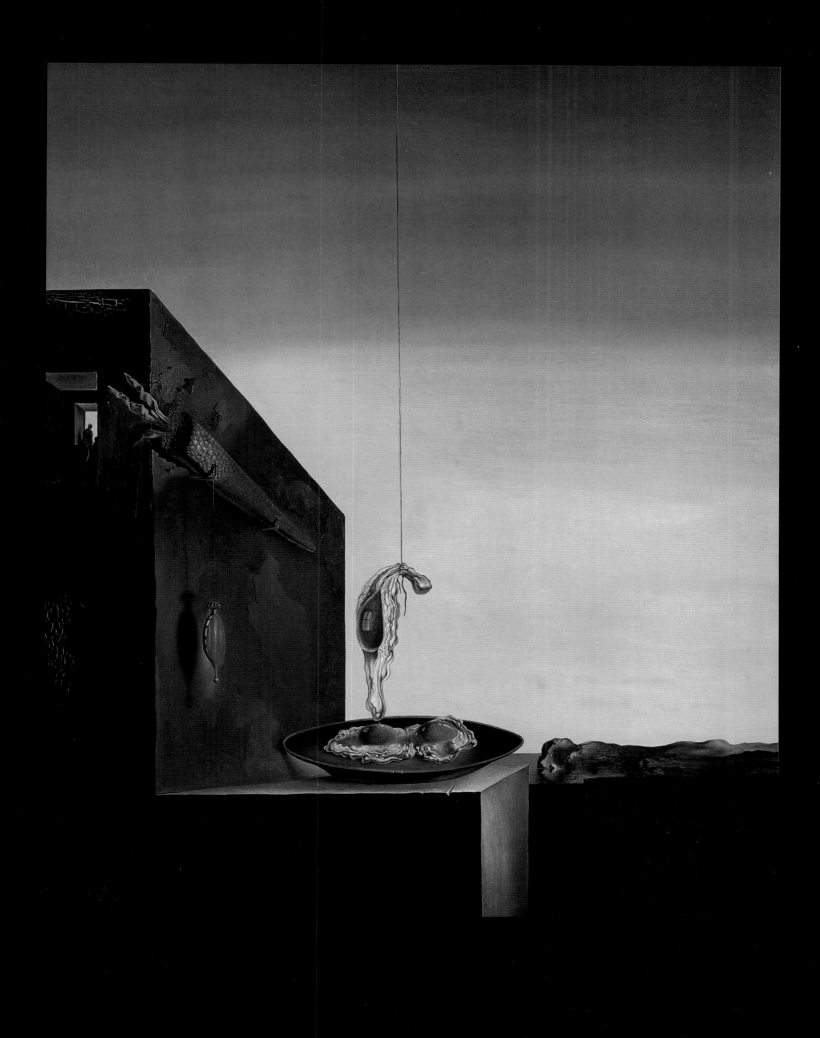

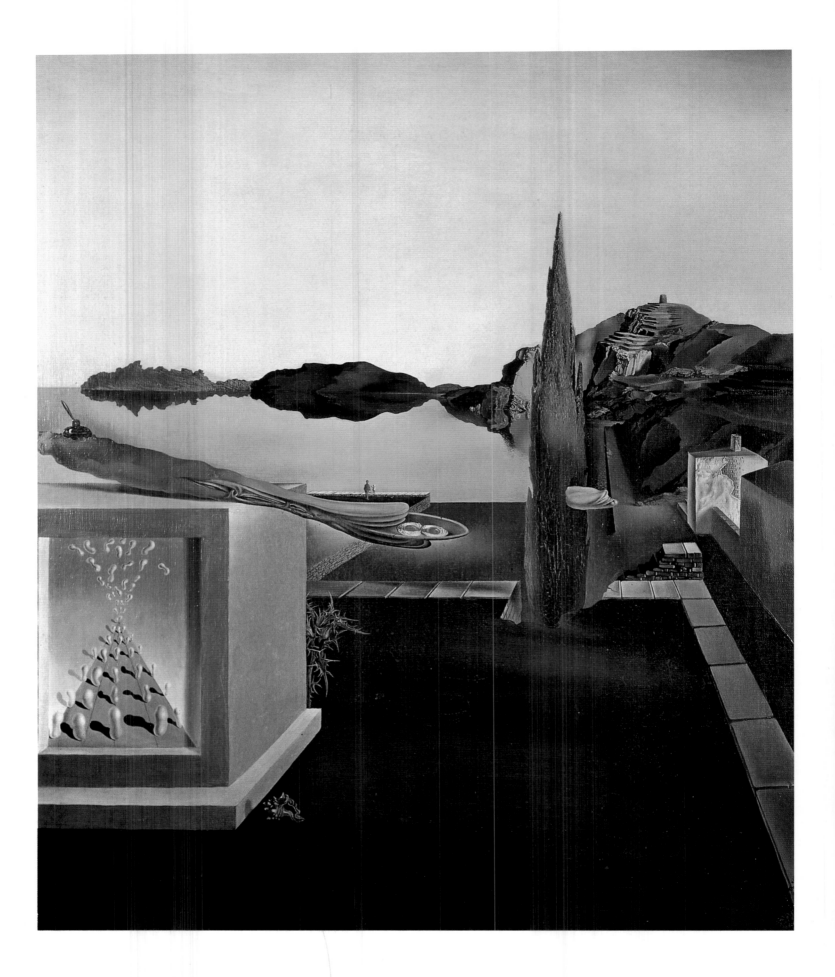

In the *Secret Life*[72] Dalí gives examples of inspirations derived from his famous method. The method itself (he commented) was "beyond (his) understanding" – as were many of his ideas, the full significance of which he was only to perceive later. "One day I hollowed out entirely an end of a loaf of bread, and what do you think I put inside it? I put a bronze Buddha, whose metallic surface I completely covered with dead fleas... After putting the Buddha inside the bread I closed the opening with a little piece of wood, and I cemented the whole, including the bread, sealing it hermetically in such a way as to form a homogeneous whole which looked like a little urn, on which I wrote 'Horse Jam.' What does that mean, eh?"

Another example: "One day I received a present from my very good friend Jean-Michel Frank, the decorator: two chairs in the purest 1900 style. I immediately transformed one of them in the following fashion. I changed its leather seat for one made of chocolate; then I had a golden Louis XV door-knob screwed under one of the feet... One of the legs of the chair was to repose continuously in a glass of beer... I called this dreadfully uncomfortable chair, which produced a profound uneasiness in all who saw it, the 'atmospheric chair.' And what does that mean, eh?"

What it meant first and foremost was that the Surrealists were beginning to be worried on account of this Dalí fellow. It seemed he was determined to outdo them at all costs. In his own conspicuous way he was loading the Surrealist, irrational artefact or object with symbolic significance – in contrast to the practice of the other Surrealists, who were busy with automatic writing and reporting dreams. Dalí was acquiring a following. One of the most characteristic Surrealist objects was Meret Oppenheim's *Fur Breakfast* (1936), a furry cup and saucer which was promptly bought by the Museum of Modern Art in New York. "The fashion in Surrealist artefacts discredited the so-called 'dream period' and put an end to it. Nothing could possibly be drearier, it now seemed... The surrealist object had created a new need of reality. People no longer wanted to hear the 'potential marvelous' talked about. They wanted to touch the 'marvelous' with their hands... The Martian and absymal landscapes of the subconscious, and flying viscera persecuting decahedrons in flames already at this time appeared intolerably monotonous... The surrealists of Central Europe, the Japanese, and the latecomers of all nations took hold of these facile formulae of the never seen in order to astonish their fellow-citizens... With the Surrealist object I thus killed elementary Surrealist painting, and modern painting in general. Miró had said, 'I want to assassinate painting!' And he assassinated it – skilfully and slyly abetted by me, who was the one to give it its death-blow, fastening my matador's sword between its shoulder-blades. But I do not think Miró quite realized that the painting that we were going to assassinate together was 'modern painting.' For I have just recently met the older painting at the opening of the Mellon collection, and I assure you it does not yet seem at all aware that anything untowards has happened to it."[73]

Even when he was most frenetically involved in making Surrealist objects, Dalí still went on painting "a few apparently very normal paintings, inspired by the congealed and minute enigma of certain snapshots, to which I added a Dalinian touch of Meissonier. I felt the public, which was

Surrealist Object indicative of Instantaneous Memory, 1932
Objet surréaliste indicateur de la mémoire instantanée
Oil on canvas, Dimensions unknown
Private collection

beginning to grow weary of the continuous cult of strangeness, instantly nibble at the bait. Within myself I said, addressing the public, 'I'll give it to you, I'll give you reality and classicism. Wait, wait a little, don't be afraid.'"

The Surrealists were right to be worried. They saw Dalí's turbulent ideas as an attack, and Dalí (not without justice) was beginning to view himself as the sole authentic Surrealist. At least, that was what he announced when he made his triumphant entry into New York on 14 November 1934. Overdoing the megalomania more outrageously than ever, he noted: "Surrealism was already being considered as before Dalí and after Dalí... Deliquescent ornamentation, the ecstatic sculpture of Bernini, the gluey, the biological, putrefaction – was Dalinian. The strange medieval object, of unknown use, was Dalinian. A bizarre anguishing glance discovered in a painting by Le Nain was Dalinian. An 'impossibile' film with harpists and adulterers and orchestra conductors – this ought to please Dalí... The bread of Paris was no longer the bread of Paris. It was my bread, Dalí's bread. Salvador's bread."[74]

The principle of "hardness" involved such things as the rocks and cliffs at Cape Creus, where the Pyrenees meet the sea. It was there that Dalí and Gala would retire whenever they were exhausted or in despair, or had no money. "The long, meditative contemplation of those rocks" played a vital part in the development of his "morphological esthetics of soft and hard," which is the same as the aesthetic of Gaudí's Mediterranean Gothic. If we compare Dalí's beloved landscape with Gaudí's *Sagrada Familia* church or Güell Park, there can be no doubt that the architectural genius, Dalí's fellow-Catalonian, must also have seen the tattered, craggy rocks and cliffs of Cape Creus. The rocks were surely an

Automatic Beginning of a Portrait of Gala (unfinished), 1932
Commencement automatique d'un portrait de Gala (inachevé)
Oil on panel, 13 x 16 cm
Fundación Gala-Salvador-Dalí, Figueras

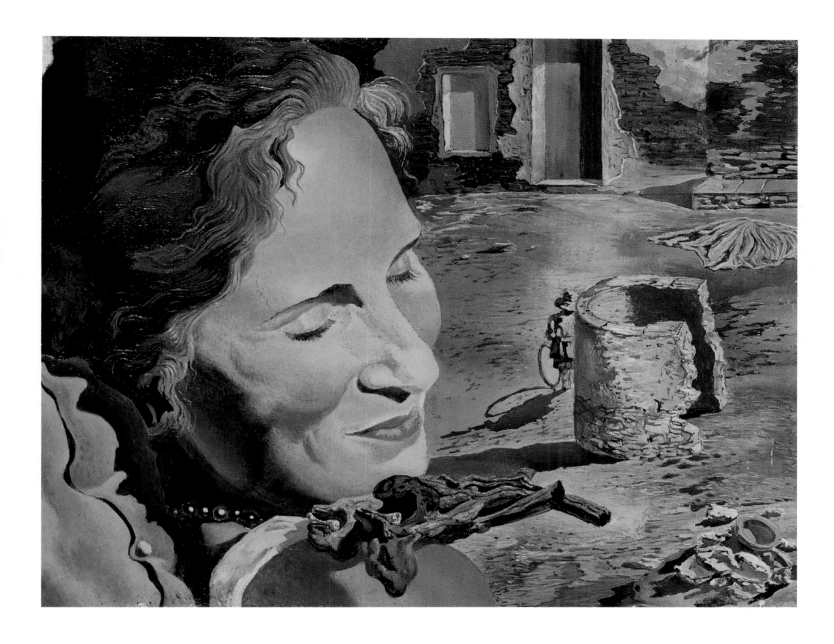

inspiration. Dalí saw them as "that principle of paranoiac metamorphosis" in tangible form. He gave this account: "All the images capable of being suggested by the complexity of their innumerable irregularities appear successively and by turn as you change your position. This was so objectifiable that the fishermen of the region had since time immemorial baptized each of these imposing conglomerations – the camel, the eagle, the anvil, the monk, the dead woman, the lion's head... I discovered in this perpetual disguise the profound meaning of that modesty of nature which Heraclitus referred to in his enigmatic phrase, 'Nature likes to conceal herself.'... Watching the 'stirring' of the forms of those motionless rocks, I meditated on my own rocks, those of my thought. I should have liked them to be like those outside – relativistic, changing at the slightest displacement in the space of the spirit, becoming constantly their own opposite, dissembling, ambivalent, hypocritical, disguised, vague and concrete, without dream, without 'mist of wonder,' measurable, observable, physical, objective, material and hard as granite.

"In the past there had been three philosophic antecedents of what I

Gala with Two Lamb Chops in Equilibrium on
Her Shoulder, 1933
Portrait de Gala avec deux côtelettes d'agneau
en équilibre sur l'épaule
Oil on panel, 8.5 x 6.5 cm
Collection of Mr. and Mrs. A.Reynolds Morse,
Loan to the Salvador Dalí Museum,
St. Petersburg (Fla.)

Jean-François Millet:
The Angelus, 1859
Louvre, Paris

*Gala and the "Angelus" of Millet Immediately
Preceding the Arrival of the Conic
Anamorphosis, 1933*
Gala et l'Angélus de Millet précédant l'arrivée
imminente des anamorphoses coniques
Oil on panel, 24 x 18.8 cm
The National Gallery of Canada, Ottawa

aspired to build in my own brain: the Greek Sophists, the Jesuitical thought of Spain, founded by Saint Ignatius of Loyola, and the dialectics of Hegel in Germany – the latter, unfortunately, lacked irony, which is the essentially esthetic element of thought; moreover it 'threatened revolution'..."[75]

What better way could there be of illustrating the principle of "softness" in contrast to "hardness" than by examining the history of *Soft Watches* – which is at once a history of Dalí's personality: "Instead of hardening me, as life had planned, Gala... succeeded in building for me a shell to protect the tender nakedness of the Bernard the Hermit that I was, so that while in relation to the outside world I assumed more and more the appearance of a fortress, within myself I could continue to grow old in the soft, and in the supersoft. And the day I decided to paint watches, I painted them soft. It was on an evening when I felt tired, and had a slight head-ache, which is extremely rare with me. We were to go to a moving picture with some friends, and at the last moment I decided not to go. Gala would go with them, and I would stay home and go to bed early. We had topped off our meal with a very strong Camembert, and after everyone had gone I remained for a long time seated at the table meditating on the philosophic problems of the 'super-soft' which the cheese presented to my mind. I got up and went into my studio, where I lit the light in order to cast a final glance, as is my habit, at the picture I was in the midst of painting. This picture represented a landscape near Port Lligat, whose rocks were lighted by a transparent and melancholy twilight; in the foreground an olive tree with its branches cut, and without leaves. I knew that the atmosphere which I had succeeded in creating with this landscape was to serve as a setting for some idea, for some surprising image, but I did not in the least know what it was going to be. I was about to turn out the light, when instantaneously I 'saw' the solution. I saw two soft watches, one of them hanging lamentably on the branch of the olive tree. In spite of the fact that my head-ache had increased to the point of becoming very painful, I avidly prepared my palette and set to work. When Gala returned from the theatre two hours later the picture, which was to be one of my most famous, was completed."[76]

Not long after, the American dealer Julien Levy bought *Soft Watches* – or rather, *The Persistence of Memory* (p. 67), as it had now been retitled. And it was Levy who was destined to make Dalí famous in the United States – and thus lay the foundation stone of his later fortune. He found the picture unusual – but not to the public taste, and therefore unsaleable. It turned out that in this he was completely wrong: the painting changed hands time after time, finally ending up in the Museum of Modern Art in New York, where it is undoubtedly the best-known picture in the museum's collection.

"I want to go to America, I want to go to America."[77] It became an obsession with Dalí. But he didn't have the money for the crossing. His contract with Pierre Colle was not renewed because Colle was in financial difficulty. The collectors who were loyal to Dalí had his work all over their walls – but Port Lligat had already devoured all the proceeds of sales. "I thus found myself at a moment when I was simultaneously at the height

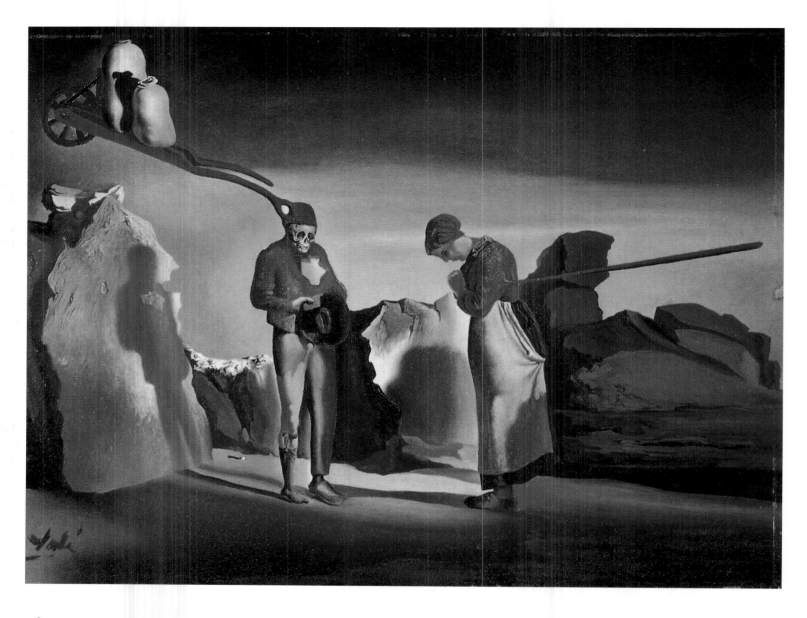

of my reputation and influence and at the low point of my financial resources."[78] In a rage, Dalí went knocking at doors – and "and after three days of furiously jerking fortune's cock it ejaculated in a spasm of gold!"[79] And they had their fare to America. On this occasion, Fortune appeared in the guise of Pablo Picasso; Dalí later admitted that he had never paid back the money he borrowed – though of course his fellow-artist from Málaga had never asked for it back, either.

On board the *Champlain*, Dalí talked the captain into having a fifteen-metre loaf baked for him when they arrived at New York. Or, to be exact, a two-and-a-half-metre loaf – since the oven on board could not handle anything longer. Dalí intended to distribute the bread to the waiting journalists as St. Francis had scattered it to the birds. But in their enthusiasm the journalists took no notice of his bread. Instead they asked countless questions: "They immediately asked me if it was true that I had just painted a portrait of my wife with a pair of fried chops balanced on her shoulder. I answered yes, except that they were not fried, but raw. Why raw, they immediately asked me. I told them that it was because my wife was raw too. But why the chops together with your wife? I answered

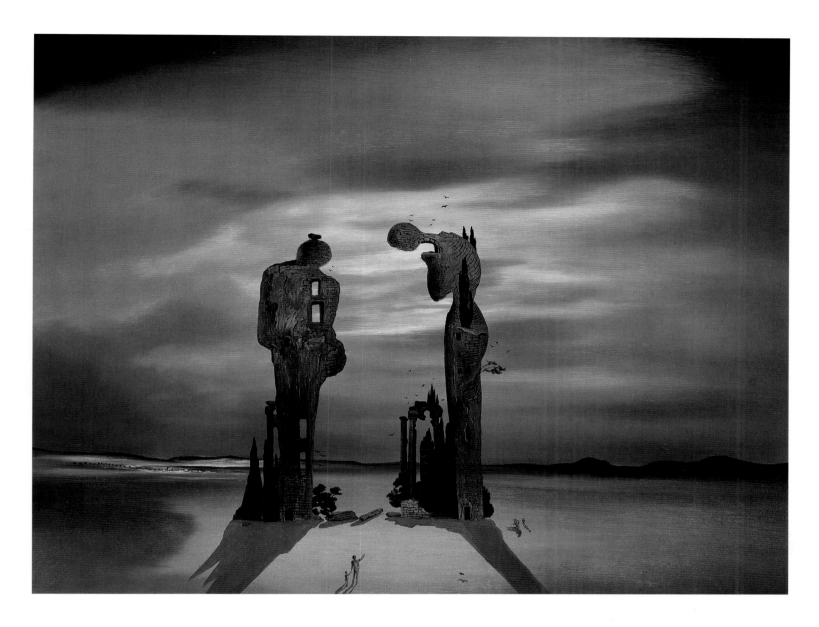

Archeological Reminiscence of the 'Angelus' by Millet, 1935
Réminiscence archéologique de l'Angélus de Millet
Oil on panel, 32 x 39 cm
Collection of Mr. and Mrs. A.Reynolds Morse,
Loan to the Salvador Dalí Museum,
St. Petersburg (Fla.)

that I liked my wife, and that I liked chops, and that I saw no reason why I should not paint them together."[80] He saw New York as a giant Gothic Roquefort cheese. He wrote as much in *New York Salutes Me*, which was handed out at his exhibition at the Julien Levy gallery – adding by way of explanation that he was very partial to Roquefort. Dalí saluted New York, too, as a new Egypt. "But an Egypt turned inside out. For she erected pyramids of slavery to death, and you erect pyramids of democracy."[81] He explained his art thus: "I simply express what I think and try to put my most arresting and fleeting visions into concrete form, everything that is mysterious, intangible, personal, unique and in my head." On 18 December he gave a lecture at the Wadsworth Atheneum in Hartford, Connecticut, and repeated: "The sole difference between a madman and me is that I am not mad." He discovered New York's cosmopolitan high society, did the rounds of receptions and lectures, interviews and debates, and stressed the role of the subconscious in his pictures: "The fact that I myself, at the moment of painting, do not understand my own pictures, does not mean that these pictures have no meaning."[82]

He liked going into drugstores with an immense loaf tucked under his arm, ordering fried eggs, and then eating them with a small piece of bread cut off the loaf – to the great amusement of anyone who happened to be there at the time. His paintings sold well: eight in New York, three of them to museums. For the return trip, the Dalís were able to treat themselves to a luxury cabin on the *Normandie*. Before they departed, Caresse Crosby threw a Dream Ball in Dalí's honour. The Americans vied fiercely to out-Dalí each other. Dalí confessed that even he (who was so rarely impressed by anything) was astounded by the riotousness of the ball at the Coq Rouge. Simply to please Dalí, ladies would appear with a birdcage on their heads, say, and otherwise practically naked. Others pretended to be wounded or mutilated in frightful ways, or stuck safety pins through their skin to do cynical violence to their own beauty. One young woman – slender, pale, cerebral – wore a satin dress with a "living" mouth. On her cheek and back and in her armpits she had eyes like terrible tumours. A man wearing a bloody nightshirt had a bedside table balanced on his head. When he opened the door of the bedside table, a flock of hummingbirds flew out. On the staircase there was a bathtub filled with water, so shaky that it threatened to tip over and flood the merrymakers at any moment. In the course of the evening a huge flayed ox was dragged into the ballroom; its slit belly was supported on crutches and contained a dozen gramophones. Gala was done up as a "choice corpse:" on her head she had a doll (which made a very real impression) that looked like a baby with its belly eaten away by ants, its head in the claws of a phosphorescent lobster.

While the sensational couple were resting on the *Normandie*, relaxing on the Atlantic crossing after the wild time they had had in America, a new Dalí scandal was in the making in Paris. The Dream Ball had quite unanticipated consequences: a correspondent for the *Petit Parisien* had cabled a story to the effect that "at a ball, the wife of painter Salvador Dalí wore a bloody model of the Lindbergh baby on her head." The journalist added that the kidnapper of the Lindbergh baby was on trial at the very same moment, and claimed that Gala's choice of headgear had caused a scandal in New York. In point of fact, his report was totally untrue: if there had been a scandal, no one but him had noticed. Still, interest in Dalí was high, and soon all Paris was filled with consternation, and occasionally with hostility. Yet again Dalí's iconoclastic, scandalous public image had backfired on him, and he noted: "I was no longer master of my legend, and henceforth Surrealism was to be more and more identified with me, and with me only ... The group I had known–both Surrealists and society people – was in a state of complete disintegration ... And a whole Surrealist faction, obeying the slogants of Louis Aragon, a nervous little Robespierre, was rapidly evolving toward a complete acceptance of the communist cultural platform."[83]

Angelus of Gala, 1935
L'Angélus de Gala
Oil on panel, 32 x 26 cm
The Museum of Modern Art, New York

Detail from:
*Gala and the Angelus of Millet Immediately
Preceding the Arrival of the Conic
Anamorphosis, 1933*
(p. 77)

Detail from:
Portrait of My Dead Brother, 1963
(p. 189)

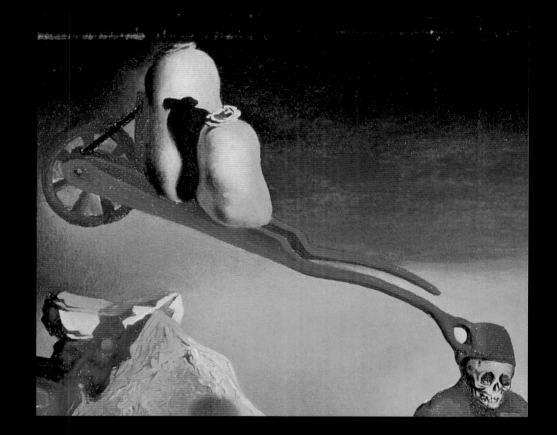

Detail from:
Atavism of Twilight, 1933–34
(p. 78)

Detail from:
Tristan and Isolde, 1944
(p. 141)

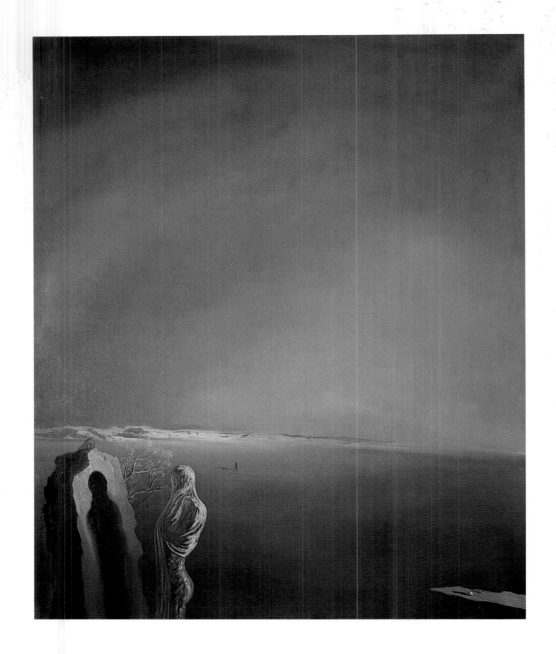

The Ambivalent Image, 1933
Image ambivalente
Oil on canvas, 65 x 54 cm
Private collection, Paris

OPPOSITE:
Geological Development, 1933
Le devenir géologique
Oil on panel, 21 x 16 cm
Private collection

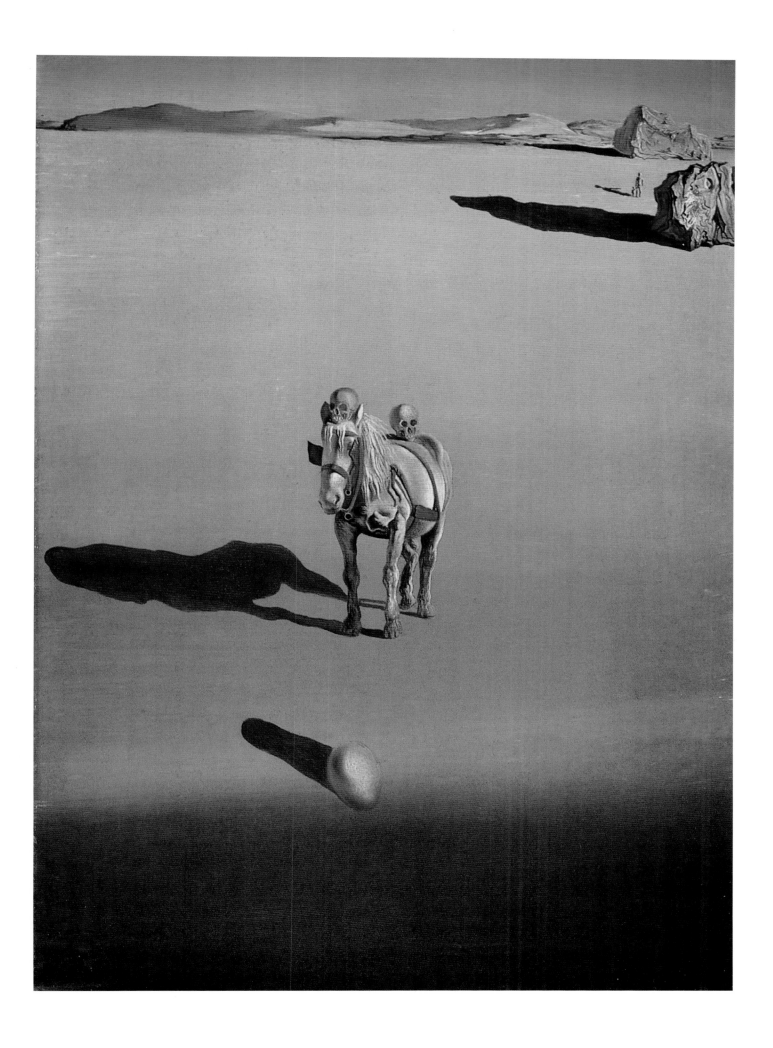

Apparation of my Cousin Carolinetta on the
Beach at Rosas, 1933
Apparition de ma cousine Carolinetta sur la
plage de Rosas
Oil on canvas, 73 x 100 cm
Private collection

Necrophilic Spring Flowing from a Grand Piano, 1933
Fontaine nécrophilique coulant d'un piano à queue
Oil on canvas, 22 x 27 cm
Private collection, Paris

Atavistic Ruins after the Rain, 1934
Vestiges ataviques après la pluie
Oil on canvas, 65 x 54 cm
Perls Galleries, New York

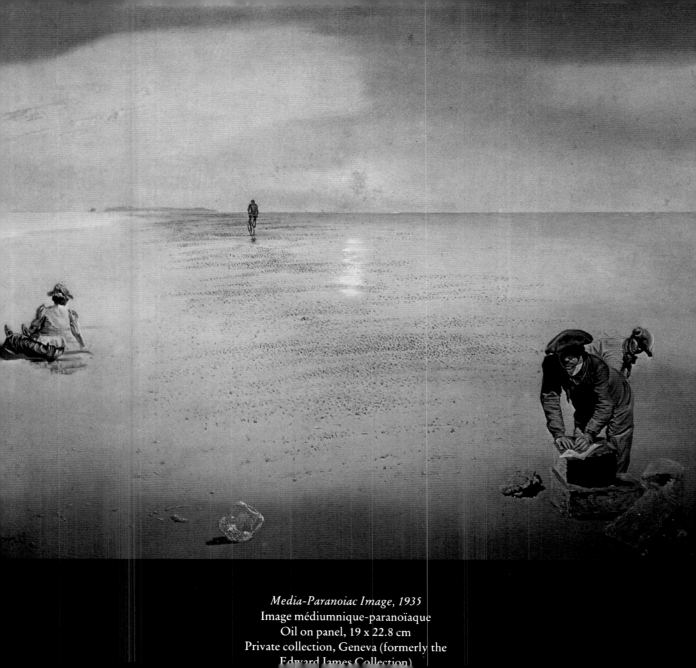

Media-Paranoiac Image, 1935
Image médiumnique-paranoïaque
Oil on panel, 19 x 22.8 cm
Private collection, Geneva (formerly the
Edward James Collection)

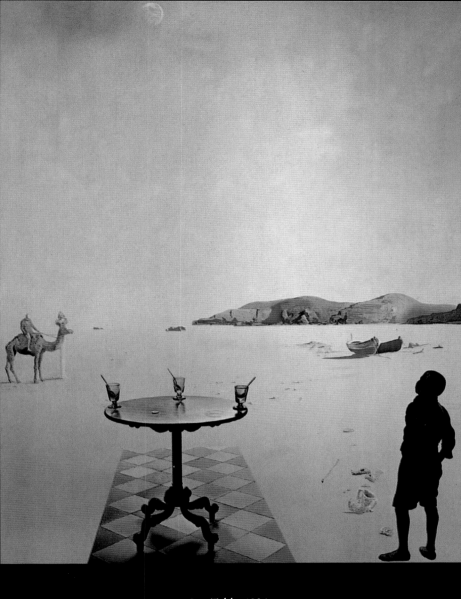

Sun Table, 1936
Table solaire
Oil on panel, 60 x 46 cm
Boymans-van-Beuningen Museum, Rotterdam
(formerly the Edward James Collection)

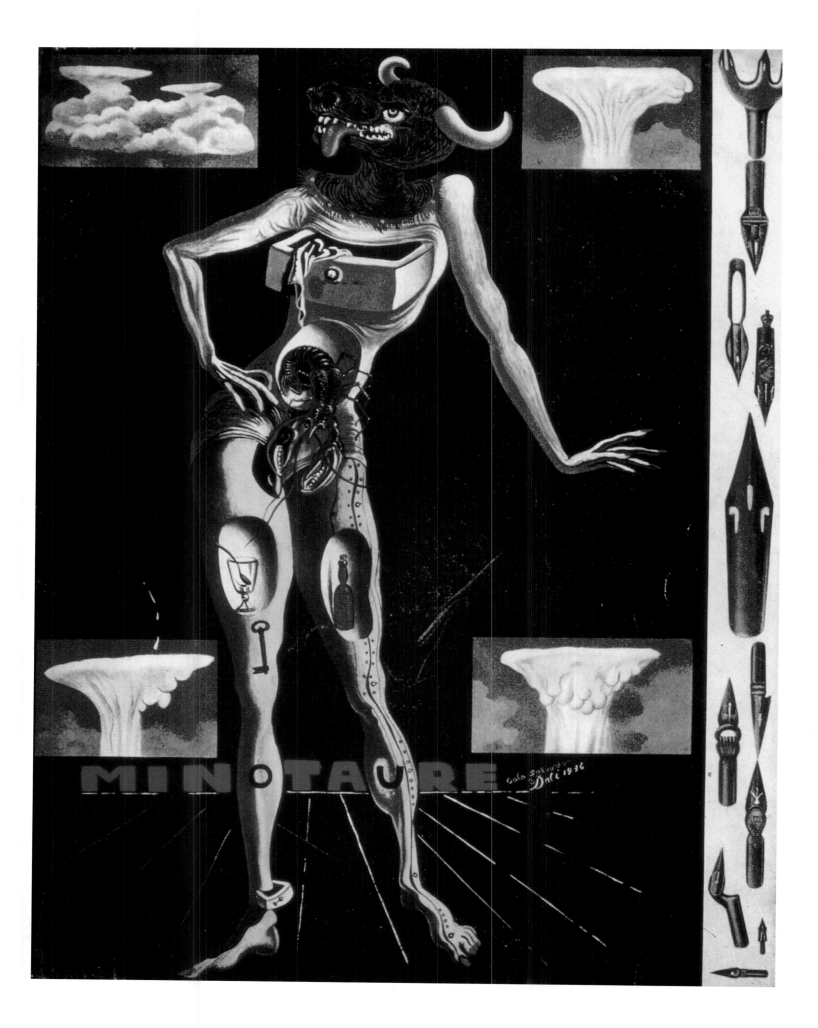

The Conquest of the Irrational

Dalí's enemies and allies tend to have one thing in common: they largely ignore his own writings. Yet when Dalí availed himself of the written or spoken word, he did so with all his extravagance and bravado, with his core reticence and his embarrassed revelations, and above all with the man's unique brilliance – and often his statements contain vital information on his evolution as a painter, the tempestuous ups and downs of his life, his tenderness and cruelty, and the stern logic that governed the apparent contradictions in his thought. Eccentric though Dalí was, through it all there ran an exemplary continuity. *The Secret Life of Salvador Dalí* gives us the first steps the child took, the youth's quest for identity, the upheavals in his life, and the hidden passionate sides of a provocative and free-thinking mind that caused scandals from the outset, cared nothing for the opinions of others, and tended to thrive on people's stupidity.

The *Diary of a Genius* (the continuation of his autobiography) expressed his personality *as Dalí* – that is to say, the public persona that used a kind of delirium to achieve effects. In the book we witness Dalí grappling with art and with his own formidable abilities. It is fascinating to follow the relentless logic with which his way of thinking develops, the steps in his conquest of the irrational. And no one describes Dalí's relations with Surrealism better than Dalí himself. He was a Surrealist "from birth," writes Dalí. He explains the reasons for the breach with Breton – who (he concedes) was after an aesthetic of the unconscious, but who imposed limits and would accept neither the full, alarming risk of the enterprise nor the lack of control. Dalí, by contrast, was naturally inclined to total, untrammelled Surrealism. If Breton closed the movement's doors to Dalí, that was understandable: he himself had founded it, only to have Dalí declare himself the truest, most absolute Surrealist and expect Breton to acknowledge himself as the master of the movement.

But for all his megalomania and conceit, his contradictions and absurdities, the traps he laid for the public, his arrant lack of shame, and in spite of his idiom of delirium, Dalí as writer can and must be taken just as seriously as Dalí the painter.

In the *Diary of a Genius*, Dalí explicitly states that he was aware from the very start that the Surrealists, whose "slogans and subjects [he] had already studied closely and taken apart minutely" when he joined the movement, would try to impose restrictions on him just as his family had

"The fact that I myself do not understand what my paintings mean while I am painting them does not imply that they are meaningless."

Cover of 'Minotaure' Magazine, no. 8, 1936
Couverture du n° 8 de la revue 'Minotaure'
Oil and collage on card, 33 x 26.5 cm
Isodore Ducasse Fine Arts, New York

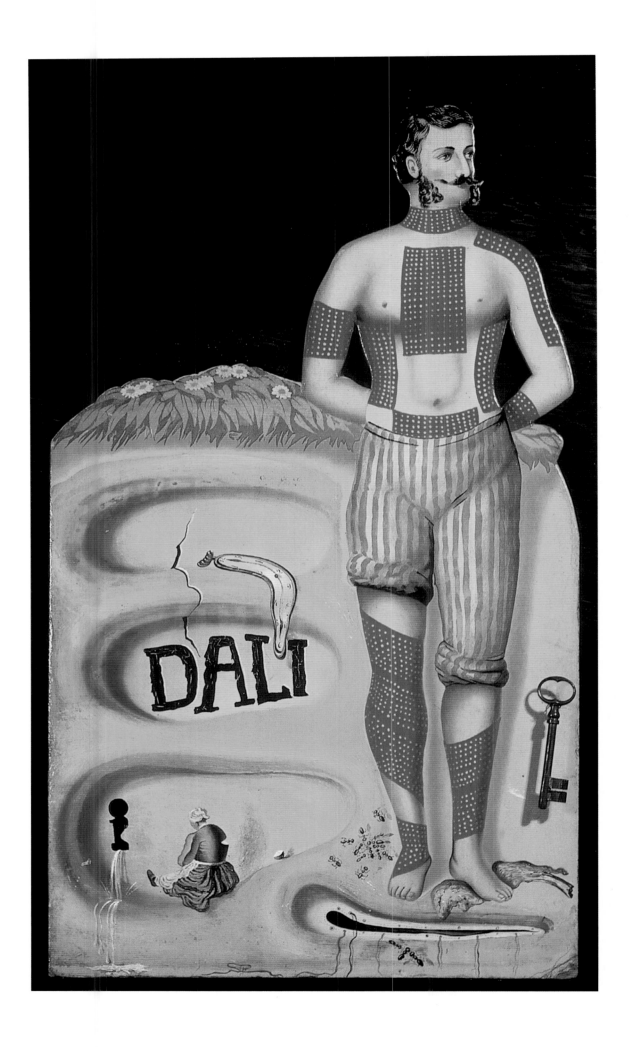

done. Gala had warned him that he "would have to put up with the same restrictions among the Surrealists as he would anywhere else, and that basically they were all Philistines."[84]

Dalí begins his book with a quotation from Sigmund Freud – "The hero is whoever rebels against the father's authority and triumphs over it"[85] – and then, having dealt with the most important writer of his times, goes on to settle scores with his new father, André Breton.

Approaching his subject with a "quite Jesuitical" honesty, yet "always with the thought at the back of my mind that I would soon become the leader of the Surrealists," Dalí "took Surrealism quite literally, rejecting neither the blood nor the excrement that was in their manifestoes. Just as I had once endeavoured to become a perfect atheist by reading my father's books, I now became so diligent a *stud. surr.* that I was soon the only full Surrealist. So much so, that in the end I was expelled from the group because I was overly-Surrealistic."[86]

It was not difficult to be expelled by Breton – many others travelled the same road, and they tended to be the best, the most independent-minded. Small wonder: a gardener wants his shrubs trained in the style he has chosen, after all. "When Breton discovered my art he was horrified at the scatological elements that stained it," Dalí reports in the *Diary of a Genius.*[87] "I was surprised. The very first steps I took were taken in sh--, which, psychologically speaking, could be interpreted as an auspicious token of the gold that was fortunately to rain down on me later. I tried craftily to persuade the Surrealists that those scatological elements could bring the movement good fortune. In vain I referred to the emphatically digestive iconography found in all eras and cultures; the hen that laid the golden eggs, the intestinal delirium of Danaë, Grimm's fairy tales. But they wouldn't have it. My decision was taken at that moment. If they didn't want the sh-- I was generously offering them, I would keep my treasures and gold to myself. The famous anagram Breton thought up twenty years later, Avida Dollars, could just as well have been prophetically proclaimed then and there."

Gala was right: up to a certain point the scatological elements were tolerated, but an excess was taboo. "Once again I came up against the same prohibition as my family had imposed. I was permitted blood. A little crap was all right. But just crap was not on. Depicting genitals was approved, but no anal fantasies. They looked very askance at anuses! They liked lesbians very much indeed, but not pederasts. One could have sadism in dreams to one's heart's content, and umbrellas and sewing machines, but no religion on any account, not even if it was of a mystical nature. And to dream of a Raphael Madonna, quite simply, without apparent blasphemy, was strictly prohibited."

Dalí continually boasted of having initiated dissent among the Surrealists. He said he agonized over how he could get them to accept an idea or picture that was totally at odds with their taste. To this end he resorted to that "Mediterranean, paranoiac hypocrisy" which he thought himself capable of only in cases of perversity. "They didn't like anuses! Craftily I sneaked masses of them past them, in disguise – Machiavellian anuses for preference. Whenever I made a Surrealist object in which no such appari-

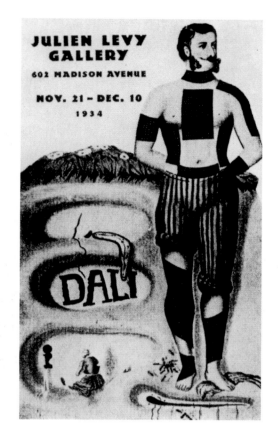

Brochure for Dalí's second solo-exhibition in the Julien Levy Gallery, New York, 1934

Surrealist Poster, 1934
Affiche surréaliste
Oil on chromolithographic poster with key,
69 x 46 cm
Collection of Mr. and Mrs. A. Reynolds Morse, Loan to the Salvador Dalí Museum, St. Petersburg (Fla.)

Mae West Lips Sofa, c.1936/37
Mae West lips sofa
Wooden frame, upholstered in deep pink and
pale pink felt, 92 x 213 x 80 cm
Produced by Green and Abbott, London
Borough of Brighton, Sussex

The famous lips sofa originated in Dalí's
1934/35 collage (see opposite page). In 1936
Dalí's patron, Edward James, ordered five sofas
to be made in London. Dalí gave instructions for
satin covering the colour of Mae West's lipstick
– shocking pink. The first version was a single
shade, but later models, somewhat altered and
bigger, were made in two shades of pink.

tion was to be seen, the whole object had the symbolic function of an
anus. Thus I used my famous active method of paranoiac-critical analysis
to counter pure, passive automatism – and the ultra-reactionary, subver-
sive technique of Meissonier to counter enthusiasm for Matisse and
abstract trends. To check the cult of primitive objects I singled out the
supersophisticated objects of the modern style, which we were collecting
together with Dior and which were one day to be revived as a 'new look.'"

Breton was an atheist. Dalí thought it would be deliciously ironic if
Surrealism were elevated to become a new, true religion – sadistic,
masochistic, dreamlike and paranoiac – with Auguste Comte as its Mes-
siah and Breton as its great preacher. We must bear in mind that Dalí was a
mystic, as he was to demonstrate amply later in life when he decided to
return to the aesthetic of the Italian Renaissance and paint works such as
The Madonna of Port Lligat (p. 159) and *Leda Atomica* (p. 156). In these
works, Dalí was not only processing the golden section and ideas bor-
rowed from modern physics; the paintings also reflect the development of
the artist's mind, with his (typical) dual allegiance to agnosticism and to
Roman Catholicism. The shamelessness he was accused of was in fact his
way of protecting his inmost self – by flinging firecrackers at his pursuers'
feet to ensure he could make a getaway, so to speak. He was attacking in
order not to be overwhelmed: a response essentially modest and chaste,
the response of the unbending savage or of the Catalonian peasant. Even
the controversial scatology derived from "angelic" inspiration, and ex-
pressed the painful awareness of a man terrified by the evidence of his own
mortality – the processes of excretion. Though he did not speak of them
much, he certainly did not turn away from them "as a cat turns away from
its excrement." Disease and decay fascinated him, as he himself said. And
he was equally obsessed by death. Dalí had to keep a cold eye on the
things he hated.

*Mae West's Face Which Can Be Used as a
Surrealist Apartment, 1934–35*
Visage de Mae West (pouvant être utilisé
comme appartement surréaliste)
Gouache on newspaper, 31 x 17 cm
The Art Institute of Chicago

Paranoiac-Critical Solitude, 1935
Solitude paranoïaque-critique
Oil on panel, 19 x 23 cm
Private collection (formerly Edward James
Collection)

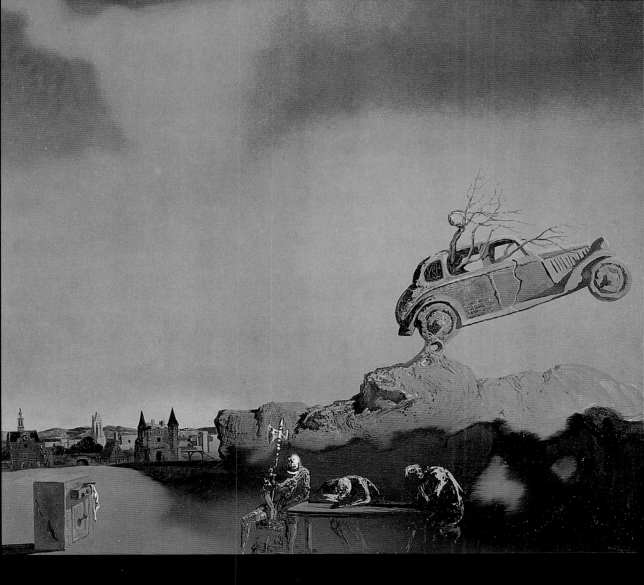

Apparition of the Town of Delft, 1935–36
L'apparition de la ville Delft
Oil on panel, 31 x 34.5 cm
Private collection, Switzerland

This was the origin of his countless acts of provocation, such as the three-metre-long backside supported on a crutch which he gave Lenin (cf. p. 53). To his intense disappointment, the painting did not spark a controversy amongst the Surrealists. "But I was encouraged by this disappointment. It meant I could go still further . . . and attempt the impossible. Only Aragon was outraged by my thought machine with beakers of warm milk. 'Dalí has gone far enough!' he roared angrily. 'From now on, milk is only for the children of the unemployed.'"[88] It was a point for Dalí: he had lured Aragon into his trap. He was delighted, and took the opportunity to take a swipe at his despised opponent. "Breton, thinking he saw a danger of obscurantism in the communist-sympathizing faction, decided to expel Aragon and his adherents – Buñuel, Unic, Sadoul, and others – from the Surrealist group. I considered René Crevel the only completely sincere communist among those I knew at the time, yet he decided not to follow Aragon along what he termed 'the path of intellectual mediocrity.' . . . And shortly afterward committed suicide, despairing of the possibility of solving the dramatic contradictions of the ideological and intellectual problems confronting the Post-War generation. Crevel was the third surrealist who committed suicide, thus corroborating their affirmative answer to a questionnaire that had been circulated in one of its first issues by the magazine *La Révolution Surréaliste*, in which it was asked, 'Is suicide a solution?' I had answered no, supporting this negation with the affirmation of my ceaseless individual activity."[89]

Breton viewed Dalí's choice of political subjects more seriously. It was startling and scandalous, and compromised the Surrealists, who did not understand that Dalí was quite logically giving preference to regimes that clung to elites, hierarchial structures, pomp and public ceremony – regimes which espoused rituals, liturgies, splendour, and the rousing

Suburbs of Paranoiac-Critical Town; Afternoon on the Outskirts of European History,
1936
Banlieue de la ville paranoïaque-critique: apres-midi sur la lisière de l'histoire européenne
Oil on panel, 46 x 66 cm
Private collection

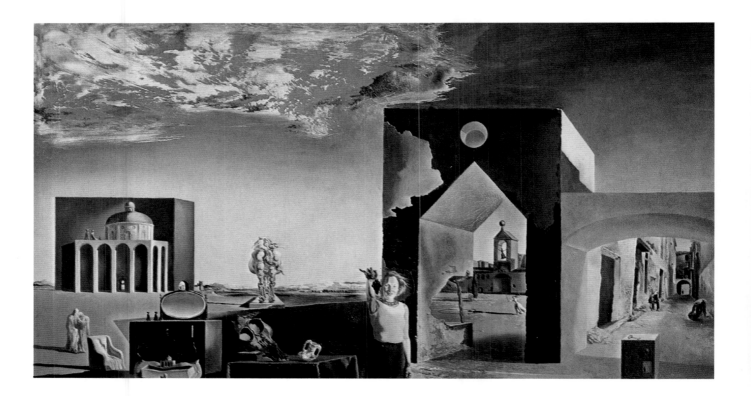

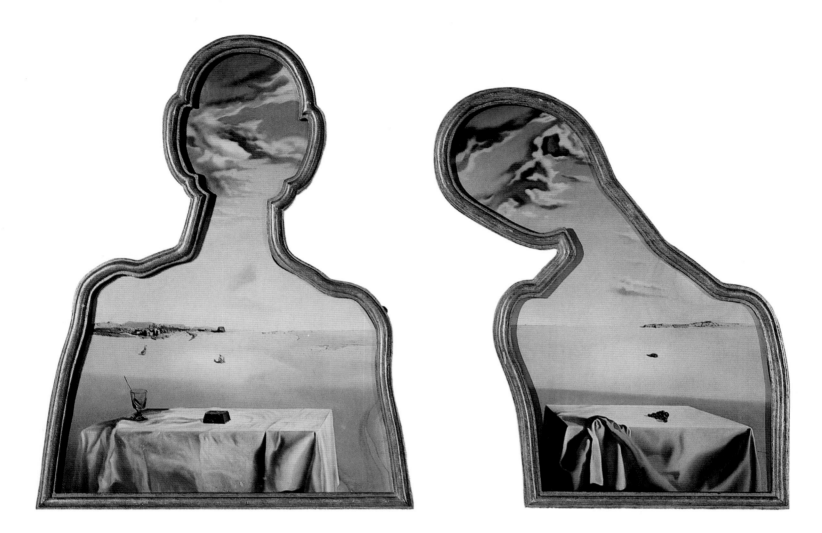

Couple with their Heads Full of Clouds, 1936
Couple aux têtes pleines de nuages
Oil on panel, 92.5 x 69.5 cm
Boymans-van-Beuningen Museum, Rotterdam

presence of a majestic army. Monarchies were plainly more magnificent than republican democracies (and Dalí – perverse creature! – preferred them to totalitarian regimes, too). His aim was to confer an aura of the miraculous on Surrealism; and he found the political Left drab and prosaic – in his view it was trivial, wretched, and even a threat, and he found it unacceptable. On the other hand, he did give extensive attention to the history of religions, in particular of Catholicism, which he increasingly came to see as a "complete architectural structure." To the Surrealists he confessed: "Very rich people have always impressed me; very poor people, like the fishermen of Port Lligat, have likewise impressed me; average people, not at all." He regretted that the Surrealists were attracting "a whole fauna of misfit and unwashed petty bourgeois... society people every day and almost every night. Most society people were unintelligent, but their wives had jewels that were hard as my heart, wore extraordinary perfumes, and adored the music that I detested. I remained always the Catalonian peasant, naïve and cunning, with a king in my body. I was bumptious, and I could not get out of my mind the troubling image, post-card style, of a naked society woman loaded with jewels, wearing a sumptuous hat, prostrating herself at my dirty feet."[90]

To fantasize about Hitler wearing women's clothing is doubtless not altogether innocuous; nor is painting a "Hitlerian wet nurse" with a swastika. Dalí's Surrealist associates had not the slightest doubt that obsession with Hitler had its political side, and did not believe for a moment that his ambiguous portrayal of the Nazi *Führer* might simply be

PAGES 102/103:
The Chemist of Ampurdán Looking for Absolutely Nothing, 1936
Le pharmacien d'Ampurdán ne cherchant absolument rien
Oil on panel, 30 x 52 cm
Folkwang Museum, Essen (formerly Edward James Collection)

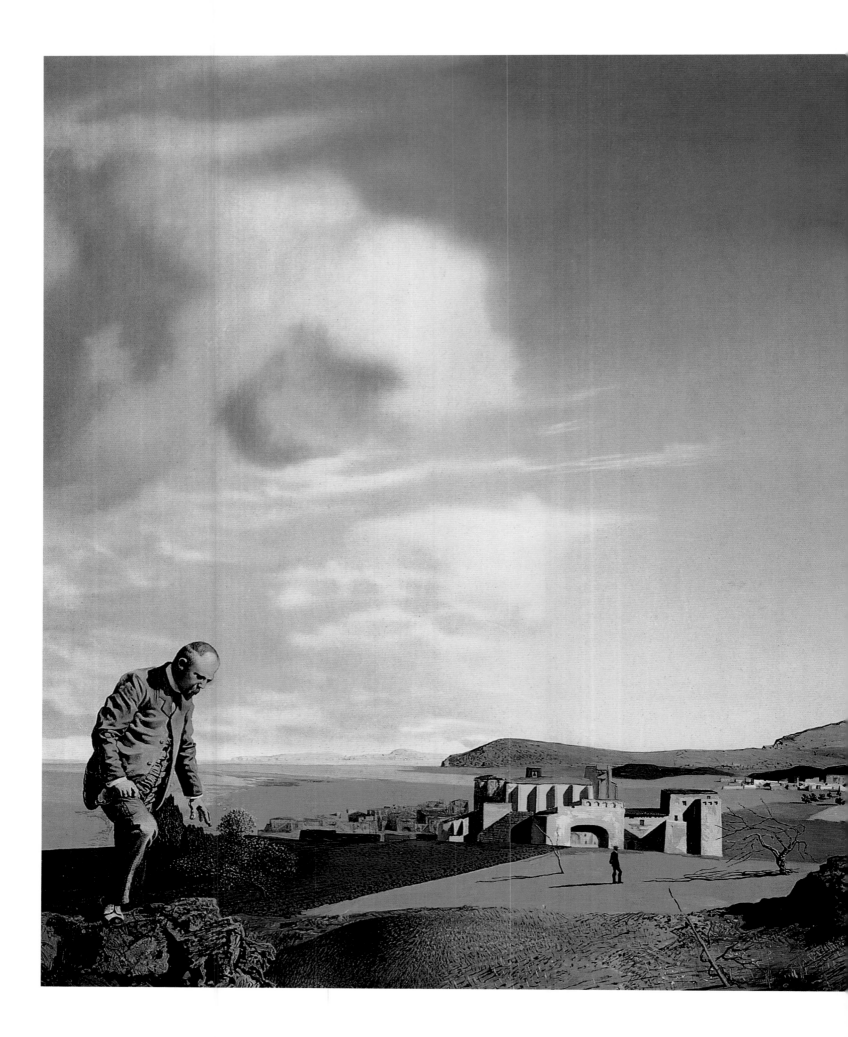

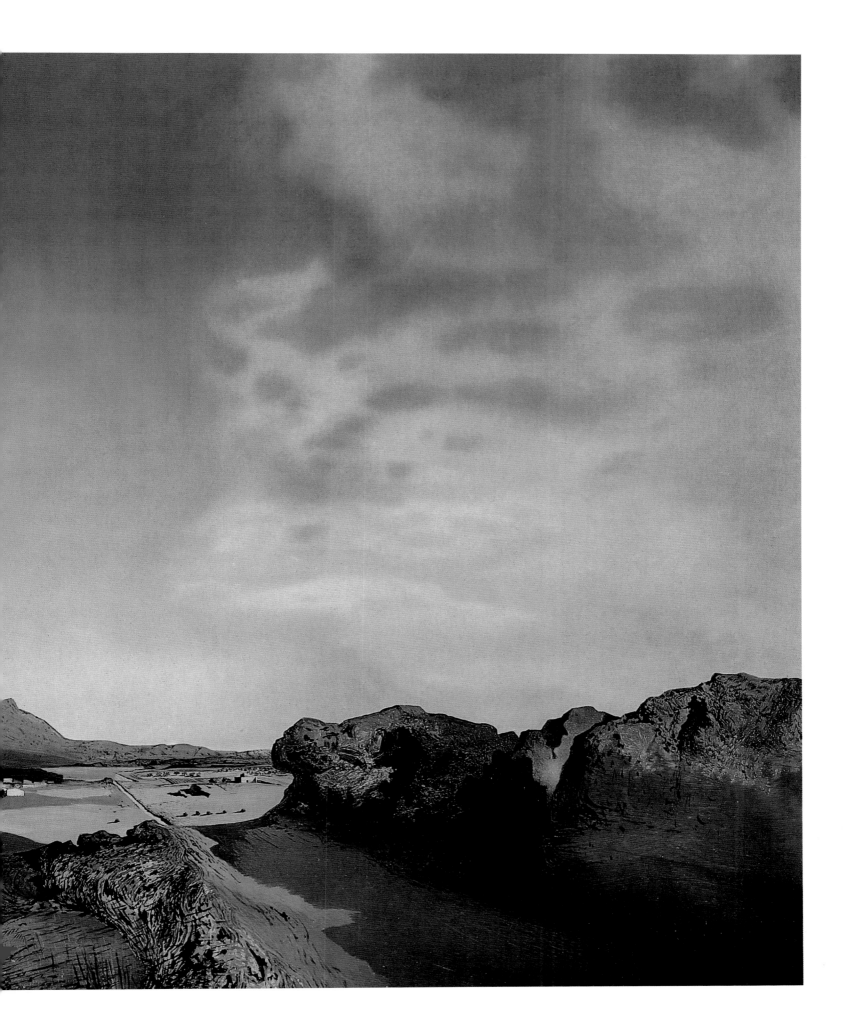

an exercise in black humour like his paintings of William Tell and Lenin. People were to tell Dalí in accusing tones that Hitler would have liked the "weakness, solitude, megalomania, Wagnerism and Hieronymus-Bosch-ism" of his pictures at this time. "I was fascinated by Hitler's soft, fleshy back, which was always so tightly strapped into the uniform," Dalí observed in his own defence. "Whenever I started to paint the leather strap that crossed from his belt to his shoulder, the softness of that Hitler flesh packed under his military tunic transported me into a sustaining and Wagnerian ecstasy that set my heart pounding, an extremely rare state of excitement that I did not even experience during the act of love."[91]

The Surrealists had no patience with his "innately contrary spirit" and were outraged. Dalí responded by challenging Breton to convene the group for an emergency meeting "at which the mystique of Hitler shall be debated from Nietzsche's irrational standpoint and from that of the anti-Catholics;" he was hoping that the anti-Catholic aspect would lure Breton.

"Furthermore, I saw Hitler as a masochist obsessed with the *idée fixe* of starting a war and losing it in heroic style. In a word, he was preparing for one of those *actes gratuits* which were then highly approved of by our group. My persistence in seeing the mystique of Hitler from a Surrealist point of view and my obstinacy in trying to endow the sadistic element in Surrealism with a religious meaning (both exacerbated by my method of paranoiac-critical analysis, which threatened to destroy automatism and its inherent narcissism) led to a number of wrangles and occasional rows with Breton and his friends. The latter, incidentally, began to waver between the boss and me in a way that alarmed him."

In fact they had long gone beyond mere dispute. Contrary to Dalí's wishes, the Surrealists remained devoted to Breton, their iron-fisted leader whose every order had to be obeyed. When required to appear before the group, Dalí showed up with a thermometer in his mouth, claiming he felt ill. He was supposedly suffering from a bout of 'flu, and was well wrapped up in a pullover and scarf. While Breton reeled off his accusations, Dalí kept checking his temperature. When it was his turn for a counter-attack, he began to remove his clothing article by article. To the accompaniment of this striptease, he read out an address he had composed previously, in which he urged his friends to understand that his obsession with Hitler was strictly paranoiac and at heart apolitical, and that he could not be a Nazi "because if Hitler were ever to conquer Europe, he would do away with hysterics of my kind, as had already happened in Germany, where they were treated as *Entartete* (degenerates). In any case, the effeminate and manifestly crackpot part I had cast Hitler in would suffice for the Nazis to damn me as an iconoclast. Similarly, my increased fanaticism, which had been heightened by Hitler's chasing Freud and Einstein out of Germany, showed that Hitler interested me purely as a focus for my own mania and because he struck me as having an unequalled disaster value." Was it his fault if he dreamt about Hitler or Millet's *Angelus*? When Dalí came to the passage where he announced, "In my opinion, Hitler has four testicles and six foreskins," Breton shouted: "Are you going to keep getting on our nerves much longer with your Hitler!"

"Do not be afraid of perfection – you will never attain it."

Venus de Milo with Drawers, 1936
Vénus de Milo aux tiroirs
Bronze with plaster-like casting and fur-rimmed knobs, 98 x 32.5 cm
Boymans-van-Beunigen Museum, Rotterdam

Detail from:
The Invention of the Monsters, 1937
(p. 112)

The Burning Giraffe, 1936–37
Girafe en feu
Oil on panel, 35 x 27 cm
Emanuel Hoffmann Collection,
Kunstmuseum, Basle

And Dalí, to general amusement, replied: "... if I dream tonight that you and I are making love, I shall paint our best positions in the greatest of detail first thing in the morning." Breton froze and, pipe clenched between his teeth, murmured angrily: "I wouldn't advise it, my friend."[92] It was a confrontation that once again pointed up the two men's rivalry and power struggle. Which of them was going to come out on top?

Following his confrontation, Dalí was given a short-lived reprieve, but then notified of his expulsion. "Since Dalí had repeatedly been guilty of counter-revolutionary activity involving the celebration of fascism under Hitler, the undersigned propose ... that he be considered a fascist element and excluded from the Surrealist movement and opposed with all possible means."[93] After he had been expelled, Dalí continued to participate in Surrealist exhibitions; after all, the movement needed Dalí's magnetic hold on the public, as Breton well knew. Thus in 1936 Dalí made his appearance at the New Burlington Galleries in London wearing a diving suit – to illustrate the thesis stated in his lecture concerning art's function of revealing the depths of the subconscious. At one point he appeared to be suffocating in it – and a panting Dalí was hastily freed of his suit and helmet, to the enthusiastic applause of the audience, who supposed it was all a well-rehearsed act.

In Paris, Dalí exhibited at the Surrealist show in the Galerie des Beaux-Arts. There was a shock in store for art lovers in the entrance hall: in his *Histoire de la peinture surréaliste*, Marcel Jean reports that "Dalí's *Rain Taxi* was on display there: an ancient boneshaker of a car, with an ingenious system of pipes pouring showers onto two dummies, a chauffeur with a shark's head and, in the back seat, a blonde in an evening gown, hair tousled, reclining amidst lettuce and chicory, with fat snails leaving their wet, slimy trails across her."[94]

At this time, Dalí published a number of key texts. The most important was his seminal essay *The Conquest of the Irrational*[95] (1935), which appeared simultaneously in Paris and New York. (Dalí had realised that if he was to achieve real fame it would have to be via America.) In it he described his quest, and wrote: "My whole ambition in painting is to manifest the images of concrete irrationality in terms of authoritative precision ... images which for the moment can neither be explained nor reduced by logical systems or rational approaches." He stressed "Paranoiac-critical activity: spontaneous method of irrational knowledge based upon the interpretive-critical association of delirious phenomena;" every one of these phenomena includes an entire systematic structure "and only becomes objective *a posteriori* by critical intervention." The infinite possibilities available to this method can only originate in obsession. Dalí concluded by seeming to do an about-turn, though in fact what he said was a warning, and clearly anticipated the consumer society and its atavistic need for whatever is edible: his imponderable, chimerical images concealed nothing other than "the familiar, bloody, irrational, grilled cutlet that will devour us all." That selfsame cannibal cutlet was to be rediscovered later by Pop Art and appropriated as its very own when Andy Warhol, Allen Jones, Claes Oldenburg, Tom Wesselmann and others sang the praises of Coca Cola, Campbell's soup and so forth.

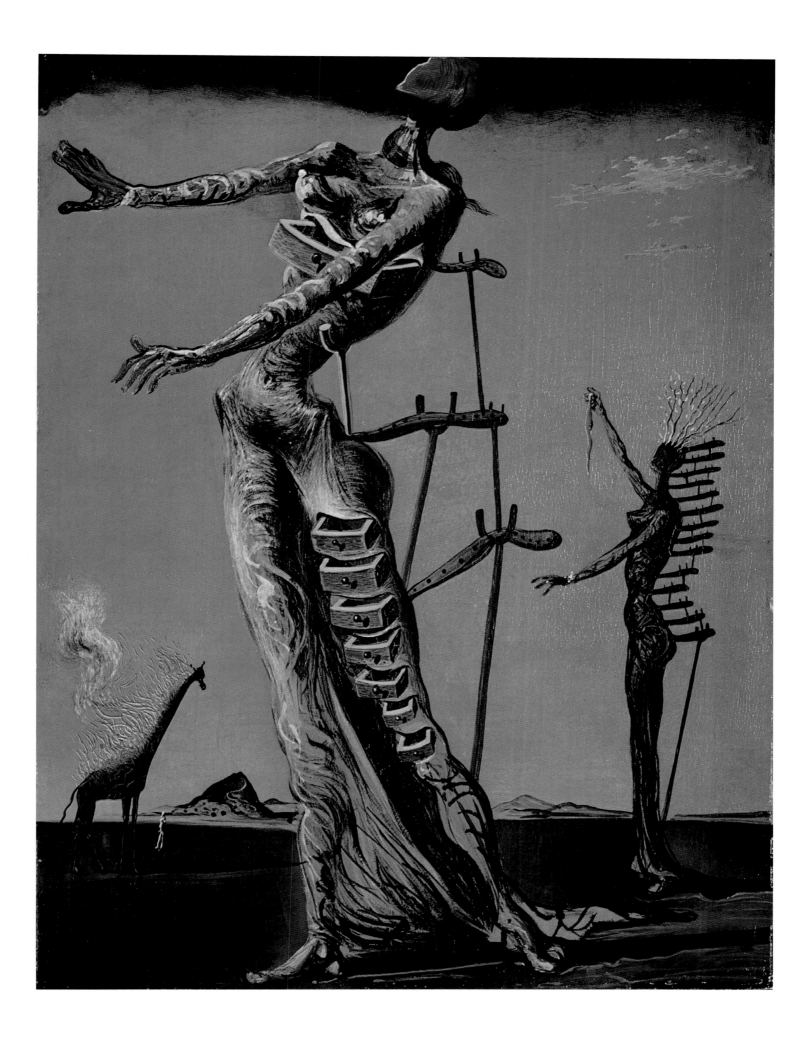

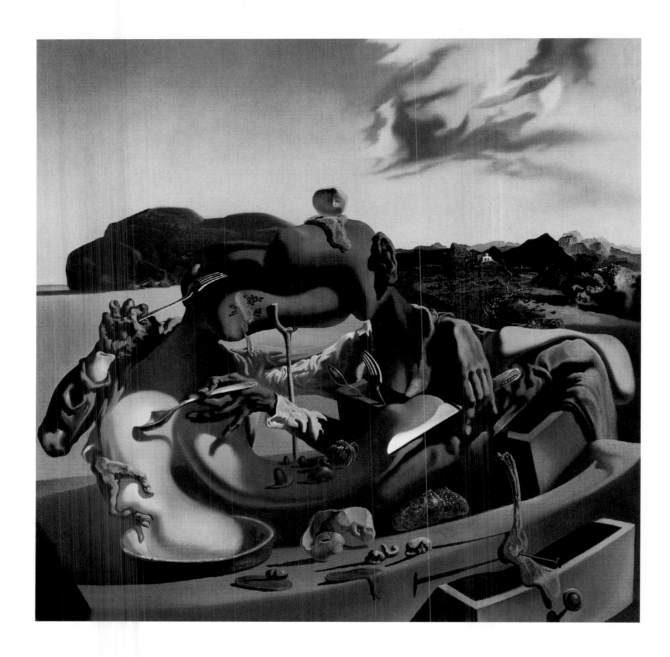

Autumn Cannibalism, 1936
Cannibalisme de l'automne
Oil on canvas, 65 x 65.2 cm
The Tate Gallery, London, (formerly Edward
James Collection)

*Soft Construction with Boiled Beans
(Premonition of Civil War), 1936*
Construction molle avec haricots bouillis,
Prémonition de la guerre civile
Oil on canvas, 100 x 99 cm
The Philadelphia Museum of Art

PAGES 110/111:
Sleep, 1937
Le sommeil
Oil on canvas, 51 x 78 cm
Boymans-van-Beuningen Museum, Rotterdam

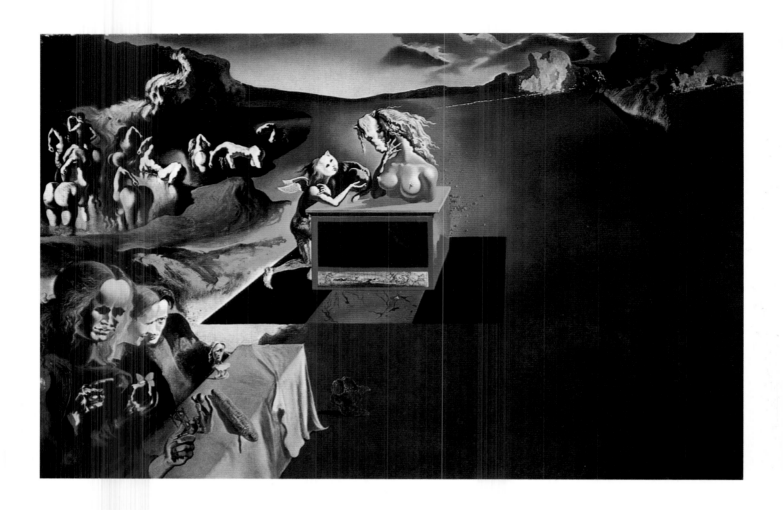

The Invention of Monsters, 1937
L'invention des monstres
Oil on canvas, 51.2 x 78.5 cm
The Art Institute of Chicago

André Breton had to admit that Dalí's paranoiac-critical method had provided Surrealism with "an instrument of prime importance." Even André Thirion,[96] who was one of the dogmatic hard-liners of the group, later conceded: "Dalí's contribution to Surrealism was of immense importance to the life of the group and the evolution of its ideology. Those who have maintained anything to the contrary have either not been telling the truth or have understood nothing at all. Nor is it true that Dalí ceased to be a great painter in the Fifties, even though it was distinctly discouraging when he turned to Catholicism... In spite of everything, what we are constantly seeing in his work is exemplary draughtsmanship, a startlingly inventive talent, and a sense of humour and of theatre. Surrealism owes a great deal to his pictures."

If Breton and the other Surrealists had difficulty swallowing Dalí's attitude to Hitler, their fellow-artist's steadily growing popularity was even more of a problem. He was the art hero of the world. People loved his constant provocations and his increasingly manneristic, detailed style of painting – a style for which he cited the Pompiers and above all their master, Meissonier, as the principal source. Dalí quite unashamedly wanted money. He said so, loudly, and didn't care a toss for social revolution.

Many people wanted his recipe for success. To one young man who asked, Dalí replied: "Then you must become a snob. Like me... For me, snobbery – particularly in Surrealist days – was a downright strategy,

because I ... was the only one who moved in society and was received in high-class circles. The other Surrealists were unfamiliar with the milieu. They had no entrée. Whereas I could get up from their midst at any time and say: 'I have an engagement,' and let slip the fact or allow people to guess (next day they would know or, better still, would hear from a third party) that I had been invited to the Faucigny-Lucinges' or other people that the group eyed as if they were forbidden fruit because they were never invited there. But the moment I arrived at the society people's homes I adopted a different, more pronounced kind of snobbery. I would say: 'Right after coffee I have to go, to see the Surrealists.' I would make out that the Surrealists had far greater shortcomings than the aristocracy, than all the people one knew in society, because the Surrealists wrote abusive letters to me in which they said high society was nothing but arseholes who understood absolutely nothing ... In those days, snobbery was saying: 'Now I must be off to the Place Blanche. There's a very important Surrealist meeting.' The effect of saying this was terrific. On the one hand I had society, politely astonished that I was going somewhere that they could not go, and on the other hand, the Surrealists. I was always off to where the rest couldn't go. Snobbery consists in going to places that others are excluded from – which produces a feeling of inferiority in the others. In all human relations there is a way of achieving complete mastery of a situation. That was my policy where Surrealism was concerned."[97]

In 1936, Spain was being torn apart by civil war. Dalí and Gala had to do without their retreats to Port Lligat. Instead they travelled around Europe, and spent some time living in Italy. The influence of the Renaissance masters Dalí saw in the great art galleries of Florence and Rome is clearly apparent in the groups of figures he subsequently used in his paintings in order to establish multiple images, as in *Spain* (p. 116) or *The Invention of Monsters* (p. 112). The latter is one of his paintings on the

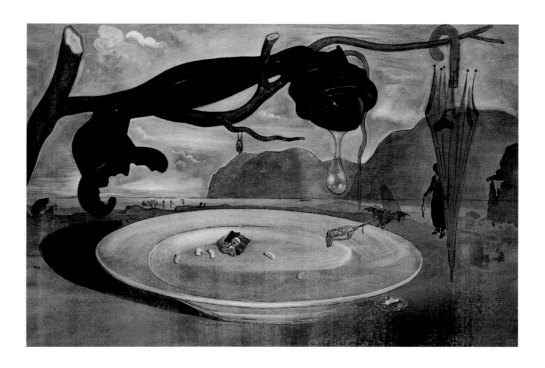

The Enigma of Hitler, 1937
L'énigme de Hitler
Oil on canvas, 51.2 x 79.3 cm
Gift from Dalí to the Spanish state

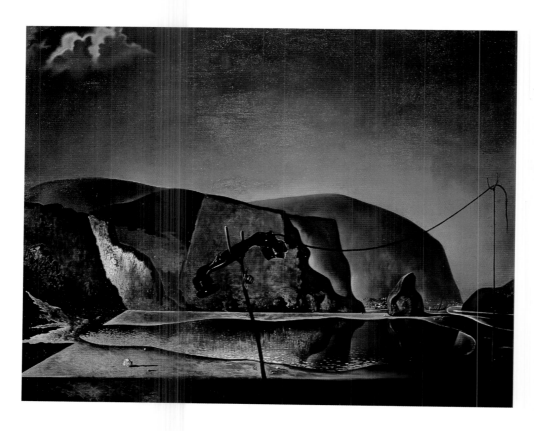

Beach Scene with Telephone, 1938
Plage avec téléphone
Oil on canvas, 73.6 x 92 cm
The Tate Gallery, London (formerly Edward
James Collection)

subject of "premonitions of war:" The artist explained that the fore-
ground double figure holding a butterfly and hourglass was the Pre-
Raphaelite version of the double portrait of Dalí and Gala immediately
behind it. True to his principle of taking no interest in politics, Dalí
viewed the civil war that was tormenting his country merely as a delirium
of edibles. He observed it as an entomologist might observe ants or
grasshoppers. To him it was natural history; to Picasso, by contrast, it was
political reality. What *Guernica* was for Picasso, *The Burning Giraffe*
(p. 107) and *Soft Construction with Boiled Beans (Premonition of Civil
War)* (p. 109) were for Dalí. Dalí was not interested in the war as such. His
only interest was in the premonitions recorded in his paintings: "Six
months before the outbreak of the Spanish Civil War, being a painter of
intestinal paroxysms, I completed my 'Premonition with boiled beans'" –
Dalí's references to food come to seem compulsive – "which shows a huge
human body, all arms and legs deliriously squeezing each other." Cook-
ing is always associated with smells. In the *Secret Life*[98] Dalí wrote
eloquently of smells: "From all parts of martyred Spain rose a smell of
incense, of chasubles, of burned curates' fat and of quartered spiritual
flesh, which mingled with the smell of hair dripping with the sweat of
promiscuity from that other flesh, concupiscent and as paroxysmally
quartered, of the mobs fornicating among themselves and with death."

But in respect of his political stance, Dalí did concede: "I was
definitely not a historic man. On the contrary, I felt myself essentially
anti-historic and apolitical. Either I was too much ahead of my time or
much too far behind, but never contemporaneous with ping-pong-play-
ing men." Dalí wrote: "The Spanish Civil War changed none of my ideas.
On the contrary, it endowed their evolution with a decisive rigor. Horror

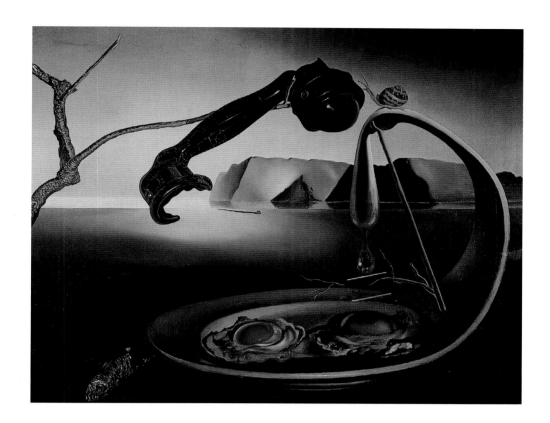

The Sublime Moment, 1938
Le Moment sublime
Oil on canvas, 38 x 47 cm
Staatsgalerie, Stuttgart

and aversion for every kind of revolution assumed in me an almost pathological form. Nor did I want to be called a reactionary. This I was not: I did not 'react' – which is an attribute of unthinking matter. For I simply continued to think, and I did not want to be called anything but Dalí. But already the hyena of public opinion was slinking around me, demanding of me with the drooling menace of its expectant teeth that I make up my mind at last, that I become Stalinist or Hitlerite. No! No! No! and a thousand times no! I was going to continue to be as always and until I died, Dalinian and only Dalinian! I believed neither in the communist revolution nor in the national-socialist revolution, nor in any other kind of revolution. I believed only in the supreme reality of tradition ... If revolutions are interesting it is solely because in revolutionizing they disinter and recover fragments of the tradition that was believed dead because it had been forgotten, and that needed simply the spasm of revolutionary convulsions to make them emerge, so that they might live anew. And through the revolution of the Spanish Civil War there was going to be rediscovered nothing less than the authentic Catholic tradition peculiar to Spain ... All – atheists, believers, saints, criminals, grave-openers and grave-diggers, executioners and martyrs – all fought with the unique courage and pride of the crusaders of faith. For all were Spaniards."

His friend García Lorca was shot in his hometown of Granada, which was under occupation by Franco's forces. ("This was ignoble, for they knew as well as I that Lorca was by essence the most apolitical person on earth. Lorca did not die as a symbol of one or another political ideology, he died as the propitiatory victim of that total and integral phenomenon that was the revolutionary confusion.") Meanwhile, Dalí

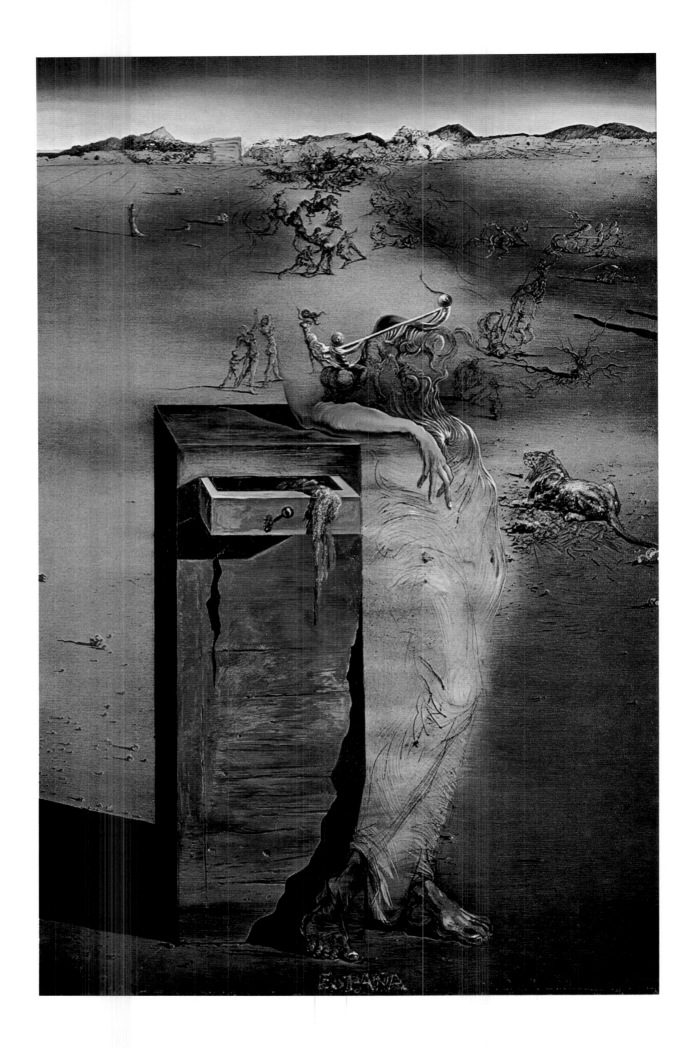

The Great Paranoiac, 1936
Le grand paranoïaque
Oil on canvas, 62 x 62 cm
Boymans-van-Beuningen Museum, Rotterdam
(formerly Edward James Collection)

OPPOSITE:
Spain, 1938
Espagne
Oil on canvas, 91.8 x 60.2 cm
Boymans-van-Beuningen Museum, Rotterdam
(formerly Edward James Collection)

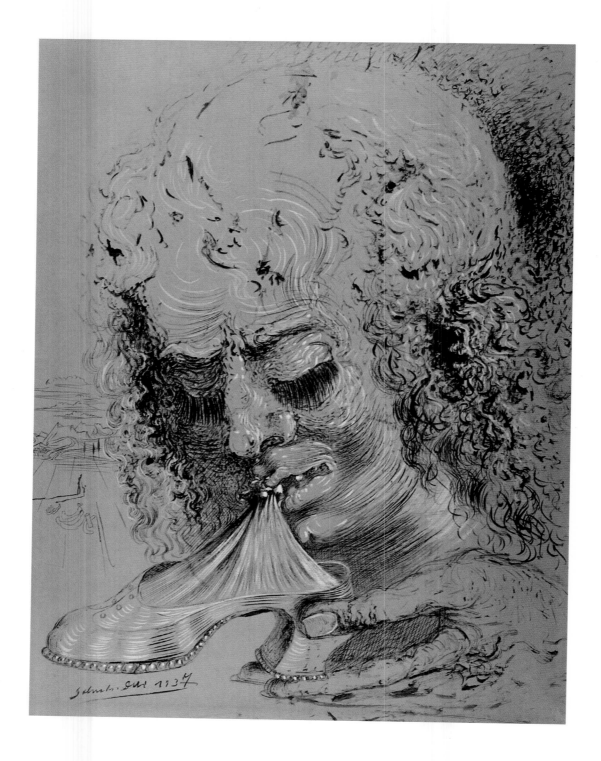

Cannibalism of the Objects, 1937
Cannibalisme des objets
Gouache and ink, 63.5 x 48.2 cm
Private collection (formerly Edward James
Collection)

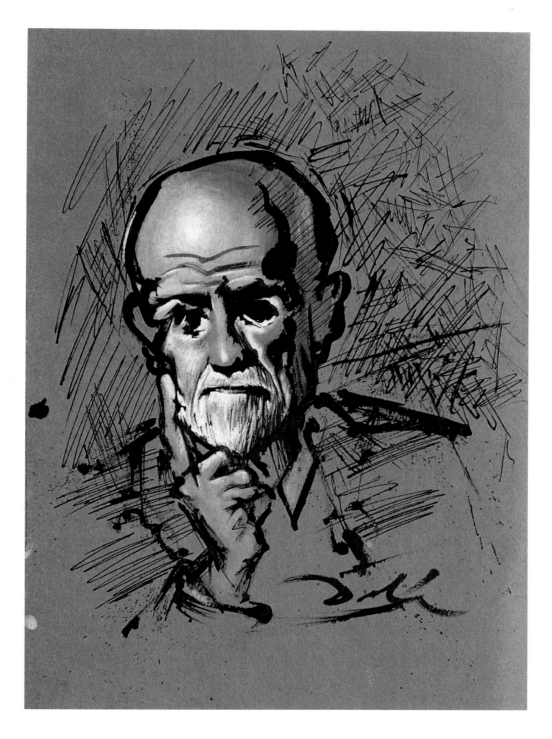

Portrait of Freud, 1937
Portrait de Freud
Drawing ink and gouache on grey background,
35 x 25 cm
Private collection

Andrea Palladio:
The "Scenae frons" of the Teatro Olimpico in Vicenza, c.1580

was studying the Renaissance. He planned to be the first advocate of the Renaissance after the war. "The disasters of war and revolution in which my country was plunged only intensified the wholly initial violence of my aesthetic passion, and while my country was interrogating death and destruction, I was interrogating that other sphinx, of the imminent European 'becoming,' that of the Renaissance." His attitude was interpreted as typical Dalí: superficial and frivolous. In fact, when anarchists shot three of his Port Lligat fisherman friends, Dalí wondered: "Would I finally have to make up my mind to return to Spain, and share the fate of those who were close to me?" It has to be admitted that, once he had slept on the question, Dalí decided that he *wouldn't* have to return.

In order to put the Spanish Civil War out of his mind, Dalí went on his travels. In 1938, a long-standing dream came true when he met Sigmund Freud. Stefan Zweig (who was to commit suicide shortly afterwards with his wife) made the meeting possible; in a letter to the world-famous founder of psychoanalysis, he wrote, "In my view Salvador Dalí …is the only *genius* among the painters of our time, and the only one who will survive it, a fanatic in his convictions and the most loyal, grateful pupil you have among artists."[99] Freud replied: "Really I am most grateful to you for the introduction that brought me yesterday's visitors. For until then I was inclined to think that the Surrealists, who appear to have taken me as their patron saint, were absolute (let us say 95 %, as with alcohol) fools. The young Spaniard with his innocent, fanatical eyes and his undeniable technical mastery has prompted me to assess this differently. It would indeed be extremely interesting to analyse the making of a picture of this kind. Critically speaking, one might still find that the concept of art resists extension if the quantitative proportion of unconscious material to pre-conscious treatment does not respect certain limits. But at all events, serious psychological problems."[100] What Dalí (who felt greatly flattered) remembered most clearly about this meeting was that Freud had paid him what he considered the finest of compliments when he said, "I have never seen a more complete example of a Spaniard. What a fanatic!"[101]

At this time, Dalí was designing material, dresses and hats – above all, cutlet hats, inkwell hats, shoe hats, skeleton dresses, dresses with drawers, and so forth – for Schiaparelli; a ballet (with costumes by Coco Chanel) for the Monte Carlo Ballet; and an opera, *Tristan Insane*, with music by Wagner. It was the time of the Munich agreement, and Dalí was also putting the finishing touches to *The Enigma of Hitler* (p. 113) and preparing his next exhibition in New York. He admitted that he did not yet know what the Hitler picture meant and that it was doubtless a transcription of dreams he had had after the Munich agreement. However, he said the painting "appeared to me to be charged with a prophetic value, as announcing the medieval period which was going to spread its shadow over Europe. Chamberlain's umbrella appeared in this painting in a sinister aspect, identified with the bat…"[102]

In New York Dalí was delighted to find that everyone was trying to imitate him. Bonwit-Teller, a department store, asked him to dress one of its windows, and gave him unqualified licence to design the display

Palladio's Corridor of Thalia, 1937
Le corridor Thalia de Palladio
Oil on canvas, 116 x 88,5 cm
Private collection, Geneva (formerly Edward James Collection)

From the catalogue of the Dalí-Exhibition in the Julien Levy Gallery, New York, 1939

precisely as he wished. Dalí went rummaging in a store and discovered some wax dummies dating from the turn of the century; they had long human hair taken from deceased persons and were terrible to behold. He planned to have one of the dummies getting into an astrakhan-lined bathtub filled to the brim with water. In its waxen hands it would be holding a mirror to symbolize the myth of Narcissus, and real narcissuses would be growing on the floor and furniture. Above a made bed there would be a buffalo's head with a bloody pig in its jaws; the buffalo's hooves would be the feet of the bed; in the black satin sheets there would be burn-holes at irregular intervals; everywhere there would be (artificial) glowing coals, even on the pillow beside the head of a wax dummy. Beside the bed stood the Phantom of Sleep, in the waxen sleeper's dream. Dalí titled the work *Day and Night*. He was convinced that it would catch the attention of passersby and would show for all to see what a true Dalí Surrealist vision was like. In this he was not mistaken.

When the display was installed, the crowds that gathered were so large that they impeded the traffic. The management hurriedly decided to remove the main features of the display. When Dalí saw his vandalized exhibit, he calmly climbed into the window and (attracting another crowd) tipped up the bathtub, which smashed the window, soaking the onlookers. Dalí climbed out through the hole in the window and was arrested. Gala and some friends hurried to the police station. "The judge who tried my case betrayed upon his severe features the amusement that my story afforded him. He ruled that my act was 'excessively violent' and that since I had broken a window I would have to pay for it, but he made a point of adding emphatically that every artist has a right to defend his 'work' to the limit."[103]

Once again, Dalí was the talk of the town. The following day, the press took his side, praising the blow he had struck "in independence of American art." He received a number of offers, among them an offer to design a pavilion for the World's Fair on the theme of 'The Dream of Venus.' Once again, however, his licence to work as he wished was not honoured. His instructions were not followed, and the organizers of the World's Fair refused to allow him to put a replica of Botticelli's Venus outside the pavilion, with a fish-head instead of her own; and in revenge Dalí published his *Declaration of the Independence of the Imagination and the Rights of Man to His Own Madness*. Dalí had now grasped that the Americans mainly wanted the use of his name for publicity purposes and were less interested in showing the fiendish fruits of his imagination to the public. Dalí's response was to demand the cheque before he would even talk to potential clients.

The publicity created by the smashed Bonwit-Teller window was well timed and helped launch his own solo exhibition, which opened at the Julien Levy Gallery on 21 March 1939. *Life* magazine reported his latest triumph: "No exhibition had been so popular since Whistler's *Arrangement in Black and Grey No. 1: The Artist's Mother* was shown in 1934. The crowd gaped open-mouthed at pictures with bewildering titles like *Wreck of an Automobile Giving Birth to a Blind Horse Chewing a Telephone* or *The One-eyed Idiot*. A fortnight later, Dalí, one of the

richest young painters in the world, had sold 21 of his works to private collectors for over $ 25,000. Two works remain to be sold: *The Enigma of Hitler* ($ 1,750) and *The Infinite Enigma* ($ 3,000)." And *The Art Digest* reported: "The Dalí exhibition was preceded by the usual publicity campaign, dreamt up in this case by the masters of publicity, Dalí and Levy, for New York's journalists and the broad gullible public . . . after he had smashed the store window, he stepped out through the hole onto the sidewalk and into the front pages of the daily papers . . ."

Dalí returned to Europe. In spite of his experiences in New York he was convinced that America was now the only country that enjoyed an unusual degree of liberty, "for where one may dialogue with open scissors in one's hand there is healthy flesh to cut and liberty for all sorts of famines. Unfortunately Europe, to which I was returning, was already exhausted with its masturbatory and sterile self-refinement."[104]

Impressions of Africa, 1938
Impressions d'Afrique
Oil on canvas, 91.5 x 117.5 cm
Boymans-van-Beuningen Museum, Rotterdam
(formerly Edward James Collection)

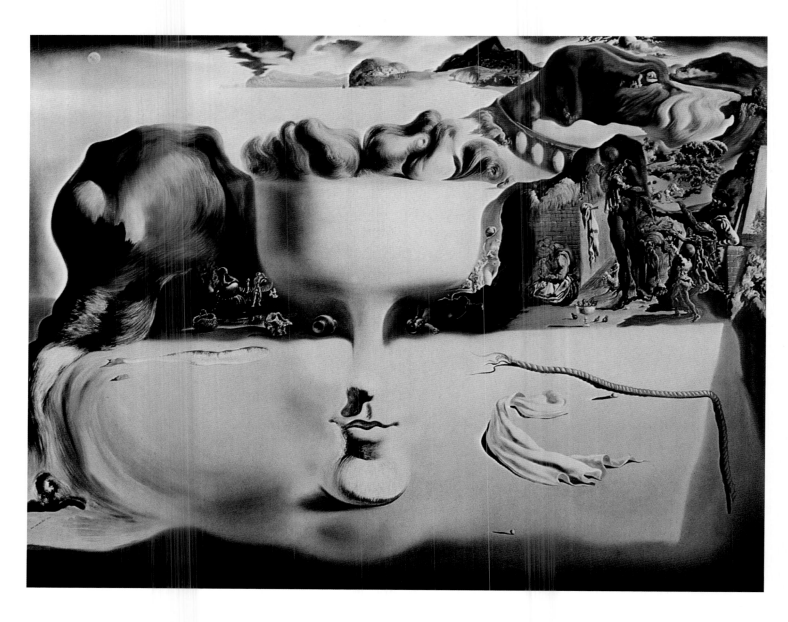

Apparation of Face and Fruit Dish on a Beach, 1938
Apparition d'un visage et d'un compotier sur une plage
Oil on canvas, 114.8 x 143.8 cm
The Ella Gallup Sumner and Mary Catlin
Sumner Collection, Hartford (Conn.)

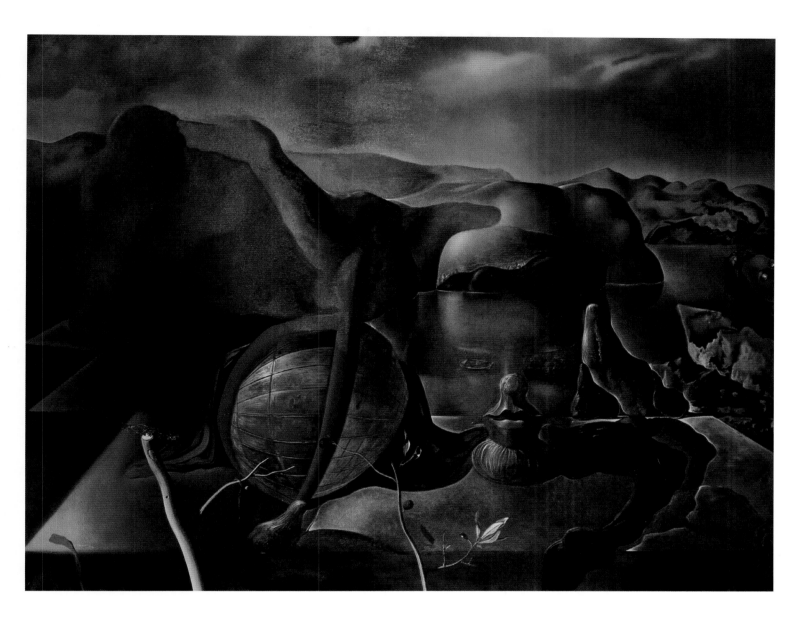

The Endless Enigma, 1938
L'énigme sans fin
Oil on canvas, 114.3 x 145 cm
Gift from Dalí to the Spanish state

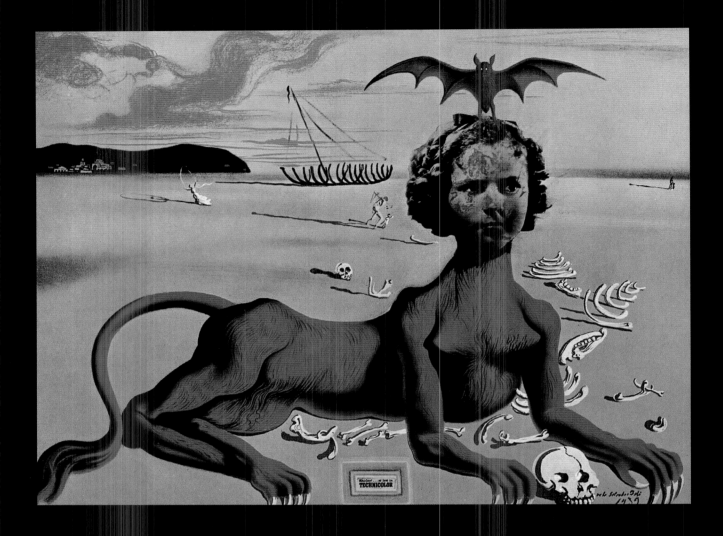

Shirley Temple, the Youngest Sacred Monster of
Contemporary Cinema, 1939
Shirley Temple, le plus jeune monstre sacré du
cinéma de son temps
Gouache, pastel and collage on card,
75 x 100 cm
Boymans-van-Beuningen Museum, Rotterdam

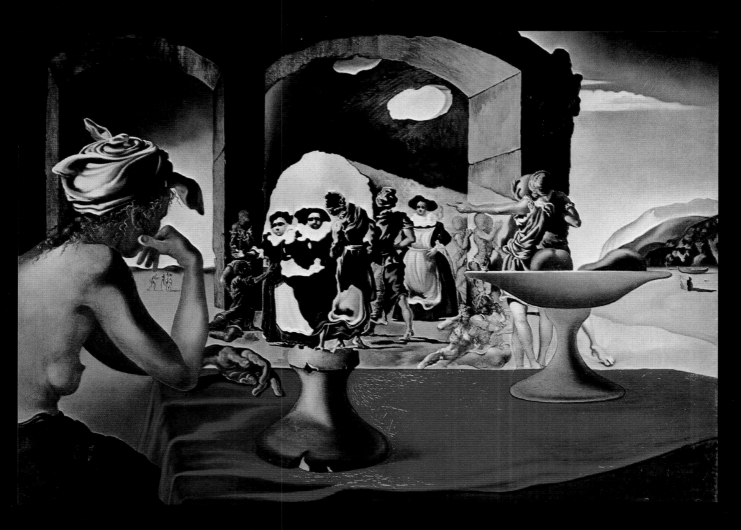

Slave Market with Invisible Bust of Voltaire, 1940
Marché d'esclaves avec apparition du buste
invisible de Voltaire
Oil on canvas, 46.5 x 65.5 cm
Collection of Mr. and Mrs. A. Reynolds
Morse, Loan to the Salvador Dalí Museum,
St. Petersburg (Fla.)

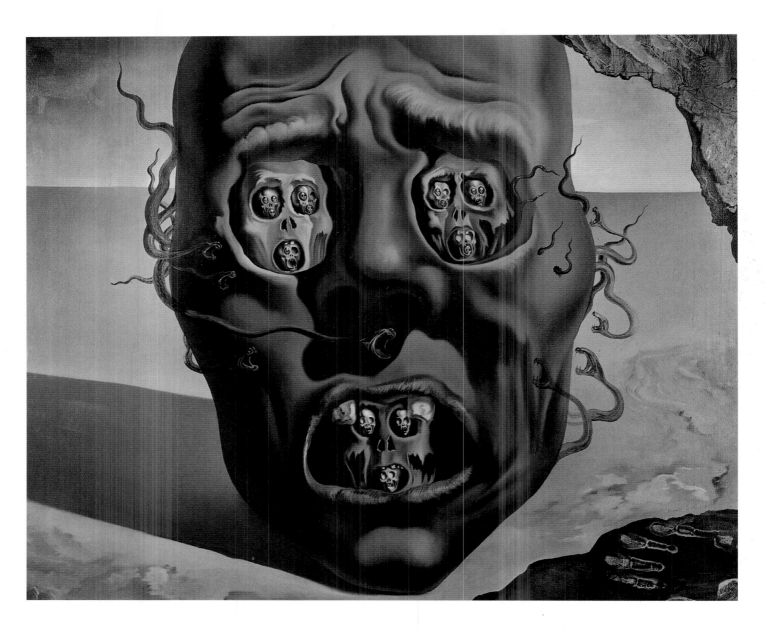

The Face of War, 1940
Visage de la guerre
Oil on canvas, 64 x 79 cm
Boymans-van-Beuningen Museum, Rotterdam

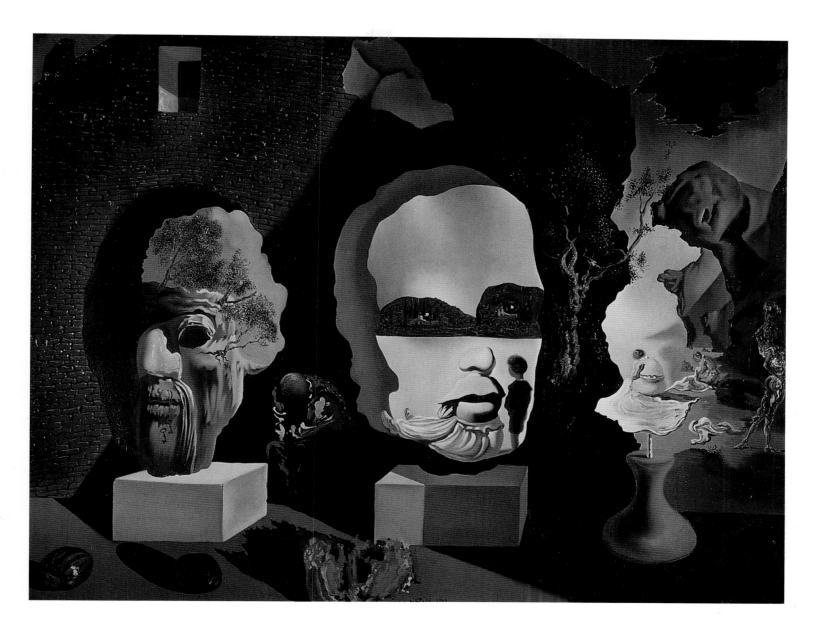

The Three Ages, 1940
Les trois âges
Oil on canvas, 50 x 65 cm
Collection of Mr. and Mrs. A.Reynolds Morse,
Loan to the Salvador Dalí Museum,
St. Petersburg (Fla.)

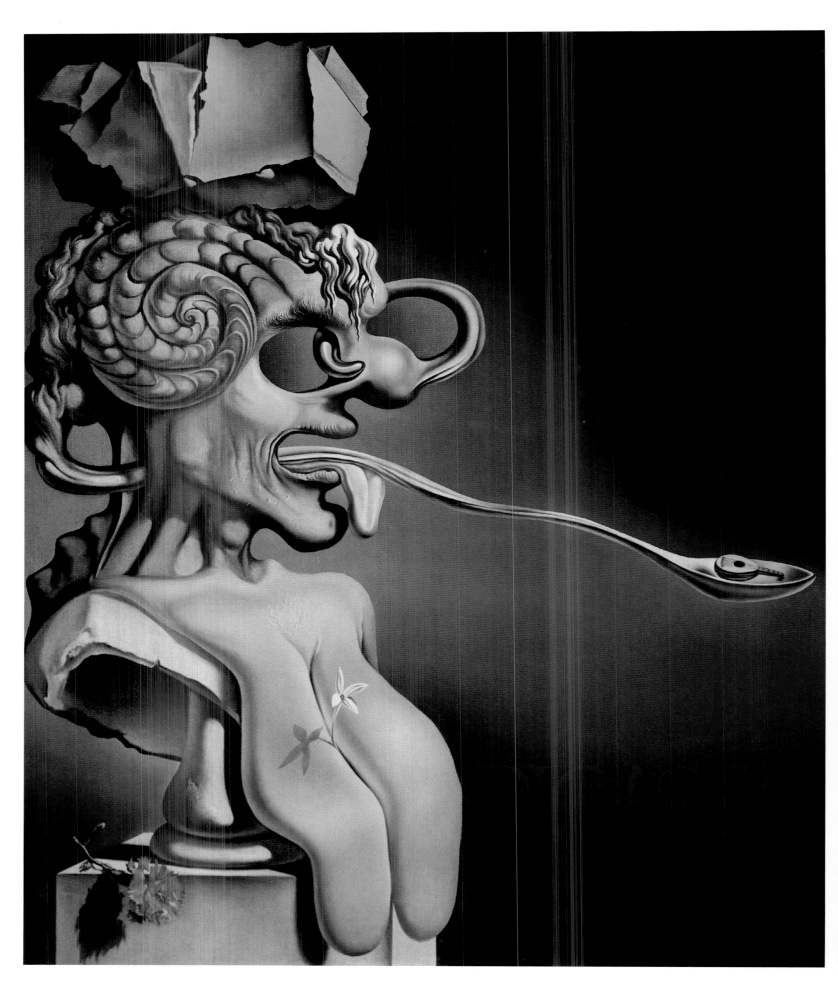

The Magic Secrets of Avida Dollars

The Second World War obliged Dalí to leave Europe. "I needed, in fact, immediately to get away from the blind and tumultuous collective jostlings of history, otherwise the antique and half-divine embryo of my originality would risk suffering injury and dying before birth in the degrading circumstances of a philosophic miscarriage occurring on the very sidewalks of anecdote. No, I am not of those who make children by halves. Ritual first and foremost! Already I am concerning myself with its future, with the sheets and the pillows of its cradle. I had to return to America to make fresh money for Gala, him and myself."[105]

At the border they met a great many friends again – among them Marcel Duchamp, who had established the concept of the ready-made. Dalí claimed: "He was terrorized by those bombardments of Paris that had never yet taken place. Duchamp is an even more anti-historic being than I; he continued to give himself over to his marvelous and hermetic life, the contact with whose inactivity was for me a paroxysmal stimulant for my work."[106]

They left Arcachon together, a few days before the Germans invaded, and travelled via Spain to Portugal. Dalí made the detour to Figueras and Port Lligat on the way, to see his family and examine the state the house was in after the Civil War.

In Lisbon they met a women who looked like Elsa Schiaparelli – and *was* Elsa Schiaparelli. They met a man who could have been René Clair – and *was* René Clair. And they happened upon an old man sitting on a bench who looked exactly like Paderewski – and who really *was* Paderewski. They sailed to New York aboard the *Excambión*. Eight years of American exile awaited them.

Once in the USA they accepted their friend Caresse Crosby's invitation to stay at Hampton Manor near Fredericksburg, Virginia. In her diary for 1934–1944, Anaïs Nin described their arrival and Gala's flair for taking charge from the outset: "They hadn't counted on Mrs. Dalí's talent for organization. Before anyone realized what was happening, the entire household was there for the sole purpose of making the Dalís happy. No one was allowed to set foot in the library because he wanted to work there. – Would Dudley be so kind and drive to Richmond to pick up something or other that Dalí needed for painting? Would she (Nin) mind translating an article for him? Was Caresse going to invite LIFE magazine for a visit? In other words, everyone performed the tasks assigned to

Anonymous after Acrimboldo, 17th century
Oil on panel, 45.6 x 34 cm
Tiroler Landesmuseum, Ferdinandeum,
Innsbruck

Portrait of Picasso, 1947
Portrait de Picasso
Oil on canvas, 64.1 x 54.7 cm
Fundación Gala-Salvador-Dalí, Figueras

them. All the while, Mrs. Dalí never raised her voice, never tried to seduce or flatter them: it was implicitly assumed that all were there to serve Dalí, the great, indisputable artist."[107]

Caresse Crosby reported that she was away for a few weeks, and left the Dalís at Hampton Manor in the company of Henry Miller, the novelist. She was far from surprised when she returned to find the painter going over *The Secret Life of Salvador Dalí*, the autobiography he had written there in July 1941, while Miller was busy painting watercolours.

Dalí's first exhibition, at the Julien Levy Gallery in 1941, produced a heavy crop of reviews. *The Art Digest*, a magazine Dalí did not particularly care for, wrote ironically: "Crazy Spaniard Salvador Dalí is on 57th Street again, arousing the curiosity of sensible people who warily wonder: 'Is Dalí mad, or is he a wily businessman?' In my view the question is not quite right, because to be a wily businessman these days you inevitably have to be practically mad... Dalí's secret consists in juxtaposing the most traditional of objects in the most incongruous of ways. A horse and a telephone are not especially exciting *per se*; but if the horse nonchalantly appropriates the telephone, it starts a reaction in the observer at chromosome level. Without his feverish imagination and unpredictable statements, Dalí would simply be one competent painter among many, with a fine command of draughtsmanship and a first-rate miniaturist's talent. That this artist can draw and paint is undeniable. Countless artists with every bit as much talent are dependent on the Works Progress Administration... Is Dalí mad? Statistically, the figures are against him: there are more of our kind than there are of his."

To which we might be tempted to add that that is cause for congratulation. The critic was palpably expressing American nationalist resentment at seeing the Surrealist pollen drifting over from Europe and fertilizing the American art scene. Other, less nationalist critics, such as Peyton Boswell, emphasized the overall significance of Dalí's work and did not hesitate to see him as a witness of his age: "...Dalí has succeeded better than any other artist in creating an expression of the age." It was an age of transition, in which received values were being questioned; and Dalí was subjecting it to close, intense scrutiny – the findings of which were visible on his canvases as on a radar screen. Dalí closed his autobiography with this statement: "And I want to be heard. I am the most representative incarnation of postwar Europe; I have lived all its adventures, all its experiments, all its dramas. As a protagonist of the Surrealist revolution I have known from day to day the slightest intellectual incidents and repercussions in the practical evolution of dialetical materialism and of the pseudo-philosophical doctrines based on the myths of blood and race of National-Socialism; I have long studied theology. And in each of the ideological short-cuts which my brain had to take so as always to be the first I have had to pay dear, with the black coin of my sweat and passion." Somewhat more modestly, he added a comment that is extremely revealing: "Heaven is what I have been seeking all along and through the density of confused and demoniac flesh of my life – heaven! Alas for him who has not yet understood that! The first time I saw a woman's depilated armpit I was seeking heaven. When with my crutch I stirred the putrefied and

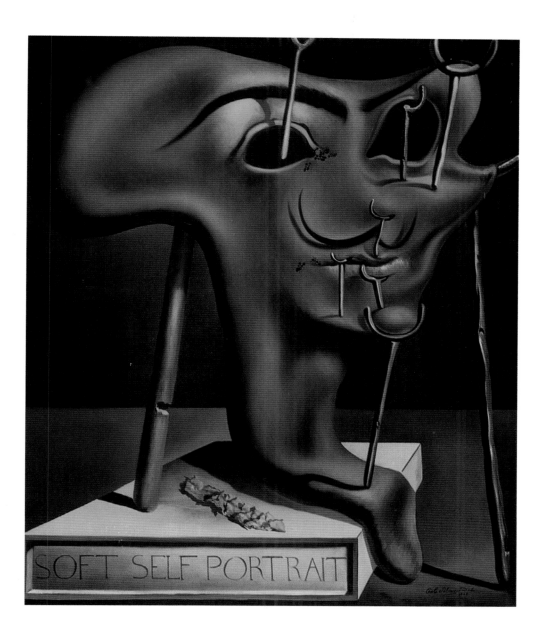

Soft Self Portrait with Fried Bacon, 1941
Autoportrait mou avec lard grillé
Oil on canvas, 61.3 x 50.8 cm
Fundación Gala-Salvador-Dalí, Figueras

worm-eaten mass of my dead hedgehog, it was heaven I was seeking. When from the summit of the Muli de la Torre I looked far down into the black emptiness, I was also and still seeking heaven! Gala, you are reality! And what is heaven? Where is it to be found? 'Heaven is to be found, neither above nor below, neither to the right nor to the left, heaven is to be found exactly in the centre of the bosom of the man who has faith! At this moment I do not yet have faith, and I fear I shall die without heaven.'[108]

In October Dalí went to New York to work on *Labyrinth*, a ballet (cf. p. 138). His libretto was inspired by the myth of Theseus and Ariadne; he also designed the set and costumes. His choreographer was another exile, Léonide Massine. The ballet was premièred in the Metropolitan Opera. Immediately afterwards, Dalí was accorded the official recognition of a retrospective show mounted by the Museum of Modern Art (together with a homage to his fellow-countryman Miró). The exhibition included over forty drawings and paintings by Dalí, from work done in his youth to the very latest products of his imagination. It afforded a fairly complete overview of his development – from Cubism to Surrealism to

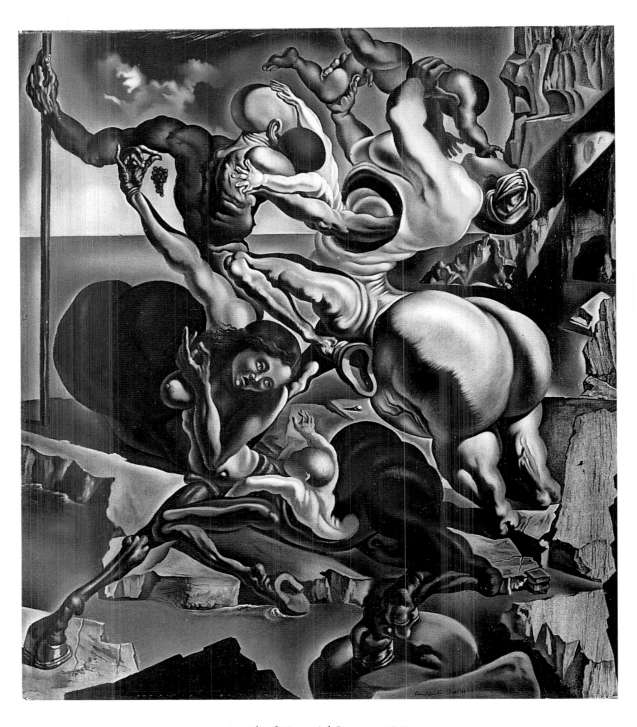

Family of Marsupial Centaurs, 1940
Familie de centaures marsupiaux
Ink and pencil, Dimensions unknown
Private collection

Melancholy, 1942
Mélancolie
Oil on canvas, 80 x 60 cm
Private collection

Philippe Halsman:
Dalí in an Egg, 1942

Dalí met the photographer in 1941 and worked
with him until Halsman's death in 1979.

drawers and telephones. The exhibition travelled to Los Angeles,
Chicago, Cleveland, Palm Beach, San Francisco, Cincinnati, Pittsburgh
and Santa Barbara, making Dalí a household name from coast to coast.

Dalí was now making a great deal of money. American vitality was
good for him – nourishing, as it were. And he was getting more and more
commercial commissions. He did not take up all the offers, but he was
well aware that these subsidiary activities represented a good way of
getting to know (and taking advantage of) the unlimited opportunities
offered by the country of his exile. It was at this time that Breton quite
rightly thought up his famous anagram, Avida Dollars. Dalí thought it
"auspicious." His break with the Surrealists was now complete. In the
New York magazine *View* (June 1941), Nicolas Calas raged: "I accept the
challenge and reply without hesitation: 'Yes, Dalí is a renegade!' ... He
claims the age of experiment is over, and tells us the rose is a prison and the
prisoner is none other than himself! As for the rose, we admire its
perfection without wondering if it is happy to be a palace of perfumed
songs or a dagger thrust into a woman's breast. The reason for Dalí's
change is quite different: when he was confronted with results (as happens
to us all) and found they were the total opposite of what his experience
had prepared him for, Dalí was terrified, felt guilty, and hastily withdrew
to aesthetic positions intended to please the leaders of the triumphant
counter-revolution while he still could ... The captive of his own errors,
no longer capable of distinguishing what is modern in science and aesthet-
ics from what is not, Dalí is like a naïve girl from the country who thinks
herself stylish if she puts a new ribbon on her grandmother's hat."

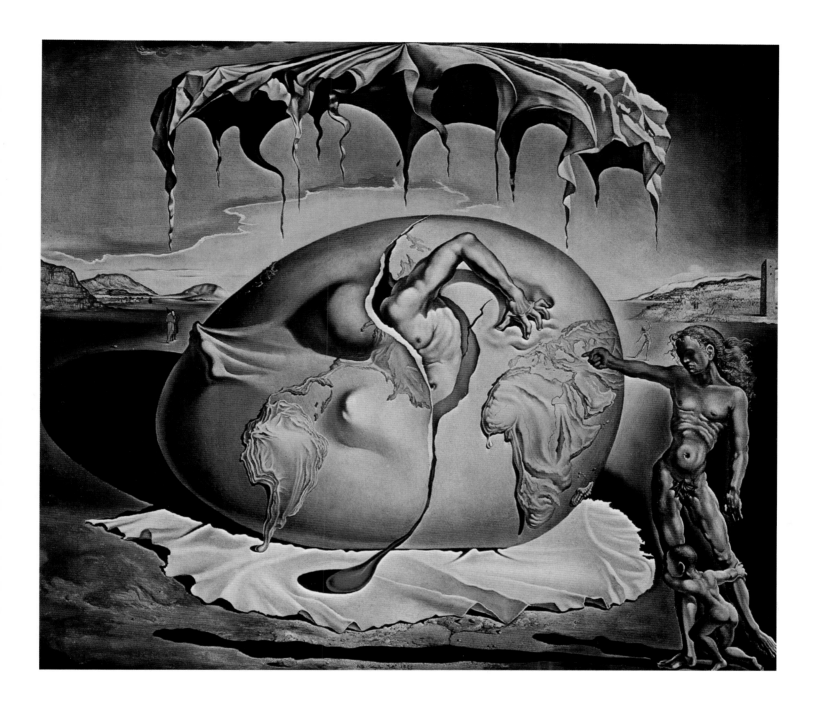

Dalí had indeed said, "Over and done with: the time for experiments is over, a thousand times over. The hour of personal creation has struck." But he paid no attention to the criticism levelled at him. He was far too busy. His years in America were years of hectic activity. He designed jewellery with the Duc de Verdura. He designed Helena Rubinstein's apartment. He did regular work for leading magazines such as *Vogue, Harper's Bazaar, Town and Country.* He produced new ballets, designing the sets and costumes himself; among them were Lorca's *El Café de Chinitas, Colloque sentimental* (based on Paul Verlaine), and *Tristan Insane.* He illustrated Maurice Sandoz's *Fantastic Memories.* In the space of a few weeks he wrote his first novel, *Hidden Faces* at the home of the Marquis de Cuevas in New Hampshire. In 1943 he created the advertising for Schiaparelli's perfume 'Shocking,' and advertised himself with a photo feature in *Click* magazine. He exhibited portraits of prominent Ameri-

Geopolitical Child Watching the Birth of the New Man, 1943
Enfant géopolitique observant la naissance de l'homme nouveau
Oil on canvas, 45.5 x 50 cm
Collection of Mr. and Mrs. A. Reynolds Morse, Loan to the Salvador Dalí Museum, St. Petersburg (Fla.)

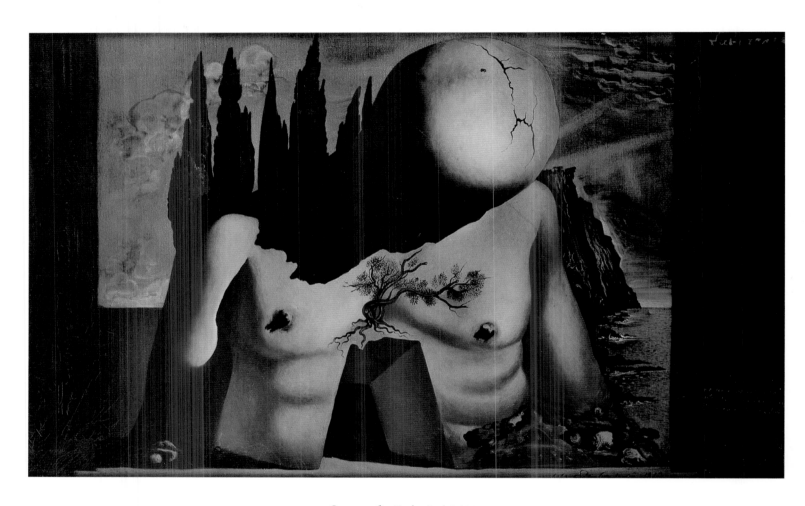

Stage set for 'Labyrinth,' 1941
Décor pour 'Labyrinth'
Oil on canvas, 39 x 64 cm
Private collection, Spain

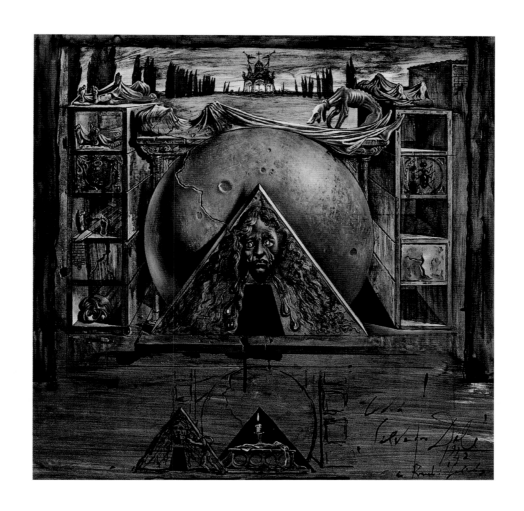

The tomb of Juliet, 1942
Le tombeau de Juliette
Oil on canvas, 50.7 x 50.7 cm
Private collection

cans at the Knoedler Gallery, New York, and even gave a dinner in aid of needy émigré artists. These activities (which do not necessarily appear here in chronological order) give some idea of Dalí's feverish activity during the war years.

1946 found Dalí in Hollywood, working with Walt Disney on a film project called *Destino*, which was unfortunately never to be completed. It was intended to use cartoon characters, settings and objects alongside real ones (an idea which has since proved fruitful for other directors), and the story involved a young girl and Chronos, God of Time. It was like a ballet: the young girl and the ancient god brought monsters into the world, monsters that drowned in primeval waters at the end of the film. When Dalí realised that the project was coming to nothing, he accepted another commission and designed the dream sequence in Alfred Hitchcock's *Spellbound*.

About this time, Dalí met the photographer Philippe Halsman; a friendship resulted that was to last until Halsman's death in 1979. At their first meeting, Halsman asked: "Dalí, you wrote that you can remember life inside the womb. I would like to photograph you as an embryo inside an egg." To which Dalí replied: "A good idea. But I should have to be completely naked." Halsman: "Of course. Would you care to undress?" Dalí: "No, not today . . . next Saturday." Countless photographs resulted from this exchange (cf. p. 136). Dalí would ask: "Can you make me look like la Gioconda? Can you do a portrait photo that makes half of me look like myself and the other half like Picasso?" And Halsman would always find a way of achieving the desired effect. Halsman gave his own explanation of Dalí's fascination with these photographs: "The real reason for Dalí's photographic eccentricity is that it is Surrealism taken to the extreme. He would like the least of his actions to be a surprise, a shock. His Surrealist creativity is only partially expressed in his paintings. His own personality is the most Surreal of his creations – and it extends into his handwriting, which is more Surreal than any of his pictures."

From then on, however, Dalí took to speaking less of the conquest of the irrational and more of the conquest of reality. In *Esquire* (August 1942) he published an article titled 'Total Camouflage for Total War,' in which he defined the essence of the Dalí method of bewildering the public and creating an absolute magic: "I believe in magic, which ultimately consists quite simply in the ability to render imagination in the concrete terms of reality. Our over-mechanized age underestimates what the irrational imagination – which appears to be impractical, but is nonetheless fundamental to all these discoveries – is capable of . . . In the realm of the real, the struggles of production are now decisive and will be in the foreseeable future. But magic still plays a part in our world."

In the pictures he painted in America, his use of colour, space, and often landscape, too, still harked back to Catalonia, even if the people in them were American. Dalí had the audacity to paint a Coca Cola bottle before anyone else, drew attention to race problems in the USA, and poked fun at the cult of American football. All these subjects appeared in a single painting. *The Poetry of America* (p. 2) – a title to which he added the words *The Cosmic Athletes* shortly before he died.

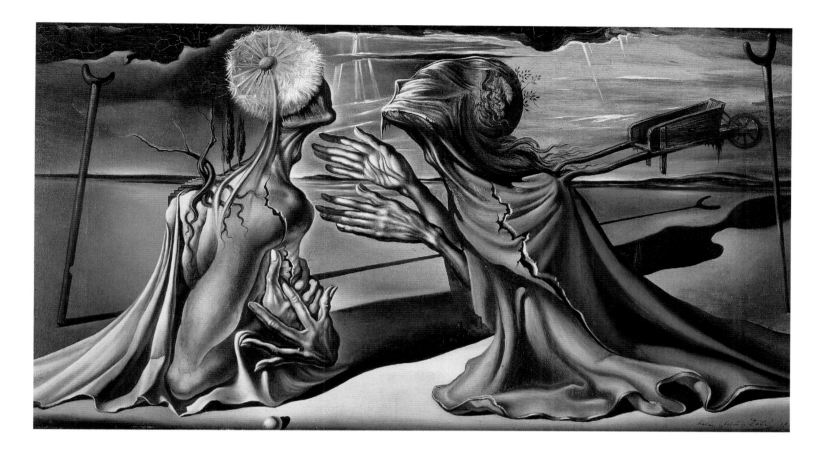

His method was now practically the reverse of what it had been. He defined his famous *Soft Self Portrait with Fried Bacon* (p. 133), for instance, as "an anti-psychological self portrait; instead of painting the soul, that is to say, what is within, I painted the exterior, the shell, the glove of myself. This glove of myself is edible and even tastes a little rank, like hung game; for that reason there are ants and a rasher of fried bacon in the picture. Being the most generous of all artists, I am forever offering myself up to be eaten, and thus afford delicious sustenance to the age."

Sigmund Freud is always present in Dalí's work, even if a religious note is increasingly struck from this time on. Dalí's comment on *Dream Caused by the Flight of a Bee around a Pomegranate, a Second before Waking Up* (p. 145) was: "For the first time, Freud's discovery that a typical narrative dream is prompted by something that wakes us was illustrated in a picture. If a bar falls on a sleeper's neck, it both wakes him and prompts a long dream that ends with the falling of the guillotine; similarly, the buzzing of the bee in the painting prompts the bayonet prick that wakens Gala. The burst pomegranate gives birth to the entirety of biological creation. Bernini's elephant in the background bears an obelisk with the papal insignia."

The dropping of the first atom bomb on Hiroshima, on 6 August 1945, deeply shocked Dalí. He expressed his response in works such as *Melancholy Atomic and Uranium Idyll* (pp. 152–3), *The Apotheosis of Homer* (pp. 142–3) and *The Three Sphynxes of Bikini*. These paintings introduced a new technique which he called "nuclear" or "atomic painting." The technique peaked in a masterpiece he completed in 1949, *Leda Atomica* (p. 156).

Tristan and Isolde, 1944
Tristan et Iseult
Oil on canvas, 26.7 x 48.3 cm
Fundación Gala-Salvador-Dalí, Figueras

PAGES 142/143:
The Apotheosis of Homer, 1944–45
L'apothéose d'Homère
Oil on canvas, 63 x 116.7 cm
Staatsgalerie Moderner Kunst, Munich

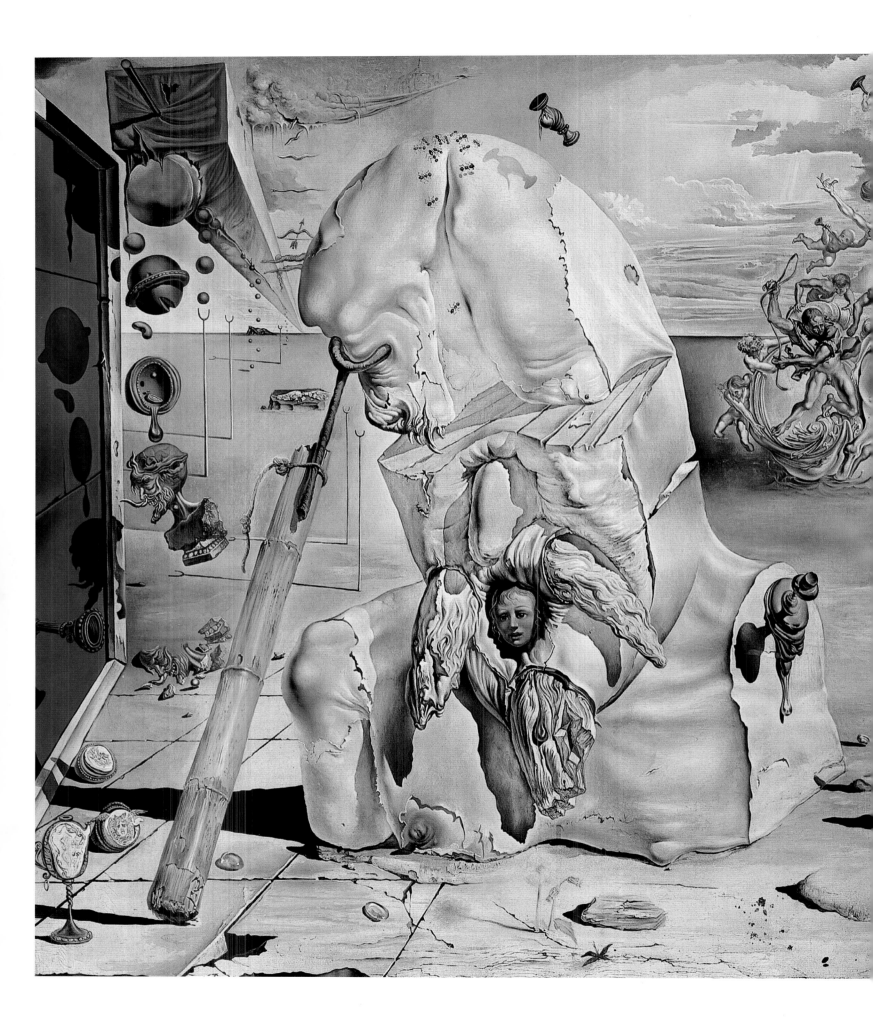

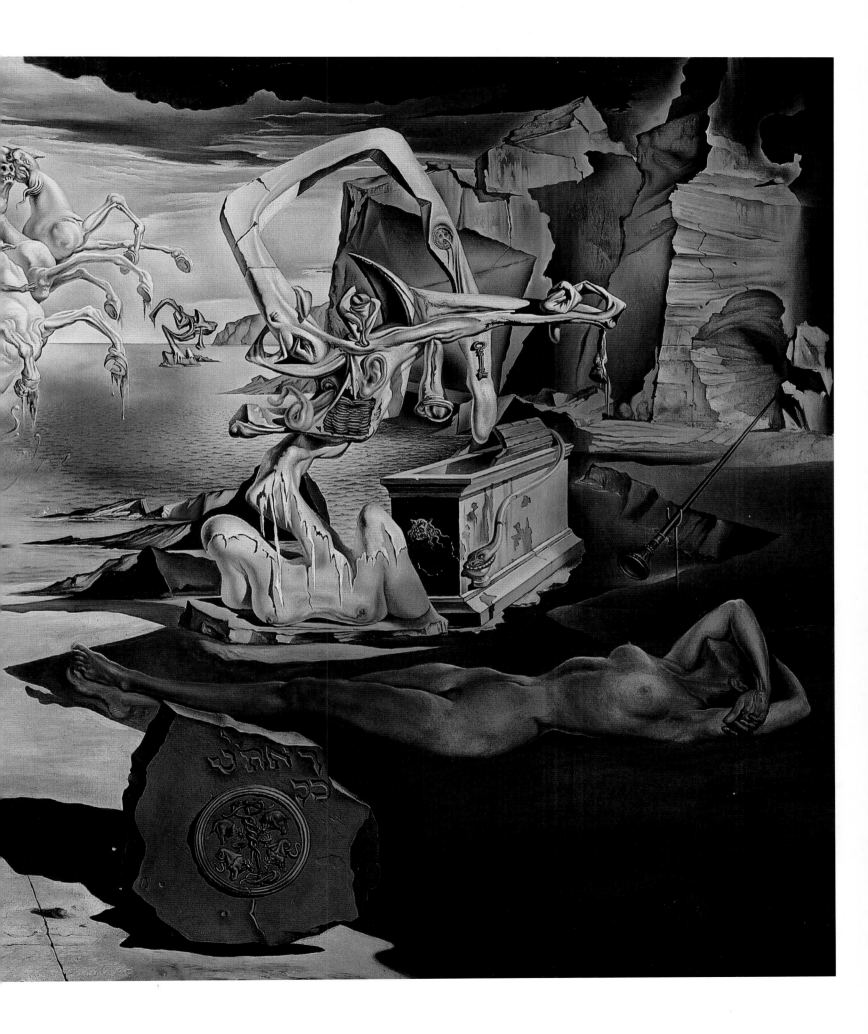

Three Faces of Gala appearing among the Rocks, 1945
Trois visages de Gala apparaissant sur des rochers
Oil on panel, 20.5 x 27.5 cm
Fundación Gala-Salvador-Dalí, Figueras

OPPOSITE:
Dream Caused by the Flight of a Bee around a
Pomegranate, a Second before Waking Up,
1944
Rêve causé par le vol d'une abeille autour d'une
pomme-grenade,une seconde avant l'éveil
Oil on canvas, 51 x 40.5 cm
Thyssen-Bornemisza Collection,
Lugano-Castagnola

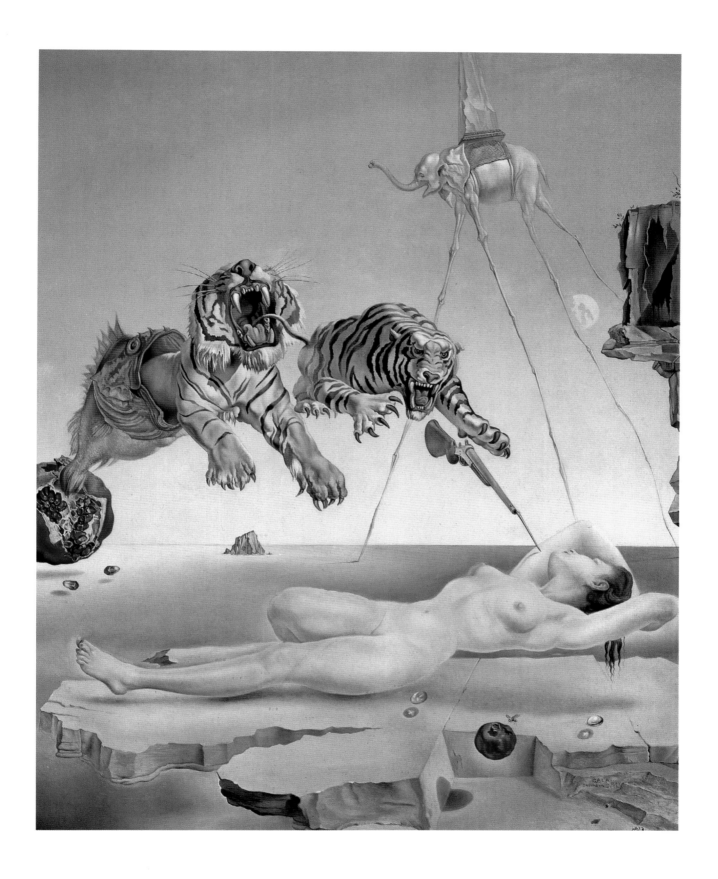

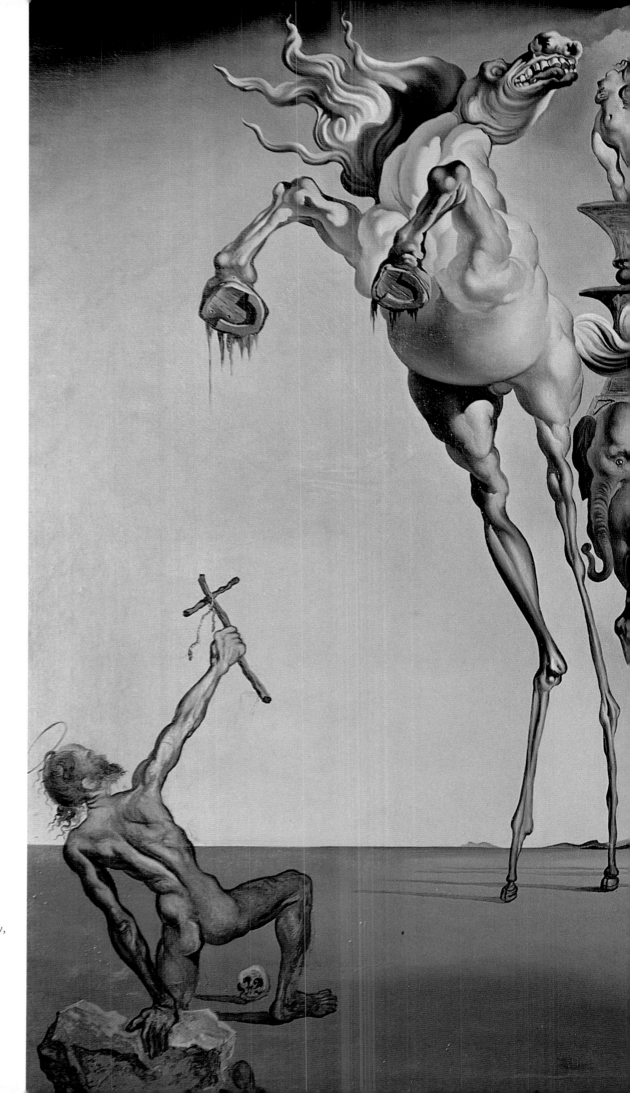

The Temptation of Saint Anthony,
1946
La tentation de Saint Antoine
Oil on canvas, 89.7 x 119.5 cm
Musées Royaux des Beaux-Arts
de Belgique, Brussels

My Wife, Naked, Looking at her own Body,
which is Transformed into Steps, Three Vertebrae
of a Column, Sky and Architecture, 1945
Ma femme, nue, regardant son propre corps
devenir marches, trois vertèbres d'une colonne,
ciel et architecture
Oil on panel, 61 x 52 cm
Private collection, New York

Galarina, 1944–45
Galarina
Oil on canvas, 64.1 x 50.2 cm
Fundación Gala-Salvador-Dalí, Figueras

Detail from:
The Sick Child, c. 1923
(p. 6)

Detail from:
Soft Construction with Boiled Beans, 1936
(p. 109)

Detail from:
Tristan and Isolde, 1944
(p. 141)

Detail from:
Galarina, 1944–45
(p. 149)

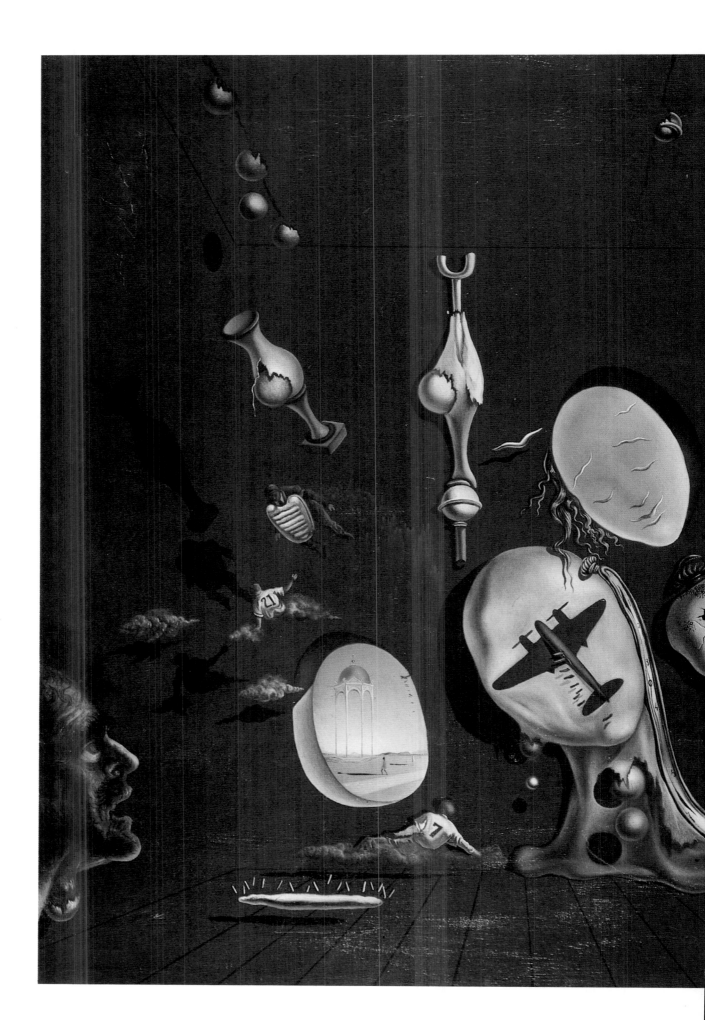

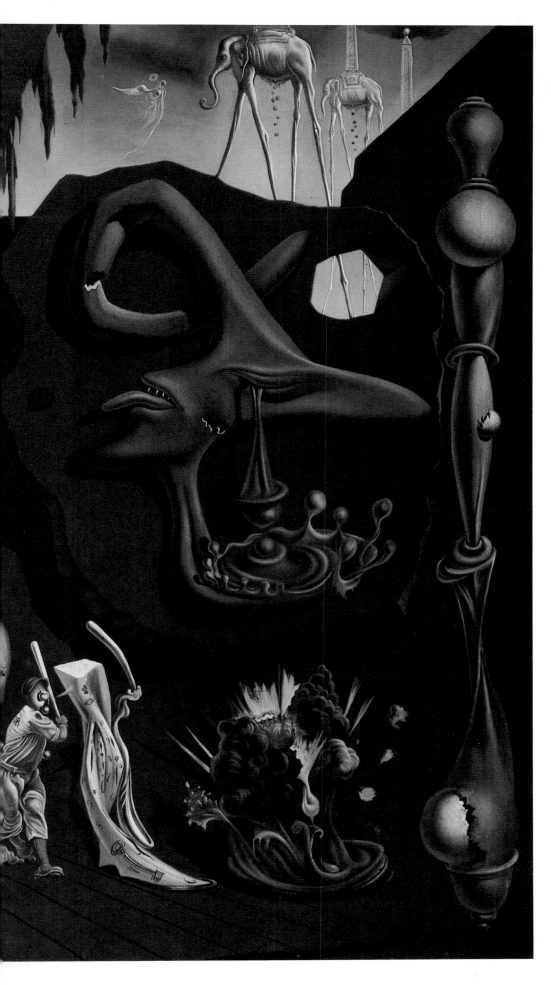

Atomica Melancholica, 1945
Idylle atomique et uranique mélancolique
Oil on canvas, 65 x 85 cm
Gift from Dalí to the Spanish state

153

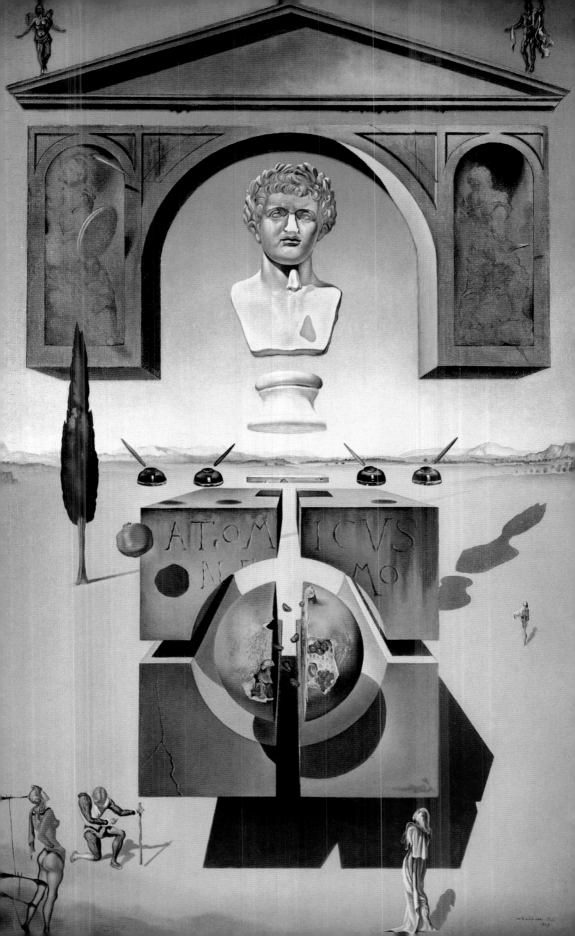

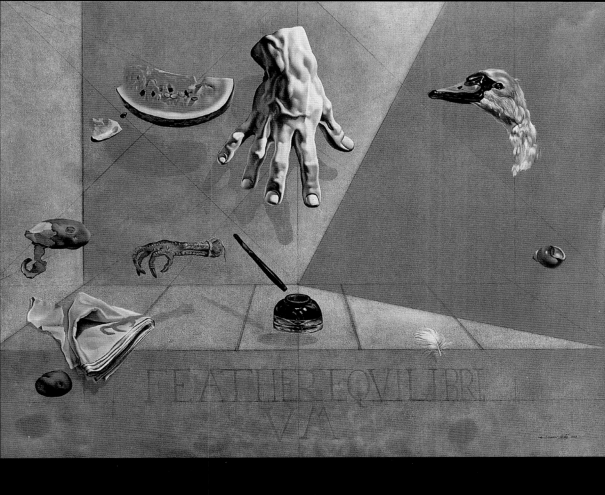

Intra-Atomic Equilibrium of a Swan's Feather, 1947
Equilibre intra-atomique d'une plume de cygne
Oil on canvas, 77.5 x 96.5 cm

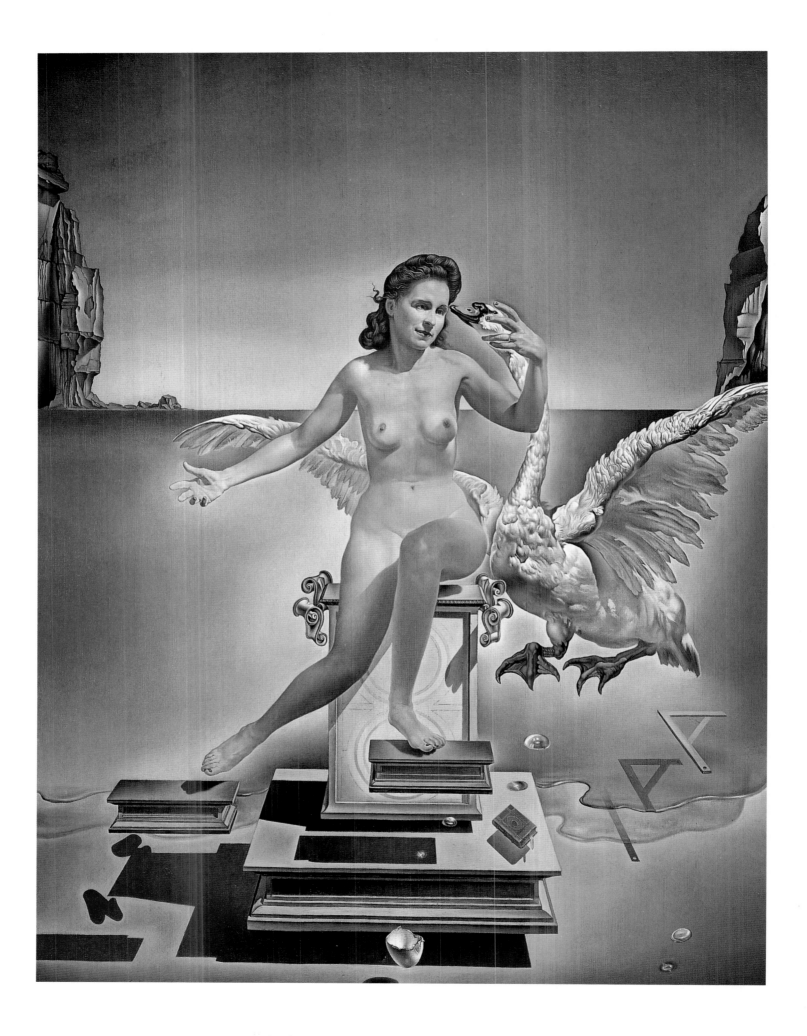

The Mystical Manifesto

For Dalí, the atom bomb was the start of a new era. He succumbed to mysticism – nuclear mysticism, as it were. The Hiroshima explosion coincided with his own classicist explosion. In its characteristically mischievous way, *Art News* commented: "The possibility cannot be ruled out that Dalí will be giving more attention to the conscious realm from now on than to the unconscious. If this does indeed prove the case, nothing need prevent him from becoming the greatest academic painter of the twentieth century." After the war, Dalí did not immediately return to Europe. The change from the psychoanalysis Dalí to the nuclear physics Dalí was making heavy demands on him.

In his *Mystical Manifesto* Dalí described the change that was occurring in him at that time: "Nothing more subversive can happen to an ex-Surrealist in 1951 than, firstly, to become mystical, and secondly, to be able to draw. I am experiencing both of these kinds of strength simultaneously. Catalonia has produced three great geniuses: Raymond de Sebonde, author of the *Théologie naturelle*, Gaudí, the creator of Mediterranean Gothic, and Salvador Dalí, inventor of the new paranoiac-critical mysticism and, as his Christian name suggests, the saviour of modern painting. The major crisis of Dalían mysticism basically derives from progress in the exact sciences in our age, especially the metaphysical spirituality of substantiality in quantum physics and – on the level of more insubstantial delusions – the horrendous gaping wounds and their co-efficients of monarchic viscosity in the whole of general morphology..."[109]

Dalí accounted for his conversion to mysticism as follows: "The explosion of the atom bomb on 6 August 1945 sent a seismic shock through me. Since then, the atom has been central to my thinking. Many of the scenes I have painted in this period express the immense fear that took hold of me when I heard of the explosion of the bomb. I used my paranoiac-critical method to analyse the world. I want to perceive and understand the hidden powers and laws of things, in order to have them in my power. A brilliant inspiration shows me that I have an unusual weapon at my disposal to help me penetrate to the core of reality: mysticism – that is to say, the profound intuitive knowledge of what is, direct communication with the all, absolute vision by the grace of Truth, by the grace of God. More powerful than cyclotrons and cybernetic calculators, I can penetrate to the mysteries of the real in a moment...

Detail from:
Intra-Atomic Equilibrium of a Swan's Feather, 1947
(p. 155)

Leda Atomica, 1949
Leda atomica
Oil on canvas, 61.1 x 45.3 cm
Teatro-Museo Dalí, Figueras

Piero della Francesca:
Madonna and Child, 1470–1475
Pinacoteca di Brera, Milan

Mine the ecstasy! I cry. The ecstasy of God and Man. Mine the perfection, the beauty, that I might gaze into its eyes! Death to academicism, to the bureaucratic rules of art, to decorative plagiarism, to the witless incoherence of African art! Mine, St. Teresa of Avila!... In this state of intense prophecy it became clear to me that means of pictorial expression achieved their greatest perfection and effectiveness in the Renaissance, and that the decadence of modern painting was a consequence of scepticism and lack of faith, the result of mechanistic materialism. By reviving Spanish mysticism I, Dalí, shall use my work to demonstrate the unity of the universe, by showing the spirituality of all substance."[110]

This avowal of mysticism was consistent enough as a product of Dalí's experience to date. And he was to be as good as his word; from that time on, until the end of his life, he applied mystical principles to his work. The paintings he would create in the years ahead often met with a mixed response; but among them are numerous masterpieces.

The second subversive force that filled the "ex-Surrealist" (who in fact remained more of a Surrealist than ever) was – by his own account – the ability to draw. Dalí discussed this in *Fifty Secrets of Magic Craftsmanship*,[111] which was a regular treatise on the art of painting and which he characteristically praised by saying: "Reading it, I really learnt to paint almost as well as Zurbarán." In the treatise he noted that people now knew how to make an atom bomb, but "no one knows what the mysterious juice was made of, the painting medium into which the brothers van Eyck or Vermeer van Delft dipped their brushes." He went on to provide his own recipes. First he dealt with questions of equipment: five different brushes to suit five different kinds of movement. Then he turned to optics, the binocular vision he was later to use (there was method in his supposed madness), and examined the astounding opportunities open to stereoscopic painting. Thanks to "much-despised sensory perception," he was able fully to adapt this way of seeing to his "system" of steered dreaming. One of his aphorisms declared: "When you are painting, always think of something else."

The advice was both mischievous and (how Dalí loved the hierarchical note!) authoritative. He then turned to the central, unique, dreamlike impulse of art, "to take oneself *ad absurdum* by hypnotically questioning one's own sense perception." He wrote of the "three eyes," which were fundamentally nothing but a re-statement of the theory of the third eye which is so common among visionaries everywhere. In his *Fifty Secrets of Magic Craftsmanship* Dalí advised young artists not merely to see, but "to see metaphysically." He also provided a host of technical hints which he had learnt through years of practice and by patient study of writing on art, among them Cennino Cennini's *Il Libro dell'Arte* (which had itself been inspired by the writings of a monk, Theophilus Presbyter). Cennini's work had been *the* treatise on the art of painting since the 14th century. Next came Luca Pacioli and the masters of the Italian Renaissance, whose secrets Dalí had rediscovered.

Having established the direction and preconditions of his current evolution, Dalí felt free to return to Europe at last. On 21 July 1948, he and Gala arrived at Le Havre. They immediately travelled on to Port

The Madonna of Port Lligat, 1950
La Madone de Port Lligat
Oil on canvas, 144 x 96 cm
Minami Museum, Tokyo

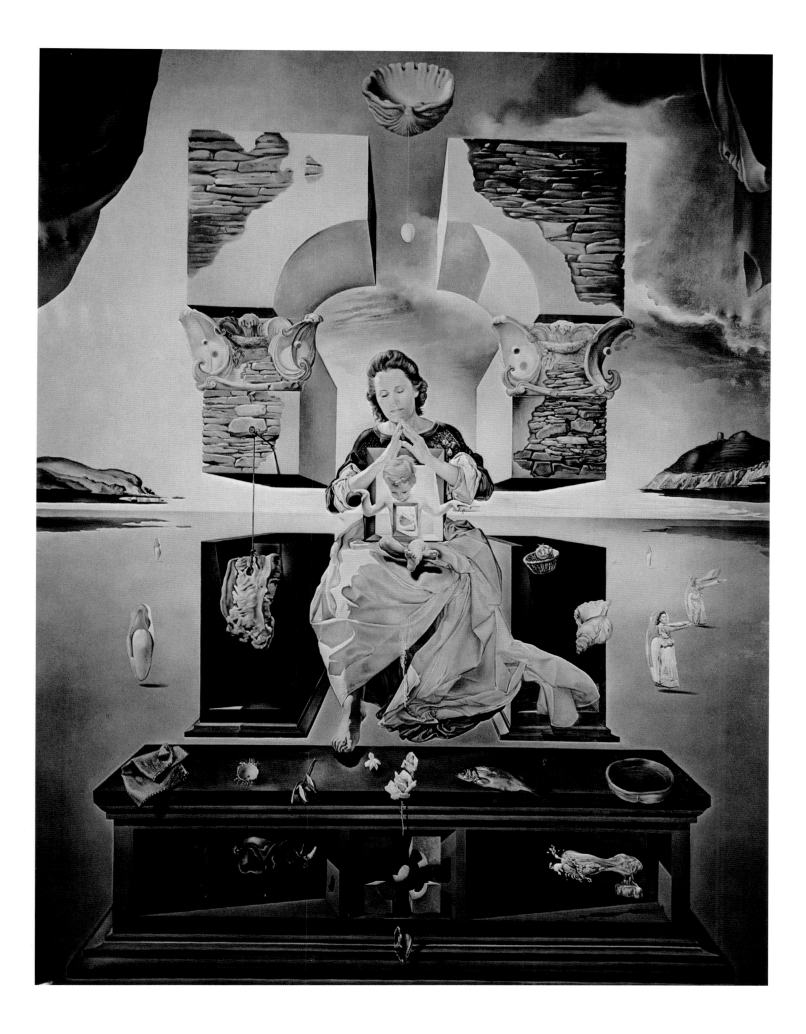

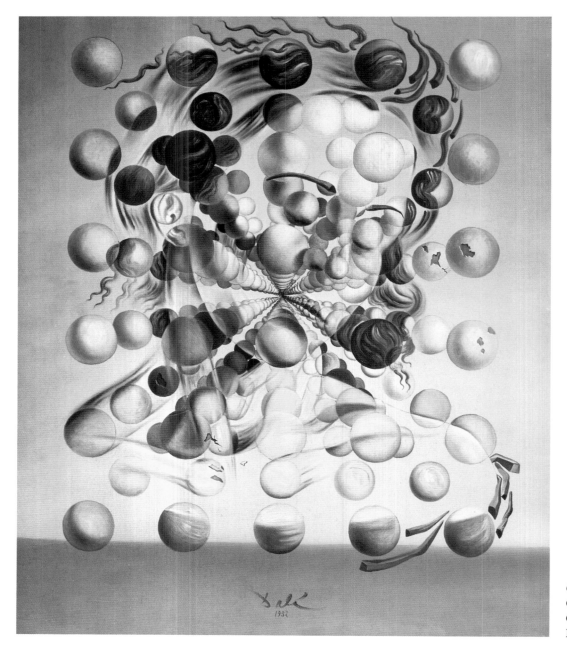

Galatea of the Spheres, 1952
Galatée aux spheres
Oil on canvas, 65 x 54 cm
Fundación Gala-Salvador-Dalí, Figueras

Lligat. There Dalí promptly set to work on two commissions he had accepted, designing the sets and costumes for Peter Brook's production of Richard Strauss's *Salome* and Lucino Visconti's of Shakespeare's *As You Like It*.

Above all, Dalí was itching to return to painting, and to establish the new Dalí approach as swiftly as possible. It was very important for him now to adopt his new religious themes; this was something that many of his critics who had no special interest in spiritual matters were unable to understand. He was obsessed with the absolute, and the classical iconography of Christianity afforded a means of exploring different artistic territory: the territory of the sacred. Great painters had always wanted to paint a crucifixion. Now the Madonna, Christ, the Last Supper and other central images were to grant him access to that heaven he was already seeking at the close of *The Secret Life of Salvador Dalí*.

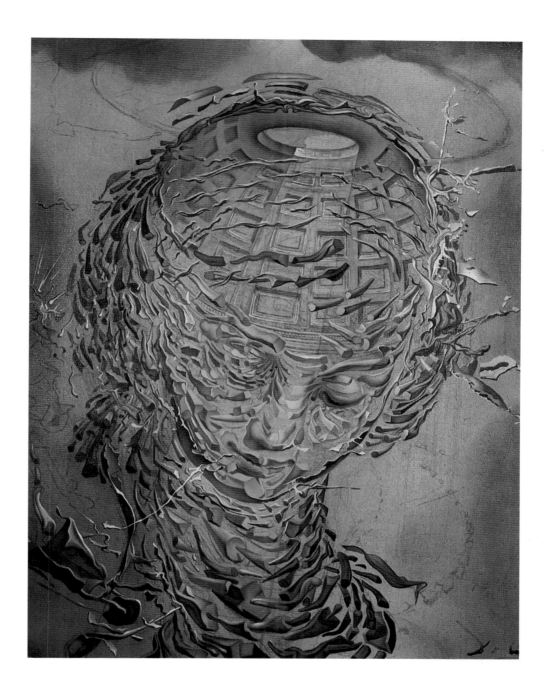

Raphaelesque Head Exploding, 1951
Tête raphaëlesque éclatée (explosant)
Oil on canvas, 43 x 33 cm
Scottish National Gallery, Edinburgh

While still in New York, Dalí had painted *The Temptation of Saint Anthony* (pp. 146–7). At that time he had extensive contacts in the film and theatre world. After working on Hitchcock's *Spellbound*, he decided to enter Albert Levin's competition for material for a film version of Guy de Maupassant's *Bel Ami*. Max Ernst won the competition, and his picture was the only colour shot in the entire black-and-white film; but even if Dalí's *Temptation of Saint Anthony* did not win, the picture is still of great significance in Dalí's work. It marks the point in his creative life when intermediates between heaven and earth become important – in this case, the elephants with their spindly legs. They anticipate the theme of levitation, which was subsequently to be fully developed in his "mystical-corpuscular" paintings. The temptation that confronts the saint takes various forms: a rearing horse, symbolic of power, but also (here) of the Fountain of Desire on its back, topped with a naked woman, another

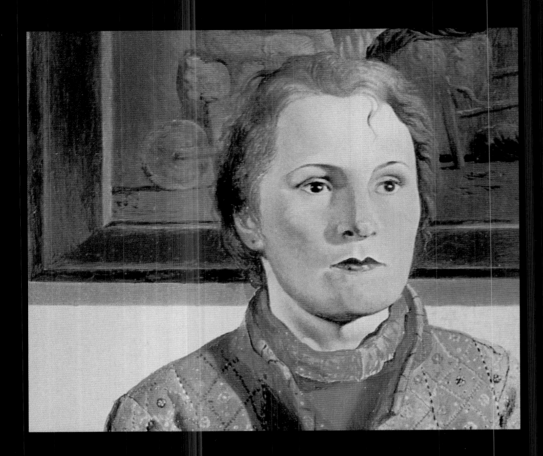

Detail from:
Angelus of Gala, 1935
(p. 81)

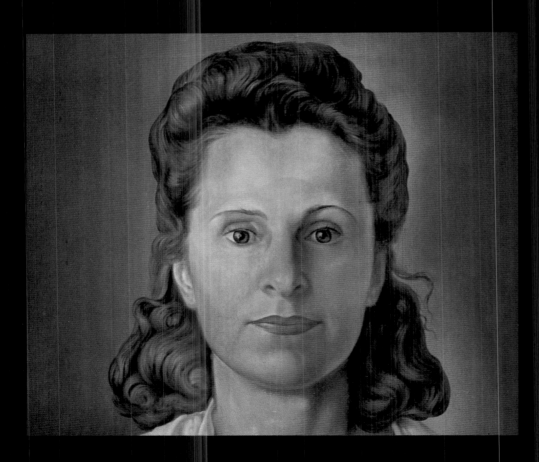

Detail from:
Galarina, 1944–45
(p. 149)

Detail from:
Leda Atomica, 1949
(p. 156)

Detail from:
*The Discovery of America by Christopher
Columbus, 1958–59*
(p. 182)

Drawing of Christ, attributed to St. John of the Cross
Avila, Spain

Christ of Saint John of the Cross, 1951
Christ de Saint-Jean-de-la-Croix
Oil on canvas, 205 x 116 cm
The Glasgow Art Gallery, Glasgow

bearing a Roman obelisk inspired by Bernini, the others with a building reminiscent of the Palladium and a phallic tower. In the distant clouds we glimpse parts of El Escorial, representing spiritual and temporal order.

Dalí decided that henceforth he would devote himself to his threefold synthesis of classicism, the spiritual, and concern with the nuclear age. "My ideas were ingenious and abundant. I decided to turn my attention to the pictorial solution of quantum theory, and invented quantum realism in order to master gravity... I painted *Leda Atomica*, a celebration of Gala, the goddess of my metaphysics, and succeeded in creating 'floating space;' and then *Dalí at the Age of Six, When He Believed He was a Girl Lifting the Skin of the Water to See a Sleeping Dog in the Shadow of the Sea* – a picture in which the personae and objects seem like foreign bodies in space. I visually dematerialized matter; then I spiritualized it in order to be able to create energy. The object is a living being, thanks to the energy that it contains and radiates, thanks to the density of the matter it consists of. Every one of my subjects is also a mineral with its place in the pulsebeat of the world, and a living piece of uranium. In my paintings I have succeeded in giving space substance. My *Cupola Consisting of Twisted Carts* is the most magnificent demonstration of my mystical way of seeing. I maintain with full conviction that heaven is located in the breast of the faithful. My mysticism is not only religious, but also nuclear and hallucinogenic. I discovered the selfsame truth in gold, in painting soft watches, and in my visions of the railway station at Perpignan. I believe in magic and in my fate."[112]

The first pictures in the new series were the two versions of *The Madonna of Port Lligat* (p. 159); he showed the smaller version to Pope Pius XII on 23 November 1949. Dalí also produced a hundred illustrations for Dante's *Divine Comedy*. A particularly fine product of his mystical, ecstatic approach was the well-known *Christ of Saint John of the Cross* (p. 165). The *Royal Heart* (p. 174), made of gold and rubies, is Dalí's arresting response to a remembered question his mother asked: "Dear heart, what do you want?"[113]

The new Dalí was derided – particularly by the Surrealists. In the new edition of his *Anthology of Black Humour*, Breton wrote: "It can be taken for granted that these remarks apply only to the early Dalí, who disappeared around 1935 and has been replaced by the personality who is better known by the name of Avida Dollars, a society portrait painter who recently returned to the bosom of the Catholic church and to the 'artistic ideal of the Renaissance,' and who nowadays quotes letters of congratulation and the approval of the Pope." On the other hand, there were others who took the new Dalí very seriously, and they included critics whose opinions carried weight. Father Bruno Froissart wrote: "Salvador Dalí has told me that nothing has as stimulating an effect on him as the idea of the angel. Dalí wanted to paint heaven, to penetrate the heavens in order to communicate with God. For him, God is an intangible idea, impossible to render in concrete terms. Dalí is of the opinion that He is perhaps the substance being sought by nuclear physics. He does not see God as cosmic; as he said to me, that would be limiting. He sees this as a thought process contradictory within itself, one which cannot be sum-

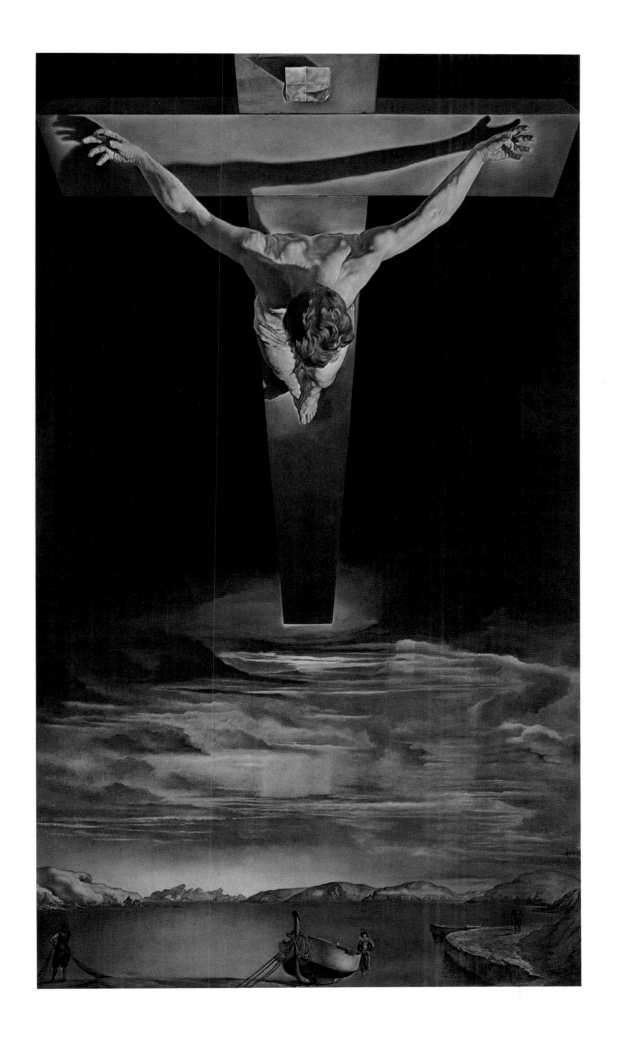

marized in a uniform concept of structure. At heart a Catalonian, Dalí needs tactile forms, and 'that applies to angels, too' ... If he has been preoccupied with the Assumption of the Virgin Mary for some time now, it is, as he explains, because she went to heaven 'by the power of the angels' ... Dalí conceives protons and neutrons as 'angelic elements;' for, as he puts it, in the heavenly bodies there are 'leftovers of substance, because certain beings strike me as being so close to angels, such as Raphael or St. John of the Cross.'"

Jean-Louis Ferrier wrote an entire book, *Leda atomica – Anatomie d'un chef-d'œuvre* about Dalí's painting *Leda Atomica* (p. 156). Ferrier compares it with other artists' treatments of the story of Leda: "Erotic 18th century engravings and graffiti provide a key to the myth of Leda; Zeus is metamorphosed into a phallus with wings, the better to seduce the wife of Tyndareus. This is the underlying meaning of the myth, and it is one that remains concealed throughout traditional art. But Dalí reverses this meaning in *Leda Atomica*. The myth now means the exact opposite; for the state of levitation in which we see the woman and the swan stands for purity and sublimation. Seen in this way, *Leda Atomica* introduces Dalí's religious period ... In Western art, down to Poussin and Moreau, the myth of Leda has always been represented without significant change. But in Moreau the swan, laying its head upon Leda's, occupies the place normally reserved for the Holy Ghost. Like Dalí, Moreau was seeing the myth of Leda in terms of initiation ritual and psychoanalysis." Ferrier hit the nail on the head: "The Dalí delirium will seem less of a delirium if we grasp that basically he is trying to introduce into everyday life the archetypes that constitute the true categories of thought – which Kant, writing a century and a half before psychoanalysis, could not know. Jung was a pioneer when he lamented the terrible lack of symbols in the world at that time ..." Ferrier ends by saying: "Salvador Dalí differs from most modern painters in his extraordinary virtuosity, which consists in a direct continuation of classical austerity. The artist's painstaking craftsmanship goes hand in hand with a polymorphous grasp of culture which includes traditional disciplines of knowledge as well as contemporary science and the findings of various types of psycholanalysis for nearly a century now. These things together are vital to the meaning of his art."

All of Dalí's works are strictly mathematical in conception. The floating state of the figures and objects in his paintings at this time related not only to the Golden Section and contemporary physics, but also to Dalí's spiritual development. Dalí, dualist as ever in his approach, was now claiming to be both an agnostic and a Roman Catholic.

Dalí attributed his twofold habits of perception to the death of his brother (before his own birth). His parents gave Dalí the same name as his dead brother, Salvador: "An unconscious crime, made the more serious by the fact that in my parents' room – a tempting, mysterious, awe-inspiring place to which access was prohibited and which I contemplated with divided feelings – a majestic photograph of my dead brother hung beside a reproduction of Velázquez's *Crucifixion*. And that picture of the Saviour, whom Salvador had doubtless followed on his angelic ascension to heaven, established an archetype within me that arose out of the four

Lapis-lazuli Corpuscular Assumption, 1952
Assumpta corpuscularia lapislazulina
Oil on canvas, 230 x 144 cm
Private collection

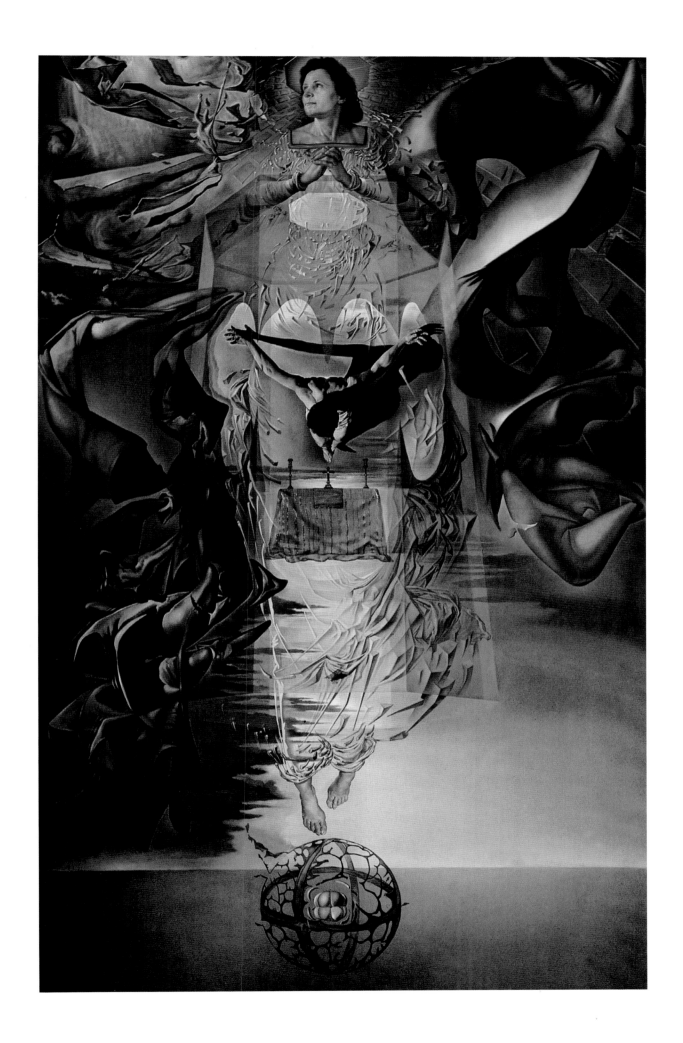

Salvadors who made a corpse of me – the more so, since I began to look as much like my dead brother as I looked like my reflection in the mirror. I thought myself dead before I became really aware that I was alive ... My preferred psychiatrist, Pierre Roumeguère, assures me that my forced identification with a dead person meant that my true image of my own body was of a decaying, rotting, soft, wormy corpse. And it is quite right that my earliest memories of true and powerful existence are connected with death ... My sexual obsessions are all linked to soft bulges: I dream of corpse-like shapes, elongated breasts, runny flesh – and crutches, which were soon to play the part of holy objects for me, were indispensable in my dreams and subsequently in my paintings, too. Crutches propped up my weak notion of reality, which was constantly escaping me through holes that I even cut in my nurse's back. The crutch is not only a support: the forked end is an indication of ambivalence."[115]

Thus the dualism or ambivalence that underpins so much of Dalí's life and work began with the death of his brother before his own birth; continued in the merging of Vermeer with the logarithmic, mathematically self-perpetuating spiral; and informed his love for Gala, his "legitimate, scented wife," his new *doppelgänger*, his muse, his Helen of Troy, his lace-maker, his "Nietzschean rhinoceros forever struggling for power." Dalí stated: "Gala gave me a structure that was lacking in my life, in the truest sense of the word. I existed solely in a sack full of holes, soft and blurred, always looking for a crutch. By squeezing up close to Gala, I acquired a backbone, and by loving her I filled out my own skin. My seed had always been lost in masturbation until then, thrown away into the void, as it were. With Gala I won it back and was given new life through it. At first I thought she was going to devour me, but in fact she taught me to eat reality. In signing my pictures 'Gala-Dalí' I was simply giving a name to an existential truth, for without my twin, Gala, I would not exist any more."[116]

For the creator of the *Soft Watches*, Dalí and Gala were the incarnations of the Dioscuri, the heavenly twins born of Leda's divine egg: "Castor and Pollux, the stereochemical divine twins," was how Dalí referred to the antecedents of himself and his "twin," Gala. And in acquiring a twin, he also "had two memories instead of one, perhaps even three, for the same price, which can only compound the immortality of memory." It is understandable enough that when one of the twins, Gala, died in 1982, the other felt abysmally lonely – the lace-maker without the rhinoceros ...

One of Dalí's best-known pictures is the *Christ of Saint John of the Cross* (p. 165). The figure appears above the bay at Port Lligat. Compositionally, the figure of Christ was inspired by a drawing St. John of the Cross had done while in ecstasy and which is in the keeping of the monastery at Avila. The figures beside the boat were borrowed from a picture by Le Nain and a drawing Velázquez did for his painting *The Surrender of Breda*. Dalí said: "It began in 1950 with a cosmic dream I had, in which I saw the picture in colour. In my dream it represented the nucleus of the atom. The nucleus later acquired a metaphysical meaning: I see the unity of the universe in it – Christ! Secondly, thanks to Father

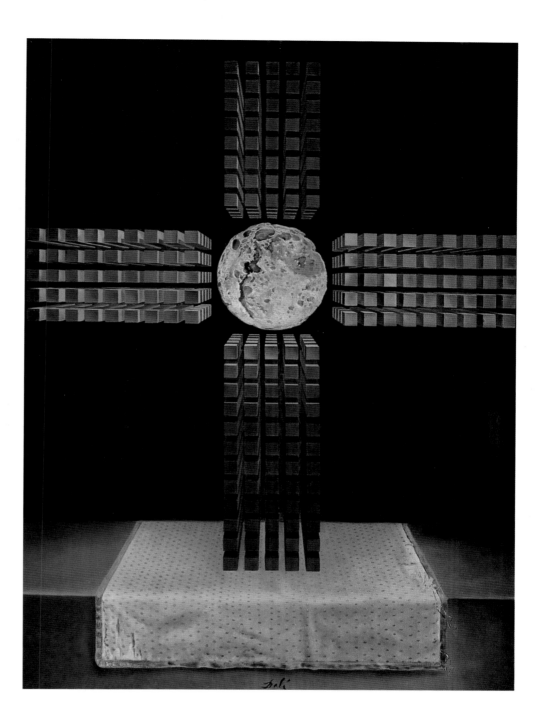

Nuclear Cross, 1952
Croix nucléaire
Oil on canvas, 78 x 58 cm
Private collection, Spain

Bruno, a Carmelite monk, I saw the figure of Christ drawn by St. John of the Cross; I devised a geometrical construct comprising a triangle and a circle, the aesthetic sum total of all my previous experience, and put my Christ inside the triangle." When the painting was first exhibited in London, an influential critic damned it as banal. And some years later it was badly damaged by a fanatic in the Glasgow Art Gallery.

None of this, needless to say, kept Dalí from attending to more profane matters. He relished Coco Chanel's declaration that her perfume was to be worn wherever one could be kissed, and Marilyn Monroe's reply, when asked what she wore in bed: "Chanel No. 5." Eroticism added a dimension to his mysticism: "Eroticism is the royal road of the spirit of God." He began to write a play, the *Tragédie érotique;* wrote a homage to the Marquis de Sade, *Les cent vingt journées de Sodome du*

divin marquis à l'envers; and he painted *Young Virgin Autosodomized by her Own Chasity* (p. 177). "Painting," he declared, "like love, goes in at the eyes and flows out by the hairs of the brush. My erotic delirium compels me to take my sodomitic tendencies to the heights of paroxysm." There was no stopping this Dalí... The man of God saw to it that he was surrounded by "the most delicious behinds one can imagine. I persuade the most beautiful of women to undress. I always say the greatest mysteries can be penetrated via the behind, and I have even discovered a profound correspondence between the buttocks of one of the women who visited me at Port Lligat and undressed for me and the space-time continuum, which I have named the continuum of the four buttocks (incidentally, this continuum is simply the representation of an atom). I think up the most delectable and insane of positions in order to maintain a paroxysmal erection, and I am totally happy if I can be present at a successful act of sodomy. For me, everything that matters happens via the eye. I managed to talk a young Spanish woman into allowing a neighbourhood youth who was courting her to sodomize her. Together with a girlfriend (the audience are important in my theatre, and play the role of accountants, so to speak), I sit on a divan. The woman and the youth enter by different doors: she is naked beneath a dressing gown, he is unclothed and his member erect. He immediately turns her round and sets about entering her. He does it so rapidly that I get up to check that he is not just pretending, since I don't want to be made a fool of. Then she shouts out ecstatically: 'This is for Dalí, for the divine Dalí!' I don't care for the expression, because I can see how ill-founded it is – particularly since this strong youth is passionately working away in the Spanish girl's behind and she is groaning with pleasure. I say: 'Do you admit that you love the man who's inside your arse?' She instantly stops play-acting and cries out: 'Yes, I worship him!' And then I saw the most astounding thing one can imagine as an expression of phenomenal beauty: the young woman, held firmly by the hips and impaled on the man, raised her arms and reached behind her, which also lifted her magnificant breasts. At the same time she turned her head back and her lips touched those of the man who was putting her through this exquisite torment. It was a perfect gesture in its way, and transformed the animal couple into a liana, conveying an angelic vision. I have never been able to tell this story without the wonderful feeling that I had revealed the secret of perfect beauty."[117]

Dalí confessed: "I spend considerable amounts on dinners, presents, dresses and entertainment to achieve my ends, to fascinate my protagonists and make them submissive to me. Sometimes the preliminaries take months, and I put together the pieces of my jigsaw with great care. I devise the most artful of perversions, I foist my weird notions on others, I talk people into doing the craziest things and they agree unconditionally."[118] And: "...my only problem is choice. I fish a vast pond in New York or Paris, where a hundred women of the world... are forever at the ready to obey my whims – not to mention the high-class professionals, whom I call *danièles* and whom I occasionally use as a stopgap."[119] And finally: "Eroticism, hallucinogenic drugs, nuclear science, Gaudí's Gothic architecture, my love of gold – there is a common denominator in all of it:

Crucifixion (Corpus Hypercubus), 1954
Corpus hypercubus ou Crucifixion
Oil on canvas, 194.5 x 124 cm
The Metropolitan Museum of Art, New York

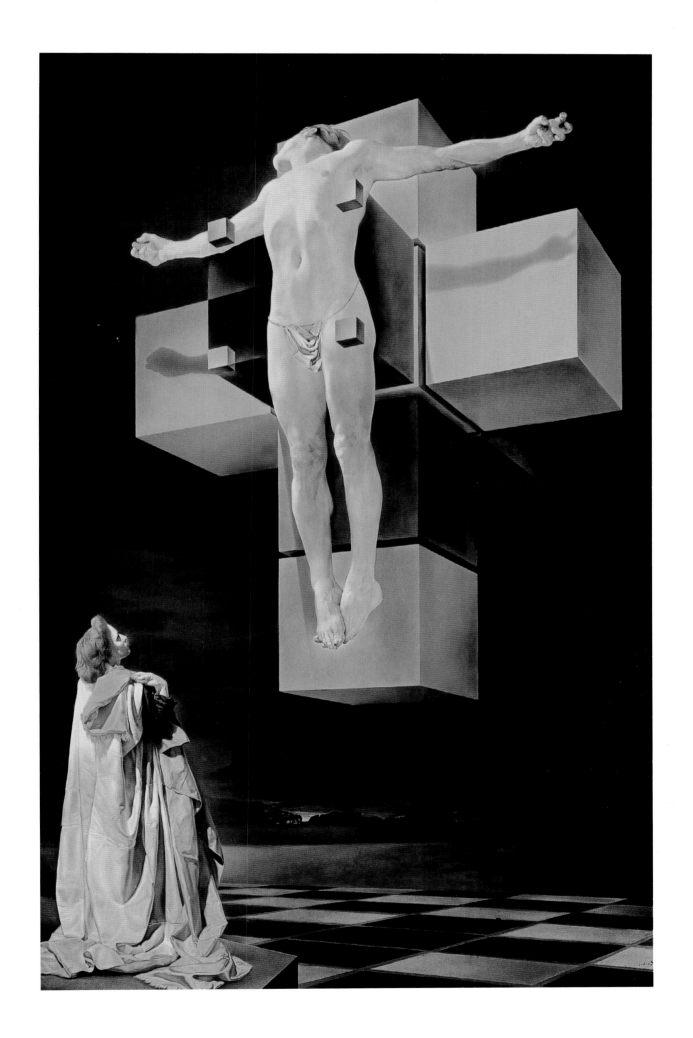

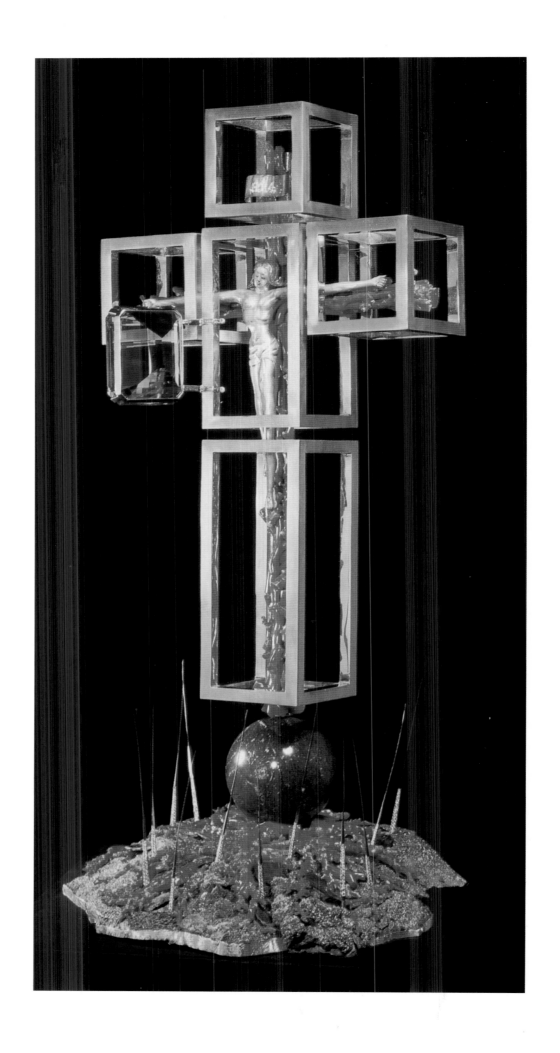

God is present in everything. The same magic is at the heart of all things, and all roads lead to the same revelation: We are children of God, and the entire universe tends towards the perfection of mankind."[120]

1950 began with a family drama: his sister Ana María published *Salvador Dalí vu par sa sœur* in Barcelona. The book opened old wounds: the confrontation with his father, his blasphemies, marriage to a divorced woman. Dalí the showman, author of the *Secret Life*, was never to forgive his sister her sentimental indiscretion; he excluded her from his will and forbade her to attend his funeral. His only reply to Ana María's book was laconically to note, "In 1930 my family cast me out without a penny. I owe my success in the world solely to the assistance of God, the light of the plains of Ampurdán, and the heroic willingness of one sublime woman to make sacrifices – my wife, Gala."

Was it perhaps a spirit of revenge that now impelled him to interpolate between *Christ of Saint John of the Cross* (p. 165) and his version of *The Sacrament of the Last Supper* (p. 178), a painting which is arguably his most erotic of all, *Young Virgin Autosodomized by her Own Chastity* (p. 177)? The history of the painting is closely connected to Dalí's sister. In his scatalogical period – which to Dalí's delight scandalized the Surrealists – he had painted a picture of his sister, a rear view which emphasized the girl's behind. To make sure that the point was not lost on anybody, he titled it: *Portait of my Sister, her Anus Red with Bloody Shit*. It was an image that remained with him and which he expressed in a poem, 'Love and Memory,' which he published in the *Editions surréalistes* in 1931. Why did he return to the subject in 1954, this time in a form that went far beyond the obscene poem? Was it revenge? True, twenty years on his memory rather glamourized Ana María, who was a short, plump woman; he reshaped her along the lines of a photograph in a soft-porn magazine. Still, it looks as if he were settling an old score with her. Continuity of this kind is indicative of the development of Dalí's mind: starting with a memory that was still fresh, mental processes in him combined analytic intelligence with powerful erotic fantasy to produce, in the 1954 picture, a veritable lyrical feast. In the painting, Ana María's firm, attractive behind is related to a rhinoceros horn, which in turn is related to fantasy images of an erection that enables him to penetrate his sister's "anus red with bloody shit." Revenge in true Catalonian style. Expressing himself through the rhinoceros horn permitted Dalí to respect the demands of chastity which, at that time, had become "an essential requirement of the spiritual life."

From then on, he used the rhinoceros horn in a number of ways – for instance, in a film he made in 1954 with Robert Descharnes titled *L'Histoire prodigieuse de la Dentellière et du Rhinocéros*. The title linked Vermeer's *Lace-maker* (cf. p. 176) with a rhinoceros, which may well seem preposterous. Of course, Dalí had been meticulous in the composition of his paintings since his youth. In the course of his work with Prince Matila Ghyka he became very interested in the dynamics of the mathematically self-perpetuating logarithmic spiral. At the same time, he came across the findings of recent research in nuclear physics, and was fascinated by the particles newly identified. The distinctive quality of Vermeer's art had intrigued him from early in his life; and in typical

Angelic Crucifixion, 1954
La croix de l'ange
Cruxifix of Chinese coral and other materials,
Height: 76 cm
Minami Museum, Tokyo

The Royal Heart, 1951–52
Le coeur royal
Gold heart with forty-six rubies (17.61-carat),
forty-two diamonds (0.57-carat) and four
emeralds, Height: 10 cm
Minami Museum, Tokyo

The Space Elephant, 1956
L'éléphant spatial
18-carat gold, two 0.10-carat diamonds,
two 4-carat emeralds, one 14-carat emerald,
Dimensions unknown
Minami Museum, Tokyo

Jan Vermeer van Delft:
The Lace-maker, c. 1665
Louvre, Paris

Young Virgin Autosodomized by her Own Chastity, 1954
Jeune vierge autosodomisée
Oil on canvas, 40.5 x 30.5 cm
Playboy Collection, Los Angeles

paranoiac style he concentrated on the one painting, *The Lace-maker*, a reproduction of which he had seen in his parents' home. The Vermeer made a peaceful impression; it was also striking for its compositional austerity and for the particle quality of the tiny brushstrokes Vermeer had used. For Dalí it represented the greatest power and the most arresting cosmic synthesis. Subsequently, in Paris, he delivered a remarkable lecture – 'Aspects phénoménologiques de la méthode paranoïaque-critique' – in which he examined the connections between the lace-maker and a rhinoceros. It is familiar enough nowadays to anyone who takes an interest in Dalí's thinking; here, it will be worthwhile quoting Dalí's own words in the *Diary of a Genius* for 18 December 1955:[121] "Yesterday evening, Dalíesque apotheosis in the temple of knowledge, before a fascinated crowd. Immediately after my arrival in the cauliflower-covered Rolls, after being greeted by thousands of flashing cameras, I began to speak in the great amphitheatre of the Sorbonne. The trembling listeners were expecting decisive words. They got them. I have decided (I say) to inform you of the most hallucinatory experience of my entire life in Paris, because France is the most intelligent country in the world. While I, Dalí, come from Spain, the most irrational country in the world... Frenetic applause greeted these opening words, because no one is more receptive to compliments than the French. The intelligence (I said) only leads us into the coefficients of a gastronomic, super-gelatinous, Proustian, stale uncertainty. For that reason it is both good and necessary if a Spaniard such as Picasso or I comes to Paris from time to time, to thrust a piece of raw meat bleeding truth under the noses of the French. At this point there was a commotion, as I had anticipated. I had won! I went on rapidly: One of the most important modern painters is doubtless Henri Matisse, but Matisse represents the after-effects of the French Revolution, that is to say, the triumph of the *bourgeoisie* and of philistine taste. Thunderous applause!!! I continued: Modern art has produced a new maximum of rationality and a maximum of scepticism. Today's young painters believe in *nothing*. It is only normal for someone who believes in nothing to end up painting practically nothing, which is the case in the whole of modern art, including the abstract, aesthetic and academic varieties." To the accompaniment of enthusiastic cheers, Dalí began to demonstrate that the curve of a rhinoceros horn is the only one that is perfectly logarithmic. He then explained his paranoiac-critical copy of Vermeer's painting, which shows the lace-maker with an infinite number of rhinoceros horns. What he had to say about the rear end of the beast prompted mirth: "On the screen there appeared the rear end of a rhinoceros which I had recently dissected only to find that it was nothing but a folded-up sunflower. The rhinoceros is not content with having one of the most beautiful logarithmic curves on its nose, no, even in its behind it has myriad sunflower-shaped logarithmic curves." Then Dalí proposed a progression: Mist = lace-maker = rhinoceros horn = particle and logarithmic granularity of the sunflower, then of cauliflower = the granularity of the sea urchin, which accoring to Dalí is nothing but a drop of water that gets goose pimples at the very moment it comes into existence, for fear of losing its original purity of form.

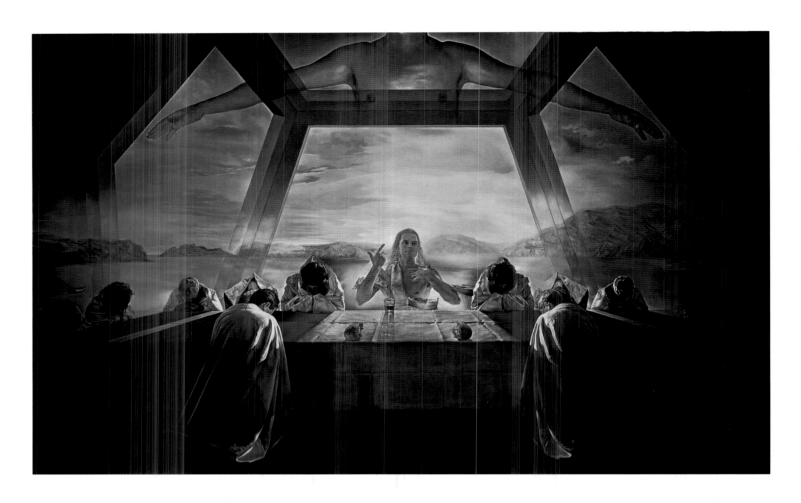

The Sacrament of the Last Supper, 1955
La Cène
Oil on canvas, 167 x 268 cm
The National Gallery of Art, Washington

Silencing the tremendous applause with a gesture, Dalí concluded: "After this evening's exposition I believe that in order to get from the lacemaker to the sunflower, from the sunflower to the rhinoceros, and from the rhinoceros to the cauliflower, one really needs a certain amount of brain."

Performances of this kind were generally preceded by "practical work" – in this case, a paranoiac-critical interpretation of Vermeer's *Lacemaker* in the rhinoceros enclosure at the Vincennes zoo. These events tended to rouse the critics from their lethargic slumbers and unsettle them. One of them, in an article headed 'Will Dalí kill modern art?' wrote: "Everything Salvador Dalí says, everything he does, and almost everything he paints, at least has the merit of embarrassing, bewildering, even annoying all those for whom modern art has its rules and frontiers and who would never dream of questioning their own certainty on the matter. Dalí sets various movements going in a field where both critics and artists all too often tend to be cosily snoozing. Scandal, provocation and crazy eccentricity – all hallmarks of the dandy – serve him in the pursuit of critical ends which use sacrilege to help 'a truth' see justice done. For twenty-five years, Dalí's work has been taking its bearings from the opposite of everything that is known as 'painting,' and has been aiming to diminish the value of whatever passes for current 'taste' – Cubism, abstract art, Expressionism and so forth. He makes no secret of it; quite the contrary, he loudly proclaims his wish 'to kill modern art.' It would be wrong to be deceived by the humorous or delirious nature of his state-

ments. Dalí is serious, very serious, and the 'first-class intelligence' which André Breton conceded in 1936 that Dalí possessed is in the service of destructive activities which may cost 'modern art' the whole of its prestige."

Dalí the exhibitionist implacably went on providing the media with material: Dalí with his famous moustache, his retinue, and his comments, the exact meaning and range of which were usually not understood. During the Surrealist period he talked a great deal and was adept at remaining silent for long stretches. Now his fame no longer permitted him to say nothing. "It is not an easy matter to hold the full attention of the public for a whole half-hour. I, however, have succeeded in doing it every single day for the past twenty years. My motto is: 'Dalí must always be talked about, even if nothing good is said about him.' For twenty years, I managed to have the newspapers publish the most inconceivable news of our times, relayed by teletype.

PARIS. – Dalí gives a lecture at the Sorbonne on *The Lace-maker* by Vermeer and the Rhinoceros. He arrives there in a white Rolls-Royce filled with a thousand white cauliflowers.

ROME. – Dalí is reincarnated in the torchlit gardens of the Principessa Pallavicini, bursting out unexpectedly from a cubic egg covered with the occult inscriptions of Raimond Lulle, and makes a dynamic speech in Latin.

GERONA, SPAIN. – The liturgical secret marriage of Dalí and Gala has just been celebrated in the Hermitage of the Virgin of the Angels. He declares: 'Now, we are archangelic being.'

VENICE. – Gala and Dalí, disguised as twenty-seven-foot-tall giants, descend the steps of the Bestegui Palace and dance with the crowd which gives them a wild ovation in the Piazza.

PARIS. – In Montmartre, Dalí, facing the *Moulin de la Galette,* is engraving Don Quixote on a lithographic stone, with arquebus shots. He says: 'Windmills produce flour – I now will produce windmills with flour.' And, filling two rhinoceros horns with flour and breadcrumbs dipped in typographic ink, he hurls them violently, accomplishing what he had just said.

MADRID. – Dalí makes a speech inviting Picasso to return to Spain, opening with the statement: 'Picasso is a Spaniard – so am I! Picasso is a genius – so am I! Picasso is a communist – neither am I!'

GLASGOW. – The famous *Christ of St. John of the Cross* by Dalí has been purchased by unanimous agreement of the city council. The price paid for this work of art arouses great indignation and a bitter controversy.

NICE. – Dalí heralds a film to feature Anna Magnani, *The Wheelbarrow of Flesh,* in which the leading lady falls madly in love with a wheelbarrow.

PARIS. – Dalí marches through the city parading a fifteen-meter long loaf of bread, which is laid in the *Théâtre de l'Etoile.* There, he delivers a hysterical speech on Eisenberg's 'cosmic glue.'

BARCELONA. – Dalí and Luis Miguel Dominguin have planned a surrealist bullfight, at the close of which a helicopter, dresses as an Infanta

in a Balenciaga gown, will transport the sacrificed bull to Heaven, to be laid on the sacred Mountain of Montserrat and devoured by vultures. Simultaneously, in a makeshift Parnassus, Dominguin will crown Gala, disguised as Leda, while at her feet Dalí will emerge, naked, from an egg.

LONDON. – In the Planetarium, the heavenly bodies have been reshifted into the pattern they had in the skies of Port Lligat at the birth of Dalí. He proclaims that the analyses of his psychiatrist, Dr. Rumaguerra, reveal that Gala and he are the incarnation of the cosmic and sublime myth of the Dioscuri. 'Gala and I, we are Jupiter's children.'

NEW YORK. – Dalí, dressed in a golden space-suit, lands in the celebrated 'ovocipede' of his invention – a transparent sphere affording a new means of transportation, which found its inspiration in the hallucinations aroused by intra-uterine paradises."[122]

One thing was certain: Dalí loathed all things plain and conventional. In the showbiz age, he welcomed any opportunity to rouse the world from its apathy – even if his extravagance, provocativeness and greed for publicity tended to obscure people's view of Dalí the great artist. His gags were endless, and infinitely various; and they mattered more to him than anything else. For years, one of the most spectacular of his gags was his habit of taking his paintings to the United States himself. He had bought an old warship from the Spanish navy for a song especially for the purpose. In the depths of winter his ship would arrive in the bay at Cadaqués and anchor; there would not be a tourist far and wide, since it was not the right season nor was the village on the tourist map at that date. But that was of no concern to Dalí. He would have the cannon fire three rounds (of blanks) to inform the local people that he was setting off for the New World. And in the evenings in Cadaqués the enthusiastic villagers would drink to their great man's health as he sailed past Gibraltar, the Azores, or the Statue of Liberty.

Another gag was Dalí's swimming pool at Port Lligat, which was designed to scare off swimmers. The bottom of the pool was covered with sea urchins. Visitors who discovered the fact tended to forgo the pleasure of a dip, and only the very plucky or the well-informed ventured in. Of course, it was perfectly safe to do so – the sea urchins were under an immense sheet of glass which screened them from contact with swimmers. Dalí took delight in terrorizing his guests.

As for dinner chez Dalí: A tureen of soup would be served, and Dalí, the host, would lift the lid and toss a sponge into the soupe. Then he would fish out the aquatic creature and cut it up on his baffled guests' plates. "Eat and drink," Dalí would tell them, "this is my soup."

"Never, never, never, never – not even for a quarter of a second – has an excess of money, publicity, success or popularity made me contemplate suicide – quite the contrary, it so happens that I like it. Recently a friend of mine, who could not understand that this caused me no suffering, asked me, temptingly, 'Don't you feel any pain whatsoever from all this success?' 'No!' And then, beseechingly, 'Not even a slight sort of neurosis?' (his tone implied 'for charity's sake!') 'No!' I replied emphatically. Then, since he was exceedingly rich, I added, 'To prove it, I could accept fifty thousand dollars on the spot without batting an eyelash."[123]

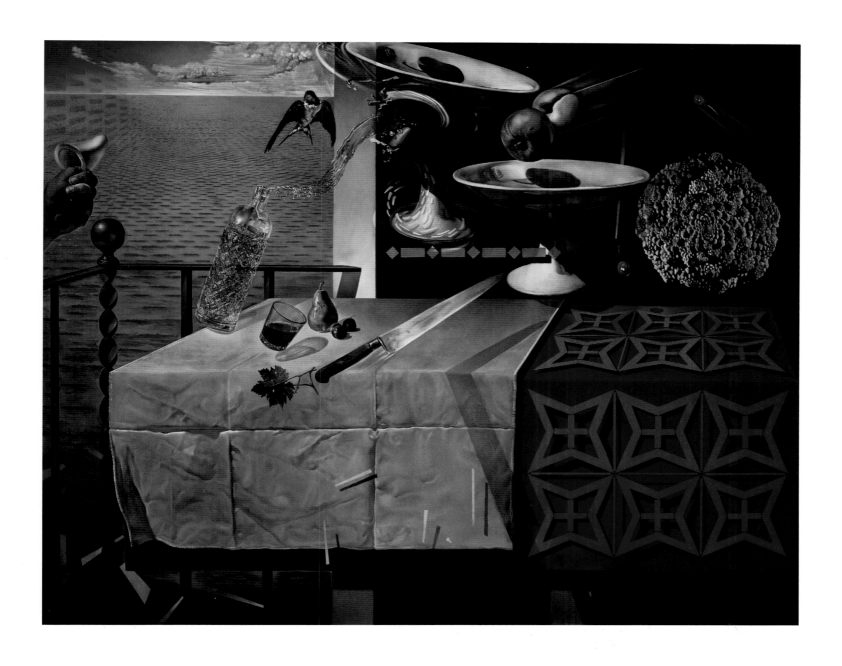

Animated Still Life, 1956
Nature morte vivante
Oil on canvas, 125 x 160 cm
Loan to the Salvador Dalí Museum,
St. Petersburg (Fla.)

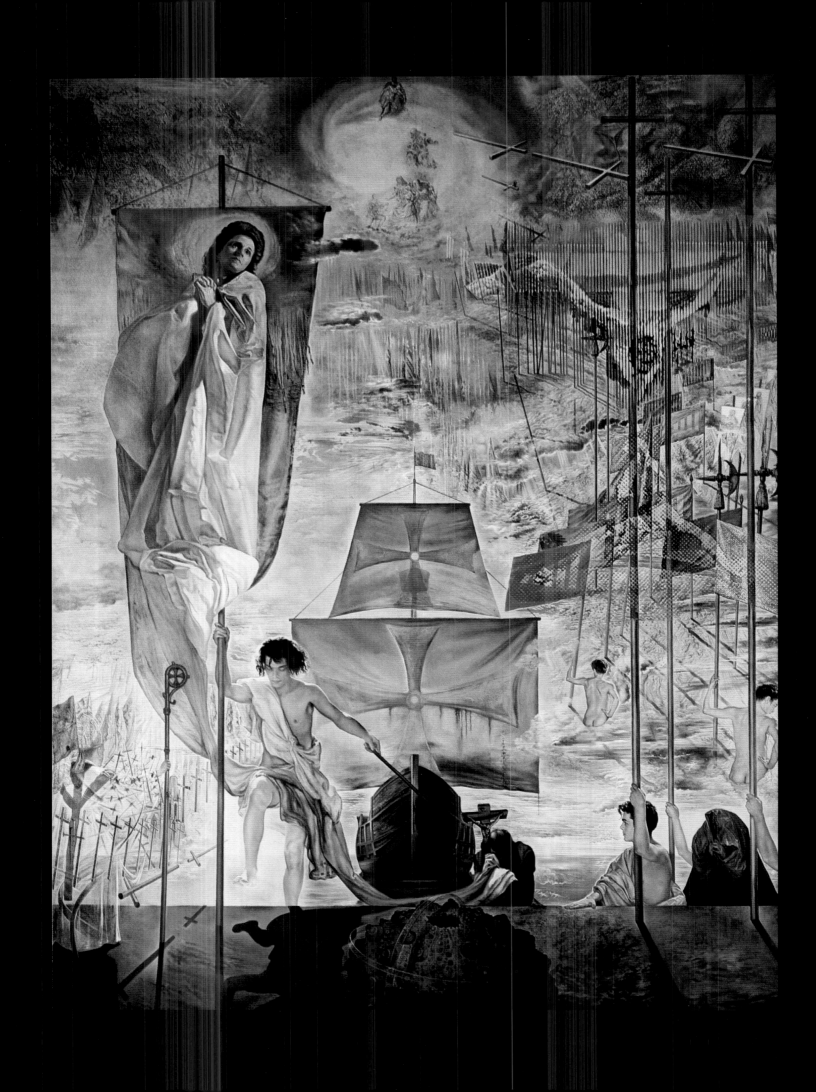

Paths to Immortality

"*I'm* not the clown! But in its naivety this monstrously cynical society does not see who is simply putting on a serious act the better to hide his madness. I cannot say it often enough: I am not mad. My clear-sightedness has acquired such sharpness and concentration that, in the whole of the century, there has been no more heroic or more astounding personality than me, and apart from Nietzsche (who finished by going mad, though) my equal will not be found in other centuries either. My painting proves it."[124]

Ever since the day Dalí first set foot in Surrealist-ruled Paris he had tirelessly been declaring that most ultra-academic painters, above all Meissonier and the Spaniard Mariano Fortuny, were a thousand times more interesting than the movements of modern art, with their African, Polynesian, Indian or Chinese objects. Thus it is not difficult to understand that he reached a point in his life when he felt he had to confront his home country. And, like the Pompiers towards the end of the 19th century, he decided to paint historical paintings in celebration of the fatherland.

In 1958/9 he painted *The Discovery of America by Christopher Columbus* (p. 182). The picture includes St. James, supposedly buried at Santiago de Compostela and the patron saint of Spain. Dalí explained that the painting was a first existential attempt to grasp his country entire. *The Discovery of America by Christopher Columbus* was a significant step in Dalí's new approach to art. For the first time we see the representational method of his particle period closely allied to earlier techniques. The figure on the banner is Gala, the kneeling figure with the crucifix Dalí himself. Dalí told Robert Descharnes (in a tape-recorded conversation) that he wanted to pay homage to Velázquez. That said, it does strike us that, in technical terms, his priority was to establish a photographically precise, enlarged image in which the grid structure would highlight the glorious (no irony apparently intended) halberds of the Spanish soldiers (who, as in the *Christ* picture in Glasgow, were inspired by Velázquez's *Surrender of Breda*.) Two years later Dalí did a third historical picture, *The Battle of Tetuan*, inspired by Mariano Fortuny's painting in the Museu d'Art Modern in Barcelona.

Dalí declared: "It is quite correct that I have made use of photography throughout my life. I stated years ago that painting is merely photography done by hand, consisting of super-fine images the sole significance

"It was important to shape my experience 'classically,' to confer form, a creation myth, a synthesis and an architecture of eternity upon it."

The Discovery of America by Christopher Columbus, 1958–59
La découverte de l'Amérique par Christophe Colomb
Oil on canvas, 410 x 284 cm
Collection of Mr. and Mrs. A. Reynolds Morse, Loan to the Salvador Dalí Museum, St. Petersburg (Fla.)

of which resides in the fact that they were seen by a human eye and recorded by a human hand. Every great work of art that I admire was copied from a photograph. The inventor of the magnifying glass was born in the same year as Vermeer. Not enough attention has yet been paid to this fact. And I am convinced that Vermeer van Delft used a mirror to view his subjects and make tracings of them. Praxiteles, most divine of all sculptors, copied his bodies faithfully, without the slightest departure. Velázquez had a similar respect for reality, with complete chastity..." And: "The hand of a painter must be so faithful that it is capable of automatically correcting constituents of Nature that have been distorted by a photograph. Every painter must have an ultra-academic training. It is only through virtuosity of such an order that the possibility of something else becomes available: Art."[125]

Dalí prophetically added: "I foresee that the new art will be what I term 'quantum realism.' It will take into account what the physicists call quantum energy, what mathematicians call chance, and what the artists call the imponderable: Beauty. The picture of tomorrow will be a faithful image of reality, but one will sense that it is a reality pervaded with extraordinary life, corresponding to what is known as the discontinuity of matter. Velázquez and Vermeer were divisionists. They already intuited the fears of modern Man. Nowadays, the most talented and sensitive painters merely express the fear of indeterminism. Modern science says that nothing really exists, and one sees scientists passionately debating photographic plates on which there is demonstrably nothing of a material nature. So artists who paint their pictures out of nothing are not so far wrong. Still, it is only a transitional phase. The great artist must be capable of assimilating nothingness into his painting. And that nothingness will breathe life into the art of tomorrow."

In point of fact, Dalí observed the gradual decline of modern art with contempt. As it slid into nothingness, he laughed to see what Duchamp's ready-mades in Dada and Surrealist days had led to. He was amused to see the urinal Duchamp had exhibited in New York in 1911 as a sculpture titled *Fontaine*. "The first person to compare the cheeks of a young woman with a rose was plainly a poet. The second, who repeated the comparison, was probably an idiot. All the theories of Dadaism and Surrealism are being monotonously repeated: their soft contours have prompted countless soft objects. The globe is being smothered in ready-mades. The fifteen-metre loaf of bread is now fifteen kilometres long... People have already forgotten that the founder of Dadaism, Tristan Tzara, stated in his manifesto in the very infancy of the movement: 'Dada is this. Dada is that... Either way, it's crap.' This kind of more or less black humour is foreign to the new generation. They are genuinely convinced that their neo-Dadaism is subtler than the art of Praxiteles."

Dalí recalled: "During the last war, between Arcachon and Bordeaux, Marcel Duchamp and I talked about the newly awoken interest in preparations using excrement; tiny secretions taken from the navel were considered 'luxury editions.' I replied that I would have liked to have a navel secretion of Raphael. Now a well-known Pop artist is selling artists' excrement in Verona, in extremely stylish flacons, as a luxury item. When

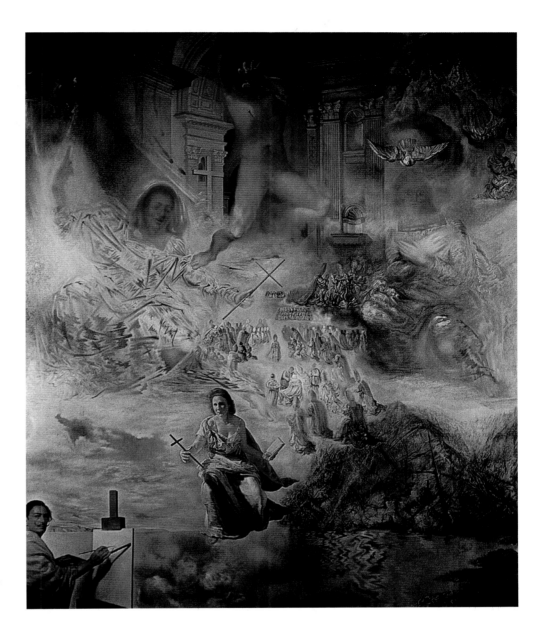

The Ecumenical Council, 1960
Le concile oecuménique
Oil on canvas, Dimensions unknown
Collection of Mr. and Mrs. A.Reynolds Morse,
Loan to the Salvador Dalí Museum,
St. Petersburg (Fla.)

Duchamp realised that he had scattered the ideas of his youth to the winds, until he himself was left with none, he most aristocratically declined to play the game, and prophetically announced that other young men were specializing in the chess match of contemporary art; and then he began to play chess..."

And Dalí observed: "At that time there were just seventeen people in Paris who understood the ready-mades – the very few ready-mades by Marcel Duchamps. Nowadays there are seventeen million who understand them. When the day comes that every object that exists is a ready-made, there will no longer be any ready-mades at all. When that day comes, originality will consist in creating a work of art out of sheer urgent compulsion. The moral attitude of the ready-made consists in avoiding contact with reality. Ready-mades have subconsciously influenced the photo-realists, leading them to paint ready-mades by hand. There can be no doubt that if Vermeer van Delft or Gerard Dou had been alive in 1973, they would have had no objection to painting the interior of a car or the outside of a telephone box..."

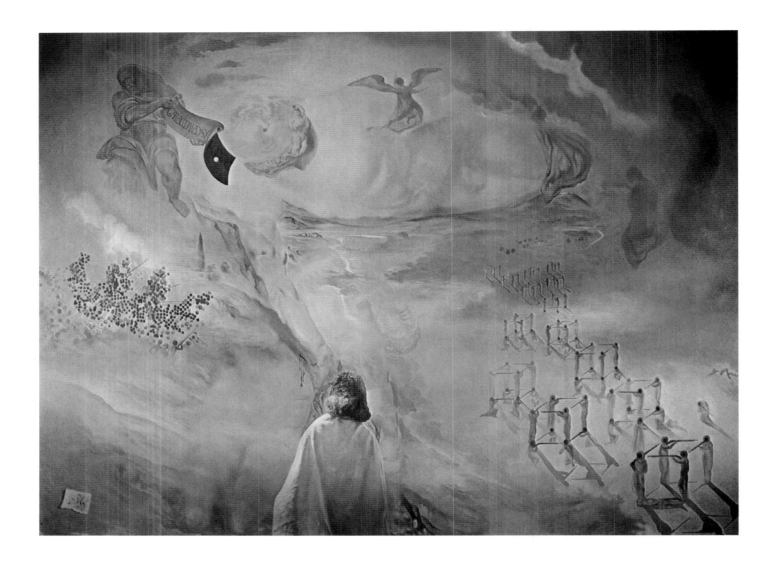

Galacidalacidesoxyribonucleicacid, 1963
Galacidalacidesoxyribonucleidacid
Oil on canvas, 305 x 345 cm
New England Merchants National Bank,
Boston, Massachusetts

The major project of 1961 was *L'Apocalypse,* an immense book published by Joseph Forêt; it weighed over 200 kilograms and was worth over two million (old) French francs. Dalí created a bronze bas-relief for the binding, combining sea urchins, teaspoons, gold leaf and stones. In August that year, in the Teatro Fenice in Venice, the *Ballet de Gala* was premièred (libretto, set and costumes by Dalí, choreography by Maurice Béjart). That year he also gave a lecture at the Paris Polytechnic, gathering five hundred students in festive garb to pay homage to the divine twins, Castor and Pollux.

On 15 October 1962, Dalí exhibited *The Battle of Tetuan* in the Palacio del Tinell in Barcelona, alongside the picture by Mariano Fortuny that had inspired it. Also in 1962, a very revealing book was published: *Dalí de Gala,* written by Robert Descharnes in collaboration with the artist.

Dalí was tirelessly creative. He painted the *Crucifixion (Corpus Hypercubus)* (p. 171) – a "hypercubic cross where the Corpus Christi acts as the ninth cube, in accordance with the rules that Juan de Herrera, the architect of El Escorial, inspired by Raimundus Lullus, laid down in his discourse on the cube." He painted the famous *Sistine Madonna,* which is

also known as *The Ear of the Madonna* or *The Sistine Virgin*. The painting was prompted by a tiny detail (to be exact: an ear) in a photograph of Pope John XXIII in *Paris Match* magazine. "The picture is almost grey. Seen at close quarters it is an abstraction; seen from a distance of two metres it becomes Raphael's Sistine Madonna; at a distance of fifteen metres the ear of an angel becomes apparent, measuring a metre and a half, and, since it is painted in anti-matter, constituting energy pure and simple. The alchemical idea of the ear. The Rabelaisian idea of birth via the ear."

Among the masterpieces Dalí painted in this final period, *Tuna Fishing* (p. 193) and the *Hallucinogenic Bullfighter* (p. 195) are undoubtedly the most important. For the latter work, full of dionysian figures, Dalí needed two whole summers (1966 and 1967). *Tuna Fishing* is a kind of legacy or testament, the fruit of forty years of devoted searching for means of visual expression. This immense picture (304 × 404 cm) painted at Port Lligat combines all the styles Dalí had worked in: Surrealism, "refined Pompierism," pointillism, action painting, tachism, geometrical abstraction, Pop art, Op art and psychedelic art. Dalí left an explanation of his aims in this painting – which ranks in importance with the 1931 *Persistence of Memory* (p. 67), now in the Museum of Modern Art, New York: "It is the most ambitious picture I have ever painted, because its subtitle is *Hommage à Meissonier*. It is a revival of representational art, which was underestimated by everyone except the Surrealists throughout the period of so-called 'avant-garde art.' It was my father who told me of the epic subject. Though he was a notary in Figueras, Catalonia, he had a talent for story-telling that would have been worthy of a Homer. He also showed me a print he had in his office by a Swiss artist – one of the Pompiers – showing a tuna catch; that picture also helped me create this painting. What finally made me decide to take the subject, which had been tempting me my whole life long, was my reading of Teilhard de Chardin, who believed that the universe and cosmos are finite – which the latest scientific discoveries have confirmed. It then became clear to me that it was that finite quality, the contraction and frontiers of the cosmos and universe, that made energy possible in the first place. The protons, antiprotons, photons, pi-mesons, neutrons, all the elementary particles have their miraculous, hyper-aesthetic energy solely because of the frontiers and contraction of the universe. In a way, this liberates us from the terrible Pascalian fear that living beings are of no importance compared with the cosmos; and it leads us to the idea that the entire cosmos and universe meet at a certain point – which, in this case, is the tuna catch. Hence the alarming energy in the painting! Because all those fish, all those tuna, and all the people busy killing them, are personifications of the finite universe – that is to say, all the components of the picture (since the Dalí cosmos is restricted to the circumscribed area of the tuna catch) achieve a maximum of hyper-aesthetic energy in it. Thus *Tuna Fishing* is a biological spectacle *par excellence*, since (following my father's description) the sea, which is initially cobalt blue and by the end is totally red with blood, represents the super-aesthetic power of modern biology. Every birth is preceded by the miraculous spurting of blood, 'honey is sweeter than blood,' blood is sweeter than blood. Currently America has the privilege

of blood, because America has the honour of having the Nobel Prize winner Watson who was the first to discover the molecular structure of desoxyribo-nucleic acid which, together with the atom bomb, constitutes the essential guarantee of future survival and hibernation for Dalí."

Hibernation because Dalí, half in jest and half in earnest, had decided to have himself frozen. "Let us assume I die. I should not like people simply to say, 'Dalí is dead.' I want them to add, 'Dalí has done it differently yet again. He's had himself frozen.'"[126] Dalí wanted to be put into preservation the moment he ceased to live, to await the discovery that would one day make it possible for Dalí the genius to be restored to life. "I am convinced that cancer will be curable and the most amazing transplants will be performed, and cellular rejuvenation will be with us in the near future. To restore someone to life will merely involve an everyday operation. I shall wait in my liquid helium without a trace of impatience."[127]

Dalí was enthusiastic about a theory advanced by a leading teratologist, Dr. Hubert Larcher, in a publication entitled *Will Blood Conquer Death?*,[128] which speculated: "What if the body does not die? If our corpse becomes a kind of life factory? There are people who are sheer filth when they are still alive and smell terrible (in our consumer society this applies particularly to bureaucrats, who smell worse than anyone else), but saints, when they die, are metamorphosed into perfume factories. Not only saints, but also great courtesans." According to Dr. Larcher, blood is naturally related to the cosmos, and may well be the substance the alchemists of old were looking for – in their retorts instead of within themselves.

Dalí pondered the point: "We know of over fifty saints who died 'in an odour of sanctity,' which is not merely a figure of speech, but objective fact. The corpses of certain saints have the property of secreting balms and fragrant oils. They have numerous excellent properties and are known as myrofacts. The most famous case is that of St. Theresa of Avila ..."

Dalí pondered every conceivable path to immortality. He published his thoughts on the matter in his remarkable *Dix recettes d'immortalité*.[129] In it, he states: "I declare that the body's most important hibernation zone is the arsehole, because the first thing that animals do when they begin their hibernation is to stop up the anus with a paste made of dirt and excrement in order to maintain their metabolism. And this is also a guarantee of intimacy!" In this publication Dalí also evolved his *sistema caga y menja* – the system of shitting and eating. "These are the precise details as Stendhal might have required: Along the lines of Brueghel's Tower of Babel, I imagined 'towers of immortality,' one in every town. Every inhabitant who wanted to move his bowels did so immediately, in accordance with a strict procedure, by crapping on the inhabitants of the story below who were waiting for food. Thanks to certain methods of mental and nutritional perfection, people produced semi-fluid excrement that was comparable, on the whole, to honey. Thus some of them caught the excrement of others in their mouths, and shat in turn on those below them ... which made for perfect equilibrium in social terms; everyone had something to eat, without needing to work." People dug their graves with

their teeth. Dalí's *sistema caga y manja* aimed to eliminate the danger of virtual death, which was a matter of the digestive processes, according to Paracelsus. Dalí noted that contemporary developments illustrated his theory: "Nowadays towers are again being built to shoot machines into space, and we are seeing how human urine and excrement can be recycled, because astronauts drink their pee and shit into small containers in which algae and mushrooms grow to staggering sizes; they can then eat these and shit them, in a cycle. It is not a vicious circle, though one might call it vicious, since the business appears to contain a minimum of errors..."[130]

Dalí also gave his attention to immortality through holography: "When I discovered that a single atom of holographic emulsion contains the complete three-dimensional image, I exclaimed: 'I want to eat it!' This astounded everyone else more than usual, especially my friend Professor Dennis Gabor, who received the 1971 Nobel Prize for Physics. In this way, though, I was at least able visually to realise one of my dearest wishes: to eat my worshipped Gala, to take atoms into me, into my organism, that contained a holographic smiling Gala or Gala swimming off Cape Creus. Gala, Belka, the squirrel, the hibernation specialist." (Belka is the Russian word for squirrel.) "The recipe for holographic immortality: to be taken with a glass of Solarés water – holographic information that can produce images containing a maximum of happy resurrection instantaneousness. The 'persistence of memory' (as I titled my famous 1930 painting of soft watches) will be complemented by the voluntary programming of desire: the image of a waking, sensual squirrel can make a person immortal."

While Dalí was waiting for immortality, he had honours heaped upon him. He was awarded the Grand Cross of Isabella the Catholic, the highest Spanish decoration. On 26 May 1978, he was elected an associate foreign member of the Académie des Beaux-Arts de l'Institut de France. At the presentation ceremony he used the opportunity to speak of Perpignan railway station, "the gravitational centre of our universe:" "That was the very point Spain revolved about when the continents were torn apart and the Bay of Biscay came into existence. If it had not been for this phenomenon we should have drifted to Australia and would now be living amongst the kangaroos – the most dreadful thought conceivable... Finally, so as not to become long-winded, I should like to second what my friend Michel de Montaigne said: One must always see the ultra-local in universal terms. And so I always conclude my writings with the words: 'Long live Perpignan railway station! Long live Figueras!'" *The Railway Station at Perpignan* (pp. 190–1) was painted after a vision: "On 19 September 1963, at Perpignan railway station, I experienced a moment of cosmogonic ecstasy: an exact vision of the constitution of the universe." The painting also includes a variation on the *Angelus* theme, and on phallic symbols and symbols of mortality.

Writing in *L'Aurore*, Michel Déon, a fellow member of the Académie Française, said: "This Renaissance man may hide as much as he likes behind his exhibitionist façade: what we like is his work, and it is on his work that he will be judged and not on his moist derrières, his prickly sea urchins, his waxed moustache, his mink-lined capes, his Rolls-Royce,

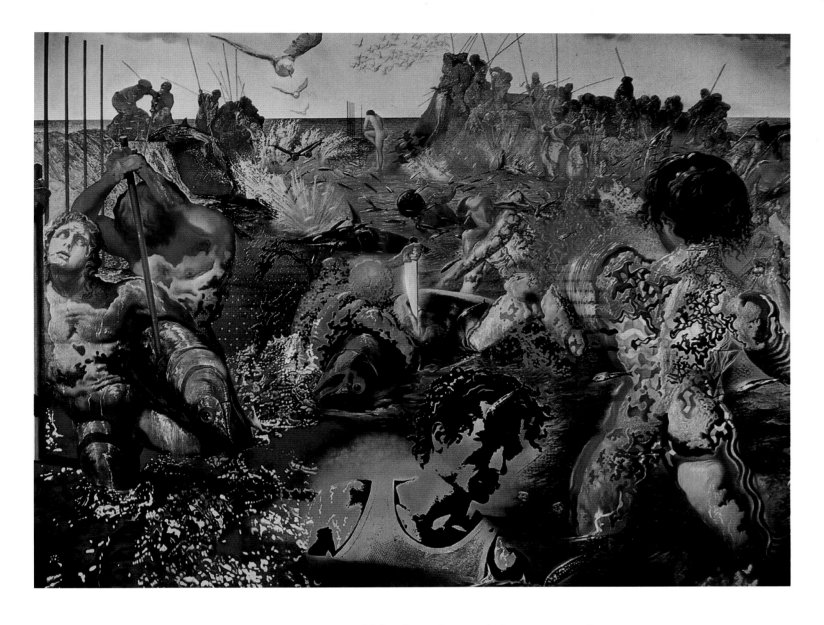

his inscrutable friendships with transvestites and his obsessive exploitation of his love for his wife, Gala. He will have introduced an awareness and austerity into painting that we supposed lost, thanks to the fragmentation Picasso initiated. A painter is always a craftsman too, and in this respect Dalí is one of the greatest. Very few realise that this artist is a technical expert, that he has rediscovered many a lost recipe, and that his finest, most famous paintings will one day bear comparison with the best of Velázquez or Raphael... People easily assume he is a fool because he says monstrous things in an astonishing common sense manner. Everyone who likes him and who considers him a genius, or at least a great talent, would welcome it if this tireless man – who has now been made a member of the Institut de France – would put a stop to some of his clowning. I should be delighted if he would shave off his twirly moustache and stop rolling his bulging eyes and if he would stop riding the prestigious and changing waves of Chance. He has had everything an artist can want. If he could bring himself to stop being a media spectacle, his art would get the full attention it merits and would doubtless increase in significance. Then we would clearly see that his work is among the

Tuna Fishing, 1966–67
La pêche aux thons
Oil on canvas, 304 x 404 cm
Paul Ricard Foundation, Île de Bendor, France

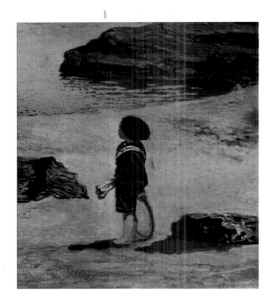

Detail from:
Spectre of Sex Appeal, 1932
(p. 55)

Hallucinogenous Bullfighter, 1968–70
Le toréro hallucinogène
Oil on canvas, 398.80 x 299.7 cm
Collection of Mr. and Mrs. A. Reynolds
Morse, Loan to the Salvador Dalí Museum,
St. Petersburg (Fla.)

greatest of the age. But that may be too much to expect of a man who has made mystification a dogma."

What greater pleasure could there be for a patriotic Spanish painter who liked chocolate than to have his pictures (together with Fragonard's) reproduced on Marquise de Sévigné chocolate boxes and, during his lifetime, to have a Dalí museum in his home town? When he walked through Figueras, Dalí could admire the mesh-like cupola atop the town theatre, designed by Pérez Piñero, whom Dalí called "the genius of architecture;" Dalí designed the museum that was installed in the building himself, working upwards from the ruins that remained after shelling in the Civil War. He designed even the tiniest details himself, from the loaves on the heads of fully-suited divers outside to the toilets and the poster for the national lottery inside. It is a kind of Cave of Dalí Baba. His works are displayed in haphazard fashion, without their titles (at his request). There are paintings, stereoscopic photographs, a bendy metal crucifix that stylistically matches Piñero's architecture, a taxi (raining inside), and so forth. But the most arresting feature of the museum is its success in affording an insight into Dalí's mind.

Thus there is a room that copies the face of Mae West, there are extremely classical studies, a nude by Bougereau, a picture by Fortuny, ceiling paintings by Dalí, tiny and immense *trompe l'œil* paintings in which Dalí (as early as 1939) seems to have been poking fun in advance at his later photorealist disciples in America – all amidst stage sets and books he illustrated. It is a veritable Dalí universe.

There is another Dalí museum, in the United States, but it has no connection with the Figueras museum designed by Dalí himself. A. Reynolds Morse opened it at Saint Petersburg, Florida, in 1982. Morse, a manufacturer, got to know Dalí over forty years ago and bought Dalí paintings throughout that period. The museum, called the Salvador Dalí Foundation Incorporated, is on the coast of Tampa Bay, which is known for its football players, black market dealers in crocodile leather, and floods. The curator says: "We have a mechanism for lifting the big pictures if the museum is flooded." (The exhibits are on ground level.) The collection includes over ninety oil paintings, some two hundred watercolours and drawings, and countless prints. Among its most famous holdings are the *Animated Still Life* (p. 181) with its suspended objects; five of Dalí's eighteen large-format works, including *Hallucinogenic Bullfighter* (p. 195) and *The Discovery of America by Christopher Columbus* (p. 182); and works dating from Dalí's youthful years, such as the 1921 self-portrait, and important works of the 1930s.

But it was France that mounted the most complete retrospective to date, in 1979 in the Centre Georges Pompidou in Paris. None of Dalí's wishes were respected. He had wanted his works to be hung above each other, filling the walls, as at 19th century salons – so that one could take in the entire Dalí at a glance. He had also wanted a gigantic illustration of the primeval garland to be made, "the first dynamic garland of humanity," with the return of prehistoric man from the hunt symbolized by unconscious and atavistic sausages. The inspiration for this was in his *Traité des guirlandes et des nids* – a treatise on garlands and nests which he had

Nude Figures at Cape Creus, 1970
Cap Creus con desnudos
Oil on copper, 39 x 49 cm
Private collection

OPPOSITE:
Gala's Castle at Pubol, c. 1973
Le château de Gala à Pubol
Oil on canvas, 160 x 189.7 cm
Gift from Dalí to the Spanish state

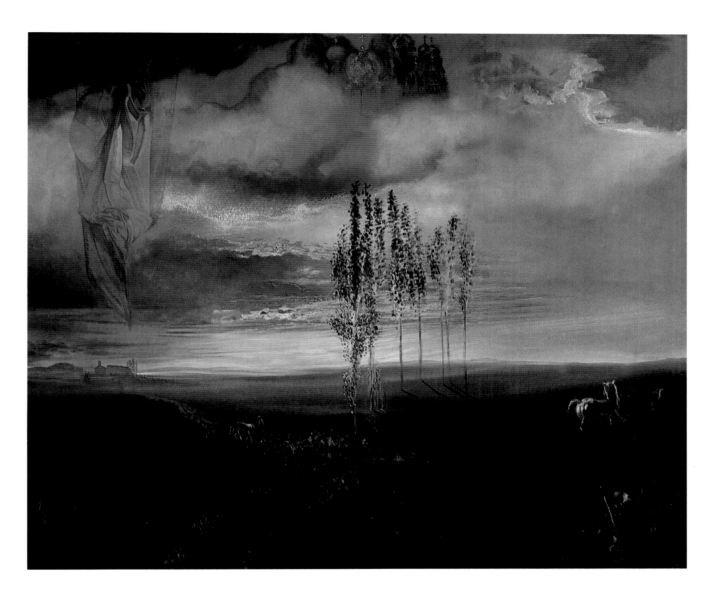

PAGE 198:
Nude, 1974
Desnudo de Calcomania
Mixed technique on card,
Dimensions unknown
Private collection
Never previously published

PAGE 199:
Figure Climbing a Stair, 1967
Personnage montant un escalier
Mixed technique on paper, 98 x 58.8 cm
Private collection

written in spring 1978 at Port Lligat. Surely a museum supposedly so committed to disposable – excuse me, conceptual – art should have been tempted.

This wish to return to prehistoric times brings us to Dalí's final period, in which he studied the phenomenon of the catastrophe. "Everything I have been doing since then is centred on the phenomenon of catastrophes," Dalí told one of the rare visitors he received at that time. Thanks to the mathematician René Thom, who had evolved a theory of catastrophes, Dalí developed a rigorously qualitative way of thinking derived from recent research in topology and differential analysis. Dalí found himself in a four-dimensional space-time continuum – for, as René Thom put it, it is possible on an abstract level, purely geometrically, to evolve a theory of morphogenesis. The examples proposed for the study of everyday phenomena in mathematical terms (a lizard on an old wall, the shape of a cloud, the fall of a dead leaf, the froth on beer) were sure to appeal to Dalí, who had long been considering flies, grasshoppers and cherries in the same light. One of his last paintings, done only a few weeks before Gala died, is stunning: *The Three Glorious Enigmas of Gala* (p. 212). Three periods in Dalí's creative life are seen united in this picture. It was a final act of triple homage to the woman who had been his *Visible Woman*, his *Leda Atomica* (p. 156), and *The Madonna of Port Lligat* (p. 159).

The great catastrophe that was impending in Dalí's own life happened on 10 June 1982, when Gala died, leaving him alone. Dalí tried to commit suicide by dehydrating. How serious was the attempt? He was convinced that dehydration and return to a pupal state would assure him of immortality. He had once read that the inventor of the microscope had seen minute, seemingly dead creatures through the lens of his invention – creatures that were in a state of extreme dehydration and which could be restored to life with a drop of water.

Dalí concluded (or at least liked the idea) that it was possible to live on beyond the point of dehydration. What he had not foreseen, though, was that, having consumed nothing for so long, it became impossible for him to swallow anything at all. From then till his dying day he was fed liquid nutriments through a tube up his nose. In his *Dix recettes d'immortalité* Dalí had written of "immortality vouchsafed by dehydration and temporary return to a pupal stage, as Collembole's discovery of a species of micro-organisms showed in 1967. These are a living fossil group that have been in existence since the Devonian (a geological system dating back approximately 400 million years)." The truth is that Dalí was not concerned about his body. All that mattered was the immortality of the "garden of his mind." Dalí also attempted an auto-da-fe, ringing and ringing the push-button bell that summoned his nurse to his bedside until eventually the wiring short-circuited and set fire to his bed and nightshirt. Luckily Descharnes was close to hand and saved Dalí's life.

Another side effect was that Dalí lost his voice. He would become impatient and fly into a temper if nobody could understand what he was saying. His retinue, including his confidant Robert Descharnes, needed great patience to decode the scarcely audible murmurs that passed his lips.

Dalí from behind, Painting Gala from behind, who is Perpetuated in Six Virtual Corneas which are Temporarily Reflected in Six Real Mirrors (unfinished), 1972–73
Dalí de dos peignant Gala de dos éternisée par six cornées virtuelles provisoirement réfléchies par six vrais miroirs (inachevé)
Oil on canvas, Stereoscopic work on two panels, each 60 x 60 cm
Fundacion Gala-Salvador-Dalí, Figueras

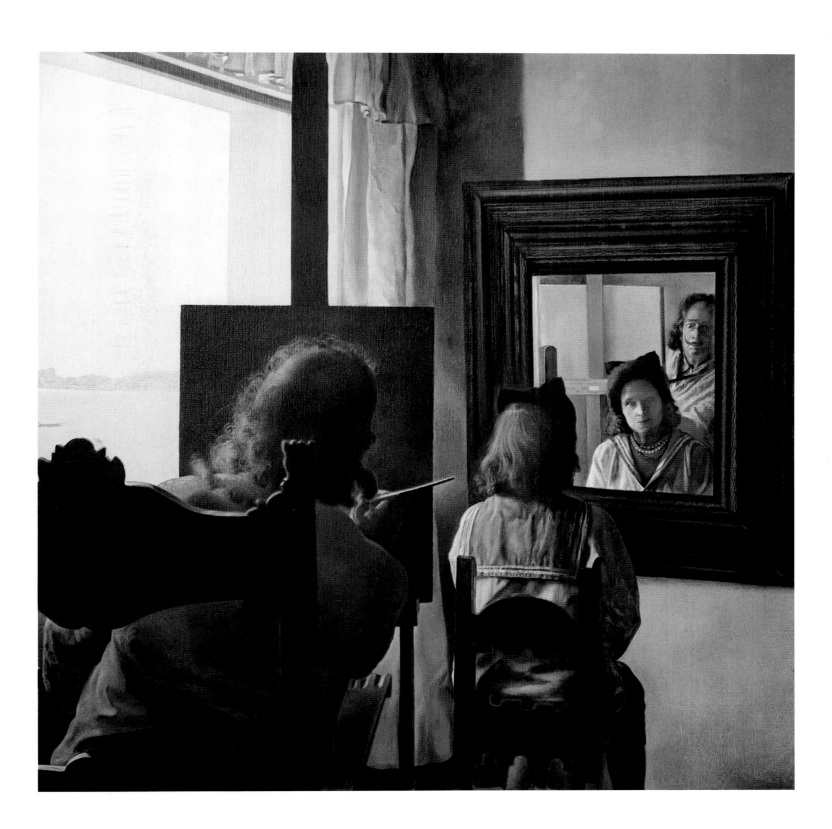

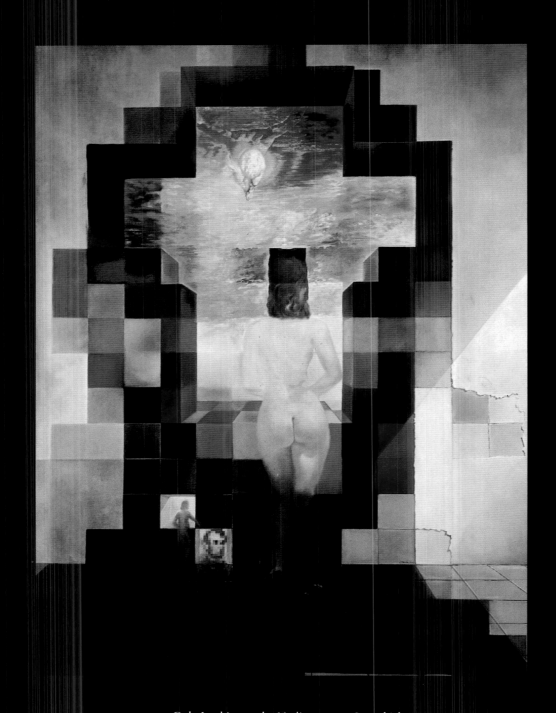

*Gala Looking at the Mediterranean Sea which
from a Distance of 20 Meters is Transformed
into a Portrait of Abraham Lincoln (Hommage
to Rothko), 1976*
Gala regardant la Mer Méditerranée qui à vingt
mètres se transforme en portrait d'Abraham
Lincoln (Hommage à Rothko)
Oil on canvas, 252.2 x 191.9 cm
Minami Museum, Tokyo

Cybernetic Odalisque, 1978
Odalisque cybernétique
Oil on canvas, 200 x 200 cm
Teatro-Museo Dalí, Figueras

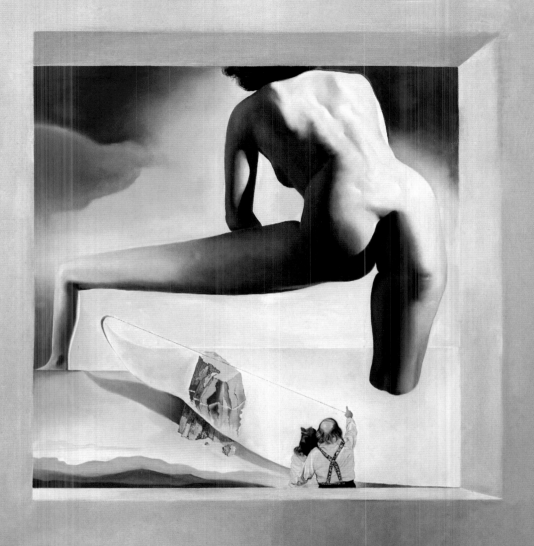

*Dalí Lifting the Skin of the Mediterranean Sea
to Show Gala the Birth of Venus, 1977*
Dalí soulevant la peau de la Mer Méditerranée
pour montrer à Gala la naissance de Vénus
Oil on canvas, Stereoscopic work on two

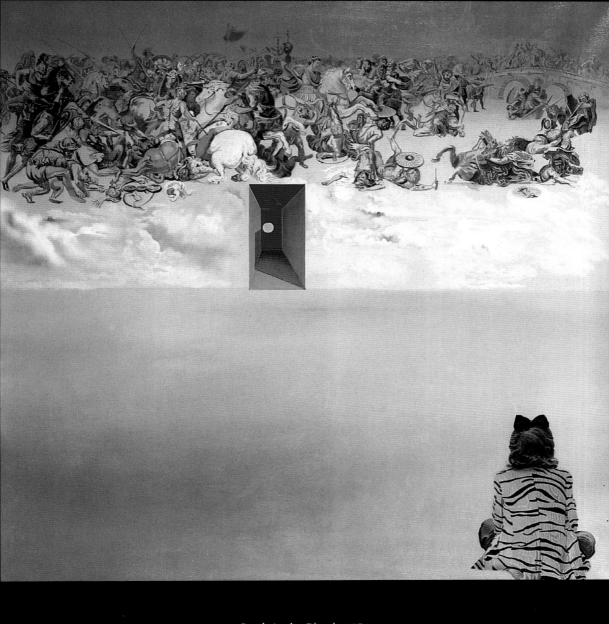

Battle in the Clouds, 1974
Bataille dans les nuages
Oil on canvas, Stereoscopic work on two
panels, each 100 x 100 cm
Gift from Dalí to the Spanish state

Their patience was particularly important when it came to business, since Dalí still ran the multinational concern that was Salvador Dalí himself. He had established a company, Demart, with Robert Descharnes as president, to protect his work and personal rights, to combat fakes worldwide, and to make new deals. Thus he presided over the creation of a perfume that bore his name; from New York to Tokyo, it was marketed in flacons in Surrealist shapes – a nose, a mouth, or (in the case of the men's product) a testicle. Business was brisk. After all, are not testicles the receptacle of the angels? Until the end he gave whatever instructions were necessary for the realisation of projects that mattered to him. One of them was the casting of statues, such as a monumental Newton for a Plaza Dalí in Madrid; a big Venus with drawers (originally for the retrospective which Robert Descharnes and Gilles Néret organized for the Seibu Museum in Tokyo in 1964); and a "rhinocerotic lace-maker" and a "rhinoceros sunflower" dating back to the filming of *L'Histoire prodigieuse de la Dentellière et du Rhinocéros* in the 1950s. He met representatives of the Minami Group (Japan) to discuss the architectural details of his third museum, the Gala-Dalí Museum in Tokyo.

Was Dalí mad? Or senile? A number of Catalonian intellectuals tried hard to claim as much, and wrote an open letter to the Catalonian prime minister, Jordi Pujol, accusing those who were close to Dalí of exerting a bad influence on the master. They also criticized the management of his business concerns and of the Gala-Dalí Theatre-Museum, and suggested that Dalí was no longer capable of making his own decisions. Dalí was incensed. He summoned Pujol to the Torre Galatea and told him with a smile: "I should like to give one of my most beautiful paintings, *Continuum of the Four Buttocks* or *Birth of a Goddess*, to the province of Catalonia." Who would question the sanity of a man who had just made a gift of a painting estimated at half a million dollars? The Catalonian intellectuals had been wasting their time.

In fact, Dalí was still delighting in life, and constantly quoted Ovid's "morte carent animae" (souls forgo death). So much still remained to be done if he was to perfect his work and be assured of immortality. In addition to his rescuer Robert Descharnes, the only one who did not grow rich at Dalí's expense and who conscientiously protected his work and person, the immediate retinue included the painter Antonio Pichot, his pupil from the artistic family that had helped him become a painter; his secretary Maria Theresa, who read the newspapers to him; and Arturo, who had been in his service since 1948 and acted as Dalí's valet, chauffeur, male nurse, and looked after the master's properties – a car workshop in Cadaqués, a sheep ranch converted into a hotel, the Coral de Gala, the famous house in Port Lligat with its outbuildings, and Pubol castle, which housed his collection.

Dalí followed scientific research more attentively than ever. He was fascinated by desoxyribo-nucleic acid (DNA), which contains the coded secrets of the species. Was not a DNA molecule a guarantee of immortality? Dalí told Descharnes that it was the most royal of cells: "Every half of a shoot is exactly linked to its matching half, just as Gala was linked to me ... It all opens and closes and interlinks with amazing precision. Heredity

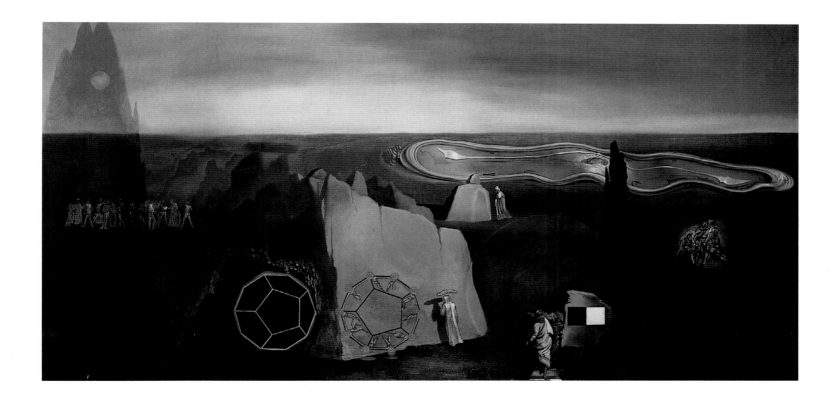

depends on a sovereign mechanism, and life is the product of the absolute rule of desoxyribo-nucleic acid."

Dalí attended to his funeral arrangements himself, and in his will he passed over Catalonia, which he felt had not paid him the respect that was his due, in favour of King Juan Carlos and the Spanish state. He observed: "Crowds go to see my pictures and will go on doing so in future because their vague, inchoate instincts tell them that obvious treasures of authenticity lie hidden in my work and have never yet been seen. Non-artistic treasures that will increasingly tend to become artistic ones." He had 'Les millions d'Arlequins' and the 'Serenade' by Enrico Toselli played to him; they had been taped for him at Maxim's in Paris as a reminder of the good old days. He wondered if he still had the time to write a tragedy. So as not to be surprised by death he began with the word, "Curtain."

His moustache waved and his body embalmed to last at least three hundred years, clad in a tunic adorned with the crown of a marquès and an embroidered border representing the double helix of DNA, the Marquès de Dalí de Pubol (the title conferred on him by King Juan Carlos I on 26 July 1982) lies at rest in a crypt beneath the glass dome of his museum at Figueras, amidst his pictures and objects – among them a Cadillac.

Searching for the Fourth Dimension, 1979
A la recherche de la quatrième dimension
Oil on canvas, 122.5 x 246 cm
Gift from Dalí to the Spanish state

"I always remained the naive, crafty Catalonian with a king dwelling within him."

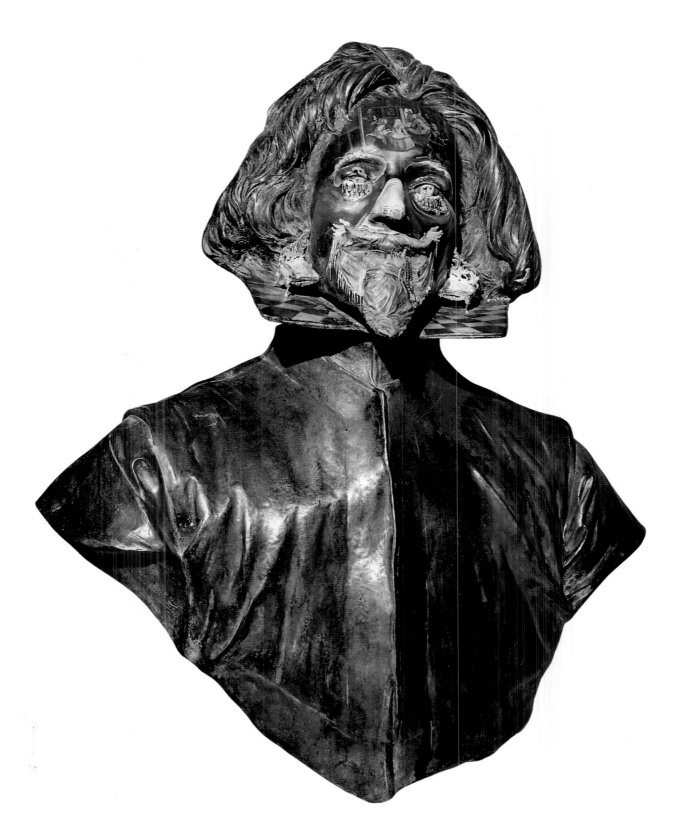

Bust of Velázquez which Metamorphoses into
Three People Talking, 1974
Buste de Vélasquez se métamorphosant en trois
personnages conversant
Painted bronze, 90 x 70 x 38 cm
Fundación Gala-Salvador-Dalí, Figueras

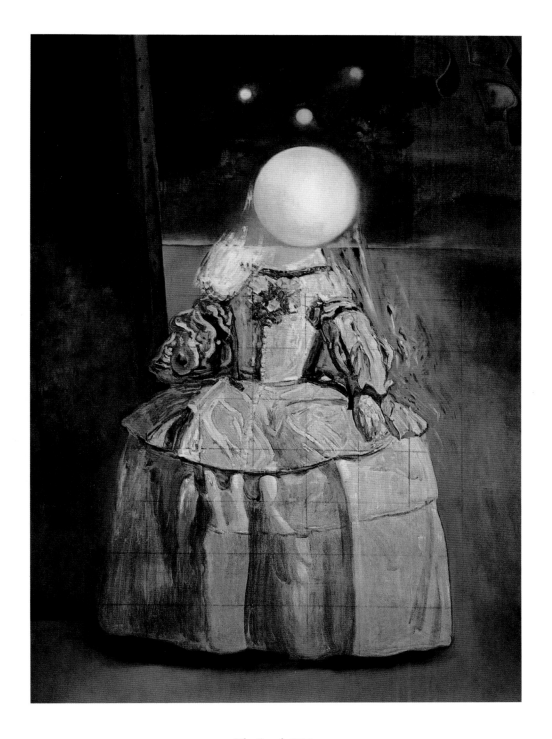

The Pearl, 1981
La perle
Oil on canvas, 140 x 100 cm
Gift from Dalí to the Spanish state

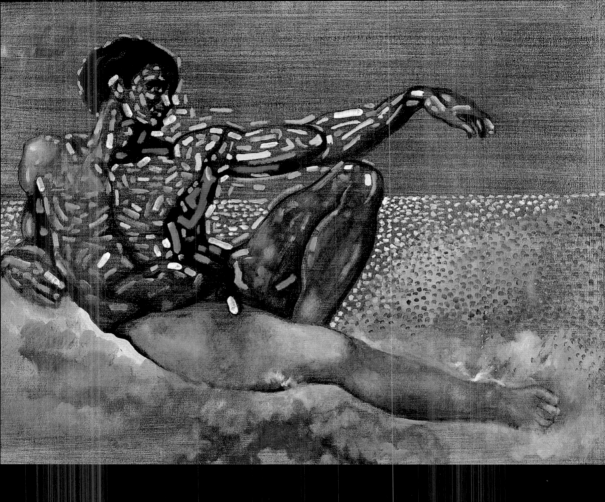

Figure Inspired by Michelangelo's Adam on the
Ceiling of the Sistine Chapel, Rome, 1982
Personnage inspiré par l'adam de plafond de la
chapelle sixtine à Rome, du à Michel-Ange
Oil on canvas, 60 x 75 cm

Athens is Burning !
– The School of Athens and the Borgo Fire, 1979 – 80
Athènes brûle!
L'école Athènes et L'incendie du Borgo
Oil on panel, Stereoscopic work on two panels,
each 32.2 x 43.1 cm
Fundación Gala-Salvador-Dalí, Figueras

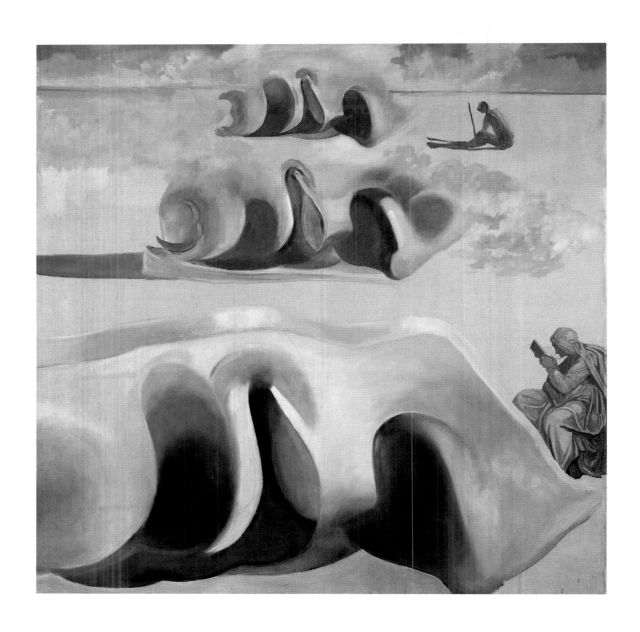

The Three Glorious Enigmas of Gala, 1982
Les trois énigmes glorieuses de Gala
Oil on canvas, 130 x 140 cm
Museo Español de Arte Contemporáneo, Madrid

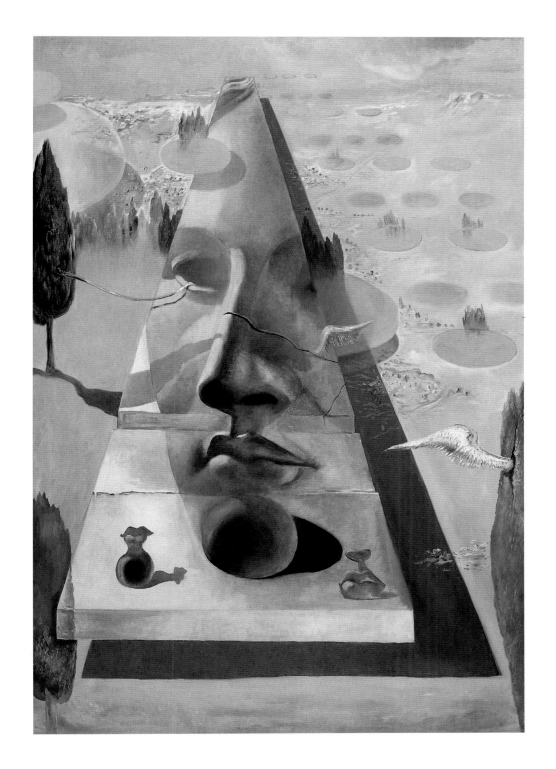

Apparation of the Face of the Aphrodite of
Knidos in a Landscape Setting, 1981
Apparition du visage de l'Aphrodite de Cnide
dans un paysage
Oil on canvas, 140 x 96 cm
Gift from Dalí to the Spanish state

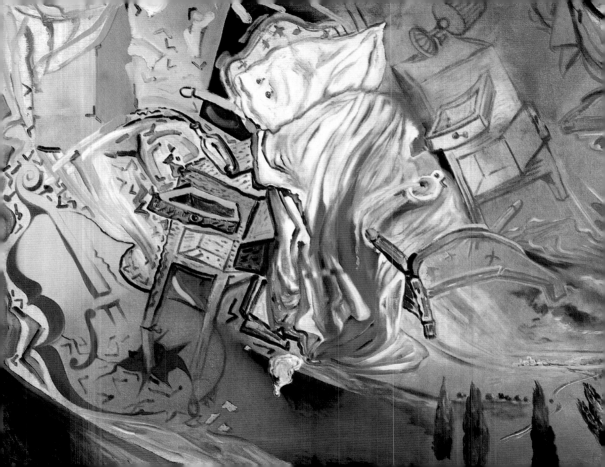

The Swallowtail, 1983
La Queue d'aronde
Oil on canvas, 73 x 92.2 cm
Gift from Dalí to the Spanish state

Dalí: A Chronology
1904–1989

1904 Salvador Dalí is born 2 May at Figueras, Spain. His talent for drawing is apparent from a very early age.

1918 An exhibition of his work at the theatre in Figueras attracts the attention of the critics.

1919 He publishes articles on the old masters in a local magazine, and *Quand les Bruits s'endorment* (poems).

1921 Dalí's mother dies in February. In October Dalí is accepted at the San Fernando Academy of Art in Madrid. He lives in a stu-

Dalí with his sister Ana María at Cadaqués, about 1925/26

dent residence, where he makes friends with Federico García Lorca and Luis Buñuel.

1923 Dalí criticizes his lecturers, disturbs the peace at the Academy, and is expelled for a year. He is also detained under arrest in Gerona for 35 days, for political reasons.

1925 Dalí spends his holidays at Cadaqués with Lorca. In November he has his first solo exhibition at the Dalmau gallery in Barcelona.

1926 Dalí goes to Paris for the first time and meets Picasso (April). In October he is permanently debarred from the Madrid Academy.

Dalí in Guëll Park, Barcelona, 1908

Dalí's father, about 1904

Dalí and García Lorca, Figueras, 1927

Dalí, about 1929

Gala, about 1930

1927 Military service from February to October. Publishes *Saint Sebastian* and develops an aesthetic theory of objectivity.

1928 Writes 'The Yellow Manifesto' with Lluís Montañyá and Sebastià Gasch.

1929 Buñuel and Dalí make *Un Chien andalou*. The film marks their official acceptance into the ranks of the Paris Surrealists. In the spring Dalí is in Paris for filming and, through Miró, meets Tristan Tzara, the Surrealists and Paul Eluard. In the summer, in Cadaqués, he seduces Eluard's wife Gala. This leads to a break with his father.

1930 He begins to evolve his paranoiac-critical method. In *Le Surréalisme au service de la révolution* he publishes *L'Âne pourri*, and in the *Editions surréalistes* his *La Femme visible*. Dalí buys a fisherman's cottage at Port Lligat near Cadaqués, and henceforth spends a good deal of each year there with Gala. Right-wing extremists wreck the cinema where the Buñuel/Dalí film *L'âge d'or* is showing.

1931 *Love and Memory* is published in the *Editions surréalistes* series.

1932 Dalí exhibits in the first Surrealist show in the USA. He writes *Babaouo*, a screenplay – though the film, like all his subsequent film projects, remains unmade. The Zodiaque

group of collectors is established, and regularly buys his work.

1933 In *Minotaure* magazine he publishes his article on edible beauty and art nouveau architecture, which revives interest in the aesthetics of the turn of the century.

1934 He exhibits *The Enigma of William Tell* (p. 53). This leads to arguments with the Surrealists and André Breton. Dalí's New York exhibition is a triumphant success.

1936 The Spanish Civil War begins. Lecturing at a Surrealist exhibition in London, Dalí narrowly escapes suffocating in a diving suit. In December he makes the cover of *Time* magazine (p. 218).

1937 Dalí writes a screenplay for the Marx Brothers and meets Harpo Marx in Hollywood (p. 218). In July he both paints and writes *The Metamorphosis of Narcissus*, a wholesale exercise in the paranoiac-critical method. He designs for Elsa Schiaparelli. Breton and the Surrealists condemn his comments on Hitler.

1938 Dalí exhibits in the Surrealist exhibition in Paris (January). He visits Freud in London (July) and draws a number of portraits of him.

1939 The breach with the Surrealists is now final. André Breton anagramatically dubs Dalí Avida Dollars. In the USA Dalí publishes his

Declaration of the Independence of the Imagination and the Rights of Man to His Own Madness. In November *Bacchanal*, a ballet, is premièred at the Metropolitan Opera in New York, with libretto and set design by Dalí and choreography by Léonide Massine.

The Surrealists in Paris, about 1930. From left: Tristan Tzara, Paul Eluard, André Breton, Hans Arp, Salvador Dalí, Yves Tanguy, Max Ernst, René Crevel, Man Ray

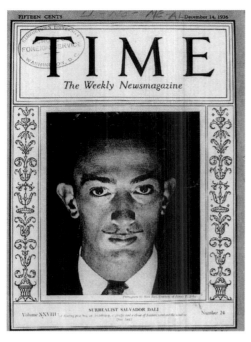

Cover of Time Magazine, 14 December 1936

1942 *The Secret Life of Salvador Dalí* is published in America.

1946 Dalí sketches cartoons for Walt Disney, and designs sequences for Alfred Hitchcock's film *Spellbound*.

1948 *Fifty Secrets of Magic Craftsmanship* is published in America.

1949 Dalí and Gala return to Europe. Dalí designs productions by Peter Brook and Lucino Visconti. He paints *The Madonna of Port Lligat* (p. 159).

1951 Dalí publishes *The Mystical Manifesto*. Beginning of his particle period.

1952 Exhibits in Rome and Venice. Nuclear mysticism.

1953 Triumphant lecture on the phenomenological aspects of the paranoiac-critical method at the Sorbonne (December).

1954 Filming begins on *L'Histoire prodigieuse de la Dentellière et du Rhinocéros*, directed by Robert Descharnes.

1956 Exhibit at the National Gallery, Washington, D.C.

1958 12 May: Dalí presents a fifteen-metre loaf of bread at a happening at the Théâtre de l'Etoile, Paris.

Dalí with his father at Cadaqués, 1948

1959 Dalí presents the "ovocipède" he has invented in Paris (p. 219).

1960 Dalí paints large-format mystical works such as *The Ecumenical Council* (p. 185).

1961 The *Ballet de Gala* is premièred in Venice, with libretto and set design by Dalí and choreography by Maurice Béjart. Dalí gives a lecture on the myth of Castor and Pollux at the Paris Polytechnic.

1962 Publication of *Dalí de Gala* by Robert Descharnes.

1963 Dalí publishes *The Tragic Myth of Millet's Angelus*. He begins to ascribe a decisive role in the constitution of the universe to Perpignan railway station.

1964 First major Dalí retrospective in the Seibu Museum, Tokyo. Dalí publishes the *Diary of a Genius*.

1971 The Salvador Dalí Museum is opened in Cleveland, Ohio with the E. and A. Reynolds Morse Collection, which is transferred to Saint Petersburg, Florida in 1982.

1978 Dalí discovers René Thom's work on mathematical catastrophe theory. April:

1940 After a brief visit to Paris, Dalí and Gala return to New York, where they remain in exile until 1948.

1941 Dalí-Miró exhibition in the Museum of Modern Art, New York.

Dalí drawing Harpo Marx on a plate, Hollywood, February 1937

Exhibits his hyperstereoscopic paintings at the Guggenheim Museum. May: Becomes a member of the *Académie des Beaux-Arts*, Paris.

1979 The *Centre Georges Pompidou* (Paris) shows a large Dalí retrospective which travels to the Tate Gallery in London.

1982 10 June: Death of Gala. July: Dalí is created Marquès de Pubol. From now on he lives in the castle at Pubol which he had given to Gala.

1983 Creation of the perfume "Dalí". An important retrospective is seen in Madrid and Barcelona. May: Dalí paints his last picture, *The Swallowtail* (p. 215).

1984 Dalí is severely burnt in a fire in his room at Pubol. Robert Descharnes publishes a study of Dalí. Retrospective in the *Pallazo dei Diamanti*, Ferrara (Italy).

1988 First Dalí exhibition in the Soviet Union at the Pushkin Museum, Moscow.

1989 23 January: Dalí dies of heart failure in the Torre Galatea, where he has been living since the fire in Pubol castle. He is interred in the crypt of his Theatre-Museum in Figueras as he himself wished. In his will he leaves his entire fortune and works to the Spanish state. In May a large retrospective is seen in Stuttgart, subsequently in Zurich.

Dalí presenting his "ovocipède" on 9 December 1959, with publisher Joseph Fôret, Josephine Baker and Martin Carol

Dalí's house at Port Lligat in 1970

Dalí with his last painting, 1983

Notes

The quotations that appear in the margins were taken primarily from the following works written by Dalí: *Journal d'un génie* (Paris, 1964); *The Secret Life of Salvador Dalí* (New York, 1942); *Conquest of Irrational* (London, 1948); *Manifeste mystique* (Paris, 1951).

1 Salvador Dalí, *Journal d'un génie* (Paris, 1964).
2 Salvador Dalí, *The Secret Life of Salvador Dalí* (London, 1948), p. 349.
3 Salvador Dalí and Louis Pauwels, *Les Passions selon Dalí* (Paris, 1968).
4 Ibid.
5 Salvador Dalí, *Journal d'un génie.*
6 S. Dalí, *The Secret Life,* p. 34.
7 Ibid.
8 S. Dalí/L. Pauwels, *Les Passions.*
9 Francesc Pujols, quoted in ibid.
10 Ibid.
11 S. Dalí, *The Secret Life,* p. 25.
12 S. Dalí, *Journal d'un génie.*
13 S. Dalí, *The Secret Life,* p. 1.
14 Ibid, p. 2.
15 Ibid, see footnote, p. 77.
16 Ibid, p. 81.
17 Ibid, p. 149.
18 Ibid, p. 149 f.
19 Ibid, p. 153.
20 Ibid, p. 159.
21 Ibid, p. 158 f.
22 Ibid, p. 160.
23 Ibid, p. 162.
24 Ibid, p. 198.
25 Ibid, p. 201.
26 Ibid, p. 203.
27 Ibid, p. 204 f.
28 Ibid, p. 205.
29 Ibid, p. 206.
30 S. Dalí and L. Pauwels, *Les Passions.*
31 S. Dalí, *The Secret Life,* p. 205.
32 Ibid, p. 206.
33 Ibid, p. 205.
34 Ibid, p. 207.
35 Ibid, p. 216.
36 Ibid, p. 207.
37 Ibid, p. 208 ff.
38 Ibid, p. 212.
39 Salvador Dalí and André Parinaud, *Comment on devient Dalí* (Paris, 1973).
41 Ibid, p. 229.
42 Ibid, p. 231.
43 Georges Bataille, 'Le jeu lugubre', *Documents, 7*, Dec. 1979.
44 S. Dalí, *The Secret Life,* p. 232.

45 Ibid, p. 241.
46 Ibid, p. 244 f.
47 Ibid, p. 248.
48 Ibid.
49 Alain Bosquet, *Entretiens avec Salvador Dalí* (Paris, 1966).
50 S. Dalí, *The Secret Life,* p. 213.
51 Ibid, p. 212.
52 Salvador Dalí, 'L'énigme de Salvador Dalí', *XXe siècle*, December 1974.
53 S. Dalí, *Journal d'un génie.*
54 S. Dalí, *The Secret Life,* p. 253.
55 Ibid, p. 296.
56 Ibid, p. 258.
57 Ibid, p. 257.
58 Ibid, p. 282.
59 Ibid, p. 260 ff.
60 Ibid, p. 287 f.
61 Ibid, p. 289 f.
62 Ibid, p. 293.
63 Ibid, p. 306.
64 Ibid, p. 307 f.
65 Salvador Dalí, 'De la beauté terrifiante et comestible de l'architecture »Modern Style«, *Minotaure*, 3–4, Paris, 1933.
66 S. Dalí, *The Secret Life,* p. 252.
67 Ibid, p. 283.
68 S. Dalí and A. Parinaud, *Comment on devient Dalí.*
69 S. Dalí, *The Secret Life,* p. 283 f.
70 Salvador Dalí, *Le Mythe tragique de l'Angelus de Millet, Interprétation "paranoïaque-critique"* (Paris, 1963).
71 S. Dalí, *The Secret Life,* p. 312.
72 Ibid.
73 Ibid, p. 313 f.
74 Ibid, p. 314.
75 Ibid, p. 304 f.
76 Ibid, p. 317.
77 Ibid, p. 327.
78 Ibid, p. 327.
79 Ibid, p. 328 f.
80 Ibid, p. 330.
81 Ibid, p. 331 f.
82 Salvador Dalí, *The Conquest of Irrational*, in: The Secret Life of Salvador Dalí, p. 435.
83 S. Dalí, *The Secret Life,* p. 338.
84 S. Dalí, *Journal d'un génie.*
85 Ibid, p. 14.
86 Ibid, p. 19 f.
87 Ibid, pp. 20–23.
88 Ibid, p. 25.
89 S. Dalí, *The Secret Life,* p. 338 f.
90 Ibid, p. 339.
91 S. Dalí, *Journal d'un génie.* Quotes on the conflict with Breton.
92 S. Dalí and A. Parinaud, *Comment on devient Dalí.*
93 Ibid.

94 Marcel Jean, *Histoire de la peinture surréaliste* (Paris, 1959).
95 S. Dalí, *La Conquête*, p. 435 f.
96 André Thirion, *Révolutionnaires sans révolution* (Paris, 1972).
97 S. Dalí, *Journal d'un génie.*
98 S. Dalí, *The Secret Life*, all following quotes on the Spanish civil war: pp. 357, 359 f., 369, 365.
99 Stefan Zweig, *Briefwechsel* (Frankfurt/M., 1987), p. 219.
100 Sigmund Freud, *Briefe 1873–1939*, eds E. and L. Freud (Frankfurt/M., 1980), p. 465.
101 S. Dalí, *The Secret Life,* p. 25.
102 Ibid, p. 371.
103 Ibid, p. 375 f.
104 Ibid, p. 378.
105 Ibid, p. 390.
106 Ibid, p. 383.
107 Anaïs Nin, *The Journals of Anaïs Nin*, vol. 3, 1939–1944 (New York, 1966).
108 S. Dalí, *The Secret Life,* p. 399 f.
109 Salvador Dalí, *Manifeste mystique* (Paris, 1951).
110 Dalí/Parinaud, *Comment on devient Dalí.*
111 Salvador Dalí, *Fifty Secrets of Magic Craftsmanship* (New York, 1948).
112 Dalí/Parinaud, *Comment on devient Dalí.*
113 S. Dalí, *Journal d'un génie.*
114 André Breton, *Anthologie de l'Humour noir* (Paris, 1953).
115 Dalí/Parinaud, *Comment on devient Dalí.*
116 Ibid.
117 Ibid.
118 Ibid.
119 Ibid.
120 Ibid.
121 S. Dalí, *Journal d'un génie.*
122 Ibid, p. 403 f.
123 Ibid, p. 404.
124 Dalí/Parinaud, *Comment on devient Dalí.*
125 Ibid.
126 Ibid.
127 Ibid.
128 quoted ibid.
129 Salvador Dalí, *Dix recettes d'immortalité* (Paris, 1973).
130 Ibid.

Bibliography

Selected Monographs and Other References:

Ades, Dawn, *Dalí,* London, 1982.

Alexandrian, Sarane, *Dalí: peintures,* Paris, 1969.

Arco, Manuel del, *Salvador Dalí, ich und die Malerei,* Zürich, 1959.

Bataille, Georges, 'Le jeu lugubre', *Documents,* 7, 1929.

Bosquet, Alain, *Entretiens avec Salvador Dalí,* Paris, 1966.

Brans, Jan, *Salvador Dalí und seine religiöse Malerei,* Munich, 1955.

Breton, André, *Anthologie de l'humour noir,* Paris, 1953.

Cowles, Fleur, *The Case of Salvador Dalí,* London, 1959.

–, *Salvador Dalí* (biography), Munich, 1981.

Dalí, Ana María, *Salvador Dalí, vist per la seva germana,* Barcelona, 1949; French: *Salvador Dalí vue par sa sœur,* Paris, 1960.

Descharnes, Robert and Salvador Dalí, *Dalí de Gala,* Lausanne, 1961.

–, *Salvador Dalí,* Paris, 1973.

– and Ogura Tadao, *Salvador Dalí* (preface by Salvador Dalí), Sheisha, Collection l'Art Moderne du Monde, Tokyo, 1974.

–, 'Die Eroberung des Irrationalen', *Salvador Dalí, sein Werk – sein Leben,* Cologne, 1984.

Dopagne, Jacques, *Dalí,* Paris, 1985.

Freud, Sigmund, *Briefe 1873–1939* (E. und L. Freud, eds), Frankfurt/M., 1980.

Gallwitz, Klaus, *Metamorphose des Narziß. Die Jugend entdeckt Dalí,* Hamburg, 1971.

Gérard, Max (ed), *Dalí de Draeger,* New York, 1968.

–, *Dalí … Dalí … Dalí …* (preface by Dr. Roumeguère), New York, 1974.

Gómez de Liano, Ignacio, *Dalí,* Barcelona, 1982.

Gómez de la Serna, Rámon, *Dalí,* New York, 1979.

Jean, Marcel, *Histoire de la peinture surréaliste,* Paris, 1959.

Lake, Carlton, *In Quest of Dalí,* New York, 1969.

Longstreet, Stephen, *The Drawings of Dalí,* Alhambra, California, 1964.

Maddox, Conroy, *Dalí,* New York, 1979.

McGirk, Tim, *Gala – Dalís skandalöse Muse,* Munich, 1989.

Morse, A. Reynolds, *Salvador Dalí. A guide to his works in public museums,* Cleveland, Ohio, The Salvador Dalí Museum, 1974.

–, *Salvador Dalí – A panorama of his art. Ninety-three oils 1917–1970,* Cleveland, Ohio, The Salvador Dalí Museum, 1974.

Nin, Anaïs, *The Journals of Anaïs Nin, vol. 3 (1939–1944),* New York, 1966.

Passeron, René, *Salvador Dalí,* Paris, 1978.

Rodriguez, Aquilera, Cesáreo, *Salvador Dalí* (Fundación Gala-Salvador Dalí), Barcelona, 1980.

Sánchez Vidal, Agostin, *Bunuel, Lorca, Dalí: El enigma sin fin,* Barcelona, 1988.

Santos Torrella, Rafael, *Salvador Dalí,* Madrid, 1952.

Soby, James Thrall, *Salvador Dalí,* New York, The Museum of Modern Art, 1941 (3rd ed, 1946).

Tapié, Michel, *Dalí,* Paris, 1957.

Thirion, André, *Révolutionnaires sans révolution,* Paris, 1972.

Zweig, Stefan, *Briefwechsel,* Frankfurt/M., 1987.

Selected Exhibition Catalogues (in chronological order):

Dalí. Ausstellung Salvador Dalí unter Einschluß der Sammlung Edward F. W. James. Rotterdam, Museum Boymans-van Beuningen, 1971; Baden-Baden, 1972 (Renilde Hammacher-van den Brande, with articles by Patick Waldberg, Robert Descharnes, Marc Audouin, Gerrit Komrij).

Salvador Dalí. Reotrospectiva. Humlebaek, Louisiana Museum, 1973; Stockholm, Moderna Museet, 1973–1974 (Knud Jensen, Steingrim Laursen, Uli Linder, et al).

Salvador Dalí. Frankfurt/M., Städtische Galerie und Städelsches Kunstinstitut, 1974 (Klaus Gallwitz).

Salvador Dalí, Retrospektive 1920–1980, and *La vie publique de Salvador Dalí.* Paris, Musée National d'Art Moderne, Centre Georges Pompidou, 1979–1980 (Daniel Abadie, et al).

Salvador Dalí. London, The Tate Gallery, 1980 (Simon Wilson).

Salvador Dalí – Gemälde, Zeichnungen, Objekte, Skulpturen (Collection of John Peter Moore), Heidelberg Castle, 1981 (Klaus Manger, Gómez de la Serna).

Retrospektive Salvador Dalí, Japanese touring exhibition: Tokyo, Isetan Museum of Art; Osaka, Daiman Art Museum; Kitaskyushu, Municipal

Museum of Art; Hiroshima, Prefectural Art Museum, 1982 (articles by Michael Stout, A. Reynolds Morse, Albert Field, Selma Holo, Robert Descharnes).

400 Obres de Salvador Dalí del 1914 al 1983. Generalitat de Catalunya/ Ministerio de Cultura, Palau Reial de Pedralbes Barcelona-Museo.

Español de Arte Contemporáneo Madrid, 1983–1984 (Ana Beristain, Paloma Esteban Leal, et al).

Dalí di Salvador Dalí. Ferrara, Galleria Civica d'Arte Moderna, Palazzo dei Diamanti, 1984 (Robert Descharnes, et al).

Salvador Dalí 1904–1989. Staatsgalerie Stuttgart, 1989 (ed Karin v. Maur, articles by Rafael Santos Torrella, Marc Lacroix, Lutz W. Löpsinger; with selected bibliography).

Selected Works by Salvador Dalí (in chronological order):

'Textes sur Vélasquez, Goya, Le Greco, Michel-Ange, Dürer, Leonardo de Vinci', *Studium,* Figueras, 1919.

'Sant Sebastiá', *L'Amic de les Arts,* 16, Sitgès, July 1927.

(with Luis Buñuel) 'Un Chien andalou', *La Révolution surréaliste,* 12, Paris, 15 December 1929, 34–37.

La femme visible. Paris, 1930.

'L'Âne pourri', *Le Surréalisme au Service de la Révolution,* 1, Paris, July 1930.

L'Amour et la mémoire. Paris, 1931.

Babaouo: scénario inédit précédé d'un abrégé d'une histoire critique du cinéma et suivi de Guillaume Tell, ballet portugais. Paris, 1932.

'De la beauté terrifiante et comestible de l'architecture »Modern Style«, *Minotaure,* 3–4, Paris, 1933.

'Interprétation paranoïaque-critique de l'image obsédante "L'Angélus" de Millet', *Minotaure,* 1, Paris, 1933.

New York Salutes Me. New York, 1934.

La Conquête de l'Irrationnel. Paris, 1935. Engl. ed.: Conquest of Irrational, in: The Secret Life of Salvador Dalí, London, 1948.

Métamorphose de Narcisse. Paris, 1937.

Declaration of the Independence of the Imagination and the Rights of Man to his own Madness. New York, 1939.

'Total camouflage for total war', *Esquire,* New York, August, 1942.

The Secret Life of Salvador Dalí. London, 1948.

Hidden Faces. New York, 1944.

Fifty Secrets of Magic Craftsmanship. New York, 1948.

Manifeste mystique. Paris, 1951.

Le Mythe de Guillaume Tell. Toute la vérité sur mon explusion du groupe surréaliste. 1952 (unpublished).

'Je suis un pervers polymorphe', *Arts,* 361, Paris, 29 May 1952. (with Philippe Halsman) *Dalí's Mustache.* New York, 1954.

'Aspects phénoménologique de la méthode paranoïaque-critique', *La Vie Médicale,* Paris, December 1956.

Le Mythe tragique de l'Angélus de Millet, Interprétation 'paranoïque-critique'. Paris, 1963.

Journal d'un génie. Paris, 1964; Engl. ed.: Diary of a genius, New York, 1965.

(with Louis Pauwels) *Les passions selon Dalí.* Paris, 1968.

Dalí über Dalí. Frankfurt–Berlin, 1972.

(with André Parinaud) *Comment on devient Dali.* Paris, 1973; Engl. ed.: The unspeakable confessions of Salvador Dalí, London, 1976.

Dix recettes d'immortalité. Paris, 1973.

Les Dîners de Gala. Paris, 1973; Engl. ed.: The Dinners of Gala, New York, 1973.

Les vins de Gala. Paris, 1977; Engl. ed.: The wines of Gala, New York 1978.

Exhibitions

This list includes all of the larger solo exhibitions as well as major group exhibitions in which Dalí participated

1918 Teatro Municipal, Figueras (Dalí's first public group exhibition)

1922 Dalmau gallery, Barcelona (Group exhibition with 8 of Dalí's paintings)

1925 Dalmau gallery, Barcelona (Dalí's first solo exhibition)
Madrid (3 works in the *First Art Salon of Iberian Artists)*

1926 Salón del Circulo de Bellas Artes, Madrid *(Modern Catalonian Art)*
Sala Parés, Barcelona (paintings in the *First Autumn Salon)*
Dalman gallery, Barcelona (Secound solo exhibition)

1927 Dalmau gallery, Barcelona (Group exhibition)
Sala Parés, Barcelona *(Second Autumn Salon)*

1928 Carnegie Institute, Pittsburgh (3 paintings in the *27th Annual International Exhibition of Paintings,* Dalí's first group exhibition in the United States)
Sala Parés, Barcelona *(Third Autumn Salon)*

1929 Kunsthaus, Zürich *(Abstrakte und Surrealistische Malerei)*
Galerie Goemans, Paris (Dalí's first solo exhibition in Paris)

1931 Galerie Pierre Colle, Paris
Wadsworth Atheneum, Hartford, Conn. (8 paintings and 2 drawings in *Newer Superrealism,* the first Surrealist exhibition in the United States)

1932 Julien Levy Gallery, New York (3 works in *Surrealist Paintings, Drawings and Photographs)*
Galerie Pierre Colle, Paris

1933 Galerie Pierre Colle, Paris (8 paintings in a Surrealist exhibition)
Galerie Pierre Colle, Paris
Paris, *VI. Salon des Surindépendants*
Julien Levy Gallery, New York (Dalí's first solo exhibition in the United States)
Galerie d'Art Catalónia, Barcelona

1934 Grand Palais, Paris (2 paintings in *Exposition du Cinquentenaire,* Salon des Indépendants)
Aux quatre Chemins, Paris (42 etchings and 30 drawings on Lautréamont's *Les Chants de Maldoror)*
Julien Levy Gallery, New York (Drawings and etchings on *Les Chants de Maldoror)*
Galerie Jacques Bonjean, Paris
Galerie d'Art Catalónia, Barcelona
Galerie Zwemmer, London (Dalí's first solo exhibition in Great Britain)
Julien Levy Gallery, New York
Wadsworth Atheneum, Hartford, Conn.

1936 Charles Ratton, Paris (2 objects in an exhibition of Surrealist objects)
New Burlington Galleries, London *(The International Surrealist Exhibition)*
MacDonald Gallery, London *(Cézanne-Corot-Dalí)*
Museum of Modern Art, New York (6 works in *Fantastic Art, Dada and Surrealism)*
Julien Levy Gallery, New York

1937 Galerie Renou et Colle, Paris
Jeu de Paume, Paris (8 paintings in *Origine et développement de l'Art international indépendant)*

1938 Galerie des Beaux-Arts, Paris (International Surrealist Exhibition with the *Rain Taxi)*
Galerie Robert, Amsterdam (Group exhibition)

1939 Julien Levy Gallery, New York

1940 Galeria de Arte Mexicano, Mexico City (Group exhibition)

1941 Julien Levy Gallery, New York (Solo exhibition, subsequently shown in the Dalzell Hatfield Gallery, Los Angeles, and in Chicago)
Museum of Modern Art, New York (Major Dalí retrospective with a Miró retrospective, which travels to eight U.S. cities by March 1943)

1943 Knoedler gallery, New York

1945 Bignou gallery, New York
Whitney Museum of American Art, New York *(European Artists in America)*

1946 Modern Institute of Art, Boston, Mass. (19 works in *Four Spaniards: Dalí, Gris, Miró, Picasso)*

1947 Galerie Maeght, Paris (International Surrealist exhibition)
Cleveland Museum of Art, Ohio
Bignou gallery, New York

1948 Galleria dell'Obelisco, Rome
Bignou gallery, New York

1950 Palais des Beaux-Arts, Brussels *(Surréalisme et abstraction* of the Collection Peggy Guggenheim, subsequently shown in the Stedelijk Museum, Amsterdam)
Carstairs Gallery, New York

1951 Galerie André Weil, Paris
Lefevre Gallery, London

1952 Kunstmuseum, Basle (22 works in *Phantastische Kunst des XX. Jahrhunderts)*
Carstairs Gallery, New York
Alemany and Ertmann, New York (Jewellery)

1953 Art Museum, Santa Barbara

1954 Palazzo Pallavicini, Rome (Major retrospective, subsequently shown in Venice and Milan)
Carstairs Gallery, New York

1955 Museum of Art, Denver, Colorado

1956 National Gallery, Washington (Exhibition of Collection Chester Dale)
 Casino Communal, Knokke-le-Zoute, Belgium (Retrospective)

1957 Musée des Beaux-Arts, Bordeaux (3 works in *Bosch, Goya and the Fantastic*)
 Musée Jacquemart-André, Paris (12 lithographs on *Don Quixote*)

1958 Knoedler gallery, New York

1960 Carstairs Gallery, New York
 D'Arcy Gallery, New York (*International Surrealist Exhibition. Surrealist Intrusion in the Enchanter's Domain*)

1961 Musée de la Ville de Paris, Paris

1963 Knoedler gallery, New York

1964 Prince Hotel Gallery, Tokyo (Major Dalí retrospective, subsequently travels to Nagoya and Kyoto)
 Municipal Art Gallery, Los Angeles

1965 Gallery of Modern Art, New York (Major retrospective, Dalí 1910–1965)
 Knoedler gallery, New York

1966 Kunsthalle, Berne (*Phantastische Kunst – Surrealismus*)

1967 Louisiana Museum, Humlebaek (6 works in *Seks Surrealister*, subsequently travels to Brussels)

1968 Palais des Beaux-Arts, Charleroi
 Museum of Modern Art, New York (*Dada, Surrealism and their Heritage*)

1969 Kunstverein, Hamburg (*Malerei des Surrealismus von den Anfängen bis heute*)

1970 Knoedler gallery, New York
 Musée de l'Athenée, Geneva (*Hommage à Dalí*)
 Museum Boymans-van Beuningen, Rotterdam (First major Dalí retrospective in Europe)

1971 Staatliche Kunsthalle, Baden-Baden (Major Dalí retrospective)
 Inauguration of the Salvador Dalí Museum, Cleveland, Ohio, with the Collection of A. Reynolds Morse
 Whitechapel Art Gallery, London (Paintings and jewellery)
 Galerie Vision Nouvelle, Paris (*Hommage à Albrecht Dürer*)

1972 Museum Boymans-van Beuningen, Rotterdam (Works from the Collection of Edward F. W. James)
 Galerie Isy Bachot, Brussels
 City Art Gallery, Auckland, Australia (*Surrealism*)

1973 Louisiana Museum, Humlebaek (Dalí retrospective, subsequently travels to Stockholm)

1974 Knoedler gallery, New York
 Städtische Galerie and Städelsches Kunstinstitut, Frankfurt

Opening of the Teatro-Museo Dalí, Figueras

1975 Salvador Dalí Museum, Cleveland, Ohio (*Erotism in Clothing*)

1977 22e Salon de Montrouge (Dalí retrospective)
 Galerie André-François Petit, Paris (*La Gare de Perpignan*)

1978 The Solomon R. Guggenheim Museum, New York

1979 Centre Georges Pompidou, Paris (Dalí retrospective, 1920–1980, also shown in the Tate Gallery, London, in 1980)

1981 Heidelberg castle (Collection of John Peter Moore)

1982 Sala Tiepolo, Madrid (*Obra grafica: Circles literaris*)
 Relocation of the Salvador Dalí Museum from Cleveland, Ohio to St. Petersburg, Florida, with the Collection of E. and A. Reynolds Morse
 Touring exhibition of Salvador Dalí Retrospective in Japan (Tokyo, Osaka, Kitaskyushu, Hiroshima)

1983 Palau Reial de Pedralbes, Barcelona (Dalí exhibition with 400 works)

1984 Pallazo dei Diamanti, Ferrara

1988 Pushkin Museum, Moscow (First Dalí exhibition in the Soviet Union, with the Argillet Collection)

1989 Staatsgalerie, Stuttgart (Major retrospective) Kunsthaus, Zürich

The publishers thank the authors Robert Descharnes and Gilles Néret as well as the following museums and institutions for reproductions on the following pages:

Robert Descharnes: p. 2, 6, 9, 11, 13, 14, 15, 16, 17, 18, 19, 21, 23, 24, 27, 28, 29, 30, 35, 37, 39, 44, 45, 49, 50, 52, 55, 57, 58, 59, 60, 62, 63, 65, 69, 73, 74, 75, 77, 78, 79, 81, 84, 85, 87, 88, 91, 92, 95, 96, 99, 100, 109, 113, 114, 115, 117, 118, 119, 125, 128, 129, 130, 133, 134, 135, 136, 138, 139, 141, 144, 148, 149, 152, 153, 154, 155, 156, 160, 161, 167, 171, 173, 174, 175, 181, 182, 185, 193, 195, 197, 199, 201, 202, 203, 204, 205, 207, 208, 209, 210, 211, 212, 213, 214, 215, 216, 217, 218, 219; Kunstmuseum Basle: p.107; Museum Folkwang, Essen: p. 102/103; Museum Ludwig, Cologne: p. 190/191; Musées Royeaux des Beaux-Arts, Brussels: p. 146/147; Collection Thyssen Bornemisza, Lugano- Castagnola: p. 145; Staatsgalerie Moderner Kunst, Munich: p. 40/41, The Tate Gallery, London: p. 108.

The reproductions on the following pages were taken from the publisher's archives: p. 22, 38, 42, 48, 51, 53, 56, 64, 67, 71, 86, 89, 90, 96, 97, 98, 101, 105, 110/111, 112, 116, 120, 121, 123, 124, 127, 131, 137, 159, 165, 177, 179, 187, 196, 198.